1,000,000 Books

are available to read at

---◇---

www.ForgottenBooks.com

---◇---

Read online
Download PDF
Purchase in print

ISBN 978-0-282-60584-1
PIBN 10858513

1 MONTH OF
FREE
READING

at

www.ForgottenBooks.com

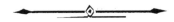

By purchasing this book you are eligible for one month membership to ForgottenBooks.com, giving you unlimited access to our entire collection of over 1,000,000 titles via our web site and mobile apps.

To claim your free month visit:

www.forgottenbooks.com/free858513

English
Français
Deutsche
Italiano
Español
Português

www.forgottenbooks.com

Mythology Photography **Fiction**
Fishing Christianity **Art** Cooking
Essays Buddhism Freemasonry
Medicine **Biology** Music **Ancient**
Egypt Evolution Carpentry Physics
Dance Geology **Mathematics** Fitness
Shakespeare **Folklore** Yoga Marketing
Confidence Immortality Biographies
Poetry **Psychology** Witchcraft
Electronics Chemistry History **Law**
Accounting **Philosophy** Anthropology
Alchemy Drama Quantum Mechanics
Atheism Sexual Health **Ancient History**
Entrepreneurship Languages Sport
Paleontology Needlework Islam
Metaphysics Investment Archaeology
Parenting Statistics Criminology
Motivational

The TRANSLATOR's

PREFACE.

THE author, tho' a man of title and fortune, made painting, for his diversion, both his study and practice; which occasioned his obliging the publick with several useful treatises on this art. In the year 1708, he published the present system, as the result of all his thoughts; and, to make it of more service, has handled it by way of principles; a method, I believe, displeasing to none who desire to know the bottom of the art, or would give reasons for what they do. Ac-

A 2

cordingly,

cordingly, the reader will find a very learned and natural account of the three capital branches, hiſtory, portraiture, and landskip; and of their four chief parts, compoſition, deſign, colouring, and expreſſion, and their incidents.

BUT tho' his home-acquirements were, in all reſpects, very great, he thought them incomplete without finiſhing his reflections abroad: For which pur-poſe he travelled into ſeveral parts of Europe, to ſee the fineſt paintings; whereby he was enabled to make the balance of painters we find in this treatiſe; an attempt, which, for its novelty, muſt needs be acceptable to the curious.

HIS love of painting induced him alſo to draw up a parallel between it and poeſy; wherein, with his uſual

can-

candour and learning, he shews the excellences and preferences of both arts.

WE shall here endeavour to make some remarks on portraiture, *as it is the branch of painting chiefly practised among us ; and at the same time to shew what may be learned from the following system, by those who study or practise this art.*

IN the balance *aforesaid,* Van-dyke *(whom, for several reasons, we may call* ours) *stands high; as having fifteen degrees of merit for composition, ten for design, seventeen for colouring, and thirteen for expression : And we accordingly discover in his works such composition, air, grace, and fine penciling, as none of his successors have hitherto attained. His*

A 3 *method*

method indeed was pretty fingular, (which our author does not wholly agree to) *and calculated for difpatch ; for he beftowed not above an hour on a fitting ; but, being pretty fure of the effects of his colours, he painted without much fcumbling ; the beft way to preferve their purity and vivacity.* Rembrant (whom the balance *equals with* Vandyke *for colouring) tho' not a perfect model for an* Englifh *facepainter, was fo careful not to torture his colours, that he chofe rather to add frefh ones ; and for this reafon his works, as well as* Vandyke's, *maintain to this day an unufual ftrength and vigour. Now, it may be naturally inferr'd, from the practice of thefe two painters, that as any colour, any ftroke, is to exprefs fome drawing, fome tendency, towards teint and likenefs, fo any great difturbance, or*

wrong

wrong colour (too often the caſe of portraiture) not only ſpoils drawing, but ſurpriſingly alters and fouls the teint, and makes the painting leſs like, and leſs durable.

BUT, to return to Vandyke : What if we ſhould ſuppoſe, that the hiſtorical management he was brought up to, under the excellent Rubens, looſened his head, gave him eaſy penciling, and a noble air, and induced him to expreſs nature with more ſpirit, even more to improve her, than if his genius and pencil had been always confined to portraiture ? It's very probable, that ſuch a genius will never quit hiſtorical freedom ; and yet, like Vandyke's, it will, on coming to portraiture, be thereby better enabled to exalt nature, and preſerve likeneſs.

A 4　　　　BUT

BUT *no pains was too great for this artiſt ; who, propoſing an exact* truth *in all things, always sketched, in black and white crayons, the ſize, attitude, and dreſs of the perſon who ſat to him, and, from them, painted afterwards his cloaths, which were ſent to him for that purpoſe. This, whatever trouble painters may think it, muſt needs look more free, natural, and becoming, and tend more to likeneſs, than any ſize, poſture, or dreſs, taken from a layman. As for hands, this artiſt painted them from thoſe of the perſons he retained for that purpoſe.*

IN ſpeaking of the attitudes, (which, with the face, are the language of portraiture) *our author makes them of two kinds ;* viz. in motion, *and* at reſt :

reſt : *The one for young people only, and the other, for any perſons indifferently ; yet, allowing the inactive to have ſome motion. Now, if the attitude be to expreſs,* who and what the ſitter is, and his very temper, *(a very nice hiſtorical point) how much does it concern the portraitiſt to ſtudy it, and make the diſtinctions aforeſaid! Whereas the poſtures of moſt of our portraits are* at reſt, *and at beſt taken from the layman.*

BUT, to prove motion, *and* hiſtorical management, *in a portrait, I muſt acquaint the reader, that I have ſeen a picture drawn in* Italy, *of an* Engliſh *gentleman, where he is repreſented in a ſitting poſture ; the ground is a piece of walling, with a window, at the outſide of which appears a perſon holding up a ſmall image of*
<div align="right">*white*</div>

white marble for the gentleman to look at, who, with extended arms, admires its beauty. And tho' his face was, on this account, fore-ſhortened . lengthwiſe, yet it retained great likeneſs.

THERE is yet behind *a favourite* hiſtorical principle *of* Vandyke *and* Titian, *which face-painters little heed,* I mean *the* claro-obſcuro ; *a com-pound* Italian *word, ſignifying ſimply,* an oppoſition of light and ſhade ; *but, in a more refined ſenſe,* any co-lours, naturally luminous and light in themſelves, oppoſed to others na-turally more brown and heavy.

THE *artifice of the* claro-obſcuro, *of whatever ſmall import painters may think it in a portrait, is certainly practicable in a family-piece ; becauſe our author tells us, that every ſuch*
 picture

picture is an hiſtory, *and becomes a* group *by the meeting of the figures of different ſexes and ages, and in different attitudes and draperies. Now this group muſt be ſo managed, that the foremoſt figures muſt not only, as be-ing nearest to the eye, receive the greateſt light, but alſo be improved by draperies of* natural *light colours, (and, in this, white and yellow ſattin does wonders) and the off-figures be more brown and heavily coloured, but with diſcretion ; ſo that the whole group may appear to have* one general light oppoſing one general ſhade.

In a word : This treatiſe will ap-pear, as our author would have it be, a palace and bulwark for art, to which both painters, and lovers of painting, may ſafely retire for inſtruction and entertainment.

A S

AS to the *tranſlation* ; we *have endeavoured to make it as acceptable to the* Engliſh *reader as poſſible, by obſerving a* medium *between too wide a paraphraſe, and too literal a verſion* ; *the propereſt method for a work that treats ſo learnedly and profoundly of the Art of Painting.*

The

The AUTHOR's

PREFACE,

ON THE

IDEA *of* PAINTING.

THE prize of a race is not to be won, if we have not the goal in our eye; nor is the perfect knowledge of any art or science to be acquired, without having *a true idea* of it. This idea is our goal or mark, and directs us unerringly to the end of our career; that is, to the possession of the science we desire.

BUT though there is nothing which does not include in itself and discover its true idea; yet we must not from hence infer, that this idea is so obvious, as not to be mistaken; or that the false idea does not often pass for the true and perfect. There are several ideas of painting, as well as of other arts: The difficulty lies in discovering which of them is the *true one*. For this purpose, it is necessary to observe, that, in painting, there are *two sorts of ideas; a*

B *general*

general idea, which is common to all men, and *a particular idea, peculiar to painters.*

The fureft way to know infallibly the *true idea* of things is, to derive it from the very *bafis* of their *effence and definition* ; for definition was invented for no other purpofe than preventing equivocation and ambiguity in ideas, banifhing thofe that are falfe, and informing the mind of the true end and principal effects of things. Whence it follows, that the more an *idea* leads us directly and rapidly to the end which its effence points out, the more certain we ought to be, that fuch an idea is a *true one.*

The effence and definition of painting is, the *imitation of vifible objects, by means of form and colours:* Wherefore the more *forcibly and faithfully painting imitates nature,* the more directly and rapidly does it lead us to its *end* ; which is, *to deceive the eye* ; and the furer proofs does it give us of its *true idea.*

The *general idea* above-mentioned ftrikes and attracts every one, the ignorant, the lovers of painting, judges, and even painters themfelves. A picture, that bears this character, permits no one to pafs by it with indifference ; but never fails to furprife us, and to detain us for a while to enjoy the pleafure of our furprize. True painting, therefore, is fuch as not only furprifes, but, as it were, calls to us ; and has fo powerful an effect,
that

that we cannot help coming near it, as if it had fomething to tell us. And we no fooner approach it, but we are entertained, not only with *fine choice*, with the *novelty* of the things it reprefents, with the hiftory or fable it puts us in mind of, with ingenious inventions, and with allegories, to give us the pleafure of employing our parts, either in difcovering the meaning, or criticifing the obfcurity of them ; but alfo with that *true and faithful imitation*, which attracted us at firft fight, and afterwards lets us into all the particulars of the piece ; *and which*, according to *Ariftotle*, never fails to divert us, how horrible foever thofe natural objects may be which it reprefents.

THE other *idea, which, as we faid, is peculiar to painters*, and to which they ought to be perfectly habituated, concerns, in particular, the *whole theory of painting* ; and fhould be fo much at command, that it may feem to coft them no reflection to exe-cute their thoughts : So that after having ftudied correct defign, fine colouring, and all their dependencies, they ought to have thofe ideas always prefent and ready, which anfwer to the feveral branches of their art.

ON the whole, *true painting*, by the force and great truth of its imitation, ought, as I have obferved, to *call the fpectator*, to furprife him, and oblige him to approach it, as if he intended to converfe with the figures:

In

In effect, when the piece bears the character of *truth*, it seems to have drawn us to it, for no other purpose, than to *entertain* and *instruct* us.

BUT here we must observe, that the *ideas* of painting in general are as different as the *manners of the several schools*. Not that painters are without those particular ideas, which they ought to possess: But the use they make of them not being at all times just, the *habits* which this use brings upon them, their attachment to *one part* more than another, and the affection they preserve for the *manner* of those masters whom they have imitated, prejudice their choice, and bias them to some favourite branch of the art; though they are under the strictest obligation to make themselves masters of every part of it, in order to contribute to the *general idea* above-mentioned : For most painters are always divided in their inclinations; some following *Raphael*, others *Michael Angelo*, others the *Caracchis*, and others the scholars of these masters: Some prefer *the whole*; others *the abundance of thoughts*; others *the graces*; others *the expression of the passions of the soul*; and there are some who give themselves wholly up to the *heat* and transport of their genius, tho' but little improved, either by study or reflection.

BUT

BUT what can be done with all thefe vague and *uncertain ideas?* 'Tis certainly dangerous to reject them; we muft therefore refolve to prefer to all other things that *truth,* which we have fuppofed in the *general idea:* For, to all *painted objects,* the appearance of *truth* is more neceffary, than the manner of any mafter whatever; becaufe truth in painting is the bafis of all the parts which heighten the excellence of this art; as the *fciences and virtues* are the foundation of all thofe accomplifhments, which can either exalt or adorn human nature. For which reafon we muft fuppofe truth on the one hand, and virtue and fcience on the other, to be in perfection, when we talk of thofe finifhings, or accomplifhments, of which either painting or human nature is fufceptible, and which, without refting upon fuch a bafis, can have no good effect. In fhort, the fpectator is not obliged to feek for *truth* in a painting; but *truth,* by its effect; muft *call to the fpectator,* and force his attention.

'TIS in vain to adorn a ftately palace with the greateft rarities, if we have forgot to make doors to it, or if the entrance be not proportionable to the beauty of the building; fo as to raife the paffenger's defire to walk in, and gratify his curiofity. All *vifible objects* enter the underftanding by the faculty of *feeing,* as *mufical founds* do by that of *hear-*

B 3 *ing.*

ing. The *eyes* and *ears* are the *doors*, which admit us to judge of *painting* and *mufick :* The firft care therefore both of the painter and the mufician fhould be, to make thefe entrances *free* and *agreeable*, by the force of their harmony; the one in his *colouring* con-ducted by the *claro-obfcuro*, and the other in his *accords*. The fpectator being thus at-tracted by the force of the performance, his eye difcovers in it thofe particular beauties which are capable of inftructing and pleafing; the curious finds in it what fuits his tafte; and the painter there obferves the different branches of his art, in order to improve himfelf by what is good, and to reject what-ever may be vicious. Every thing in a picture is not equally perfect. Some paint-ings there are, which, with feveral faults, when minutely confider'd, do not fail, ne-verthelefs, to catch the eye; becaufe of the artift's excellent management in his *colouring*, and the *claro-obfcuro*.

REMBRANT, for inftance, diverted him-felf one day with drawing his maid's picture, in order to fet it at his window, and deceive paffengers : His project fucceeded; for the fallacy was not difcover'd till fome days after. And yet, as we may juftly imagine of *Rembrant*, this effect was not owing to the beauty of the defign, nor to the noble-nefs of the expreffion. When I was in *Hol-land*, I had the curiofity to fee this picture; and,

and, finding it to be well pencil'd, and of great force, I bought it, and it has at this time a confiderable place in my cabinet.

OTHER painters, on the contrary, have fhewn in their works a good many perfections in the feveral parts of the art; yet have not been fo happy as _Rembrant_, to gain, at firft fight, fuch favourable regards: I fay, not happy; becaufe, if they have fometimes fucceeded, 'twas owing to a chance difpofition of objects, which, in the places they filled, required an advantageous _claro-obfcuro_; a perfection which cannot be denied them, but wherein the fkill of the painter had very little fhare; fince, if it had been the effect of fcience, it would have appeared in all his other productions.

THUS nothing is more common, than to fee paintings fet off a room, purely by the richnefs of their borderings, whilft the infipidity and coldnefs of thofe paintings is fuch, that people pafs unconcernedly by them, without being attracted by that truth which calls to us. Now, to make this point clearer, I muft explain it by the example of fome fkilful painters, who yet have not been mafters enough to ftrike the eye, at firft fight, by a faithful imitation, and a truth which ought to deceive, as even excelling nature itfelf. The moft remarkable example I can quote is _Raphael_, becaufe of his great reputation, and becaufe there was never any

painter

painter who poffeffed fo many parts of the art, or poffeffed them in fo high a degree of perfection.

'Tis very certain, by the confeffion of many, that men of knowledge have often fought for *Raphael*'s works in the midft of them; that is, in the halls of the *Vatican*, where are his beft performances; and have asked their guides to fhew them the works of *Raphael*, without giving the leaft indication of being ftruck with them at the firft glance of the eye, as they expected to be, from that painter's reputation. The paintings of *Raphael* did not anfwer the idea they had conceived of fo great a genius, becaufe they meafured them by that idea which one ought naturally to have of perfect works. They could not imagine, that the imitation of nature would not, in the works of fo wonderful an artift, appear in all its vigour, and all its perfection. This fhews, that without the knowledge of the *claro-obfcuro*, and of whatever depends on colouring, the other parts of painting lofe much of their merit, even when they are in that degree of perfection to which *Raphael* carried them.

I shall offer here a late inftance of the little effect which *Raphael*'s works produce at firft fight: I had it from *(a)* a friend well known for his genius and knowledge, and

(a) Monfieur *de Valincourt.*

who,

who, as it ufually happens to perfons of his
parts, has fuch an efteem for this famous
painter, as comes up to admiration. Being
fome time ago at *Rome*, he was very im-
patient to fee *Raphael's* works; the moft
admired of which are his *Frefco* paintings
in the halls of the *Vatican* : He was accord-
ingly carried thither, but happened, with
indifference, to crofs the halls, without per-
ceiving, that he had before his eyes what he
fo eagerly fought after. His conductor
thereupon ftopt him fhort, and faid ——
*Whither are you going fo faft, Sir? There's
what you look for, and you do not mind.* My
curious friend no fooner perceived the
beauties wh'ch his fine genius pointed out to
him in thofe works, but he refolved to repair
thither cften, fully to gratify his curiofity,
and to form his tafte on what he could fur-
ther difcover. But what, if, befides charm-
ing with the fight of fo many fine things,
Raphael had, at firft fight, called to him, by
the effect of a colouring proper for each
object, and fupported by an excellent *claro-
obfcuro!*

THIS gentleman thought he fhould be
extremely furprifed at the fight of paintings
that had fo great reputation; but was not:
And, not being a painter, he contented him-
felf with examining and praifing the airs of
the heads, the expreffions, the noblenefs of
the attitudes, and the graces of the parts he
beft

beſt underſtood : In other things he had but little curioſity, becauſe they relate to the painter only. This ſtory is often revived, as well by painters who never ſaw any of *Raphael's* works, as by other curious perſons, ignorant of painting.

YET it muſt be acknowledged, that ſome of this artiſt's paintings are well colour'd ; but we muſt not form our judgment of the whole, by the few of this kind ; for it is the general run of his, and other painters works, that muſt determine the extent of their capacities.

SOME object, that this great and perfect imitation is not eſſential to painting ; and that, if it were, the effects would appear in moſt pictures ; that a picture may call, and yet not always anſwer the idea of the perſon who comes to it; and that it is not neceſſary for the figures to ſeem deſirous to enter into a converſation with the ſpectator, becauſe he is already prepoſſeſſed with the notion of its being only a painting.

IT is certain, that the number of pictures which call the ſpectator is but few : But that is not the fault of the art ; the eſſential effect of which is to ſurpriſe, and deceive the eye : We muſt only blame the painter's negligence, or rather impute it to his genius, as not being exalted enough, or not ſufficiently furniſh'd with the principles neceſſary for
<div align="right">com-</div>

compelling, as it were, thofe who pafs by, to ftop, and give attention to his pieces.

BUT further; it argues more genius to make a good ufe of lights and fhades, harmony of colours, and their fuitablenefs to each particular object, than to defign a fingle figure correctly.

DESIGN, which requires much time to learn perfectly, confifts of little more than an habit, which is often repeated, of giving meafures and outlines; but the *claro-obfcuro*, and harmony of colours, is a continual fubject of reafoning, which employs the genius in ways that are as different as the compofitions themfelves. A moderate genius may, through perfeverance, attain correct defigning; but the *claro-obfcuro* requires, befides the rules, fuch a compafs of genius, as may incorporate with, and, as it were, diffufe itfelf through, all the other parts of painting.

'TIS well known, that the works of *Titian*, and of all the painters of his fchool, have fcarce any other merit than their *claro-obfcuro*, and colouring; and yet they bear a great price, are in great repute, and maintain their pofts in the cabinets of the curious, as firft-rate pictures.

WHEN I fpeak of defign, I muft be underftood to mean only that material part, which, by juft meafures, forms all objects in a regular manner; for I am not ignorant, that

that in defign there is a genius capable to feafon all forts of forms by the affiftance of tafte and elegance ; yet it is eafy to obferve, that the effect, which calls to the fpectator, arifes principally from the colouring of all the parts ; by which we are to underftand the *claro-obfcuro,* and the general harmony of colours, as alfo fuch as we call *local,* or colours which faithfully imitate thofe of any particular object. But all this hinders not the other parts of art from being neceffary to help forward the whole work, and from mutually affifting each other ; fome to form, others to adorn the objects painted, in order to give them a tafte and grace that may in-ftruct, refpectively, both lovers and painters, and, in a word, may pleafe every one.

THUS, as it is the duty of painting, both to call and pleafe ; when it has called the fpectator, it muft neceffarily entertain him with all the various beauties of which it is capable.

I MUST now proceed to fet the feveral parts of painting in their natural order, that I may confirm the reader in the idea I have been endeavouring to eftablifh : And becaufe this idea is founded on *truth,* I fhall begin the following difcourfes with a treatife on this fubject : which I am the more obliged to do, becaufe the fubject of *truth,* and the *idea of painting,* are fo nearly allied, as to be almoft the fame thing ; for all the parts

of

of painting are no further valuable than they
bear this character of truth.

AFTER the idea of painting which I have
endeavoured to eftablifh, and after the trea-
tife upon truth, I fhall fpeak of the other
parts of painting; and if the grounds I go
upon are folid, they may poffibly fcreen me
as well from the falfe critick, as from thofe
who are ignorant of the true principles of
the art.

SUCH principles I will endeavour to efta-
blifh, as may ferve to build a rampart and
palace for painting, where great painters,
true criticks, lovers of painting, and all per-
fons of good tafte, may fafely retire. In-
vention will furnifh the thought of the
ftructure, and chufe its painter-like fituation,
which, though fanciful, and fometimes even
wild, will, neverthelefs, be extremely agree-
able. Invention will alfo prepare the ma-
terials, and difpofition compart the rooms,
for receiving all the folid beauties and orna-
ments we would place in them. After in-
vention and difpofition, defign and colouring,
and their dependencies, are ready to perform
their parts in executing the building. Co-
louring will vifit every thing, and every-
where diftribute its gifts, according to the
exigence and propriety of the place; and,
jointly with defign, will chufe the furniture
of the palace. Defign alfo will, by way of
pre-eminence, have alone the charge of over-
<div align="right">feeing</div>

feeing the architecture, as colouring will
have that of chufing the pictures ; and both
will co-operate to put the finifhing hand to
the ftructure.

THE fituation, to make it commodious
for painting, muft be diverfified with objects
produced without art or culture, as rocks,
· cafcades, mountains, rivulets, forefts, fkies,
and fields, all in an uncommon manner, yet
keeping within the bounds of probability,
and which will be more particularly handled
in my difcourfe on landfkip.

AMONG other inhabitants of this palace,
painting will receive poefy with all the
marks of diftinction fhe deferves, where they
will live together, like two kind fifters, who
ought to love one another, without jealoufy,
and without difputes: It is with a parallel
between thefe two arts I intend to clofe this
fyftem of painting.

SOME perfons of good fenfe have blamed
me for making ufe of the defect in *Raphael*
to confirm my fentiment on the idea of
painting ; *Raphael*, who ought not to be
mentioned, fay they, but as the model of all
perfection, confidering the general and efta-
blifhed reputation he has acquired. They
own, I have reafon in the main ; yet fay,
that I ought to chufe fome other example,
and join with people of underftanding in
treating *Raphael* with more complaifance.
They add, that the curious are already fet
<div align="right">againft</div>

againſt me, becauſe they have imagined, that I preferr'd *Rubens* to *Raphael*; and that the example I make uſe of to confirm my ſentiment, would rather irritate than convince them; and would likewiſe, with them, very much leſſen the opinion which the world entertains of my ſkill in painting.

I can only anſwer, that I choſe *Raphael* ×× as an example, that is, what often happens at the firſt ſight of his works, for no other reaſon, but becauſe he excelled more-in all the parts of his art, than any other painter; and becauſe I ſhould reap more advantage, and more certainly eſtabliſh my ſentiment on the idea of painting, if I ſet it in oppoſition to all *Raphael's* perfections. To chuſe *Raphael*, therefore, as an example, becauſe he poſſeſſed more excellencies than any other painter, and in order to ſhew, that all excellencies loſe much of their luſtre, when they are not accompanied with a colouring which calls the curious to admire them, can never be thought to argue a contempt of him.

My intention is not to write, either for the learned in painting, or the ignorant, but for ſuch as are born with an inclination to this fine art, and may at leaſt have improved it by converſing with able judges, and learned painters: I write, in a word, for young pupils, who may have ſet out in a right path, and for all thoſe, who, after acquiring ſome tincture of deſign and colouring, have

impartially

4

impartially examined the beft works, and are docile enough to embrace thofe truths which may be hinted to them.

As for half-learned painters, who have fet out in the wrong path, and moft of the book-learned, they ufually maintain the falfe ideas which they have haftily embraced; and, tho' ftrangers to defign or colouring, or *Raphael,* or *Rubens,* will talk of thofe two painters according to an antient tradition, which, though much leffened of late by good reflections, has yet left its impreffions on the minds of many.

As for myfelf, I can fay, that having, in my travels, view'd, with great attention, the fineft pictures in *Europe,* I have ftudied them with fondnefs; and fuch parts as nature has beftowed upon me, I have improved and employed this way: I admire every thing that is good in the works of the great mafters, without refpect to names, or any other complaifance. I value the feveral celebrated fchools: I love *Raphael, Titian,* and *Rubens;* and I do my utmoft endeavours to dive into the rare accomplifhments of thofe great painters: But, whatever perfections they may have, I love truth better : Truth alone is what fhould be had in view, efpecially by one who writes for the publick : This is a refpect to which the publick has a right, and therefore I thought I could not excufe myfelf from paying it.

OF

O F

T R U T H

I N

P A I N T I N G.

MA N, however much given to lying,
hates nothing fo much as a lye, and
the fureft way to gain his confidence
is, to treat him with fincerity : 'Tis needlefs,
therefore, to make an encomium here on
truth, fince every one loves it, and feels the
beauties of it ; nothing is good, nothing
pleafes, without truth ; 'tis reafon, equity,
good fenfe, and the bafis of all perfection ;
'tis the aim of the fciences ; and all the arts,
whofe object is imitation, have no other ten-
dency than to inftruct and direct men, by a
faithful imitation of nature : Wherefore
thofe, who either cultivate the fciences, or
exercife the arts, cannot fay that their en-
deavours have been crowned with fuccefs,
if, after all their pains, they have not dif-
covered that truth which they look upon as
the reward of their ftudies.

<div align="center">C</div>

BESIDES

B E S I D E S the general truth, which ought
to appear in all things, there is a truth pecu-
liar to each of the fine arts, and to each of
the fciences. My prefent defign is, to dif-
cover what is truth in painting, and of what
importance it is to the painter to exprefs it
well.

B U T before we enter on the fubject, it
muft be premifed, with regard to imitation
in painting, that though the true object is
the natural one, and the feigned object that
in the picture, the latter is, neverthelefs,
called true, when it is a perfect imitation of
the former. It is therefore the truth in
painting, which I fhall endeavour to dif-
cover, in order to fhew its worth and necef-
fity. I obferve, in painting, three kinds of
truth, *viz.*

The fimple;
The ideal; and
The compound, or perfect truth.

T H E fimple, which I call the primary
truth, is a plain and faithful imitation of the
motions that exprefs nature, and of thofe
objects which the painter has chofen for his
copies, fuch as they appear to the eye at firft
fight; fo as the carnations may feem to be
real flefh, and the draperies real ftuffs, in
their feveral varieties, and each object main-
tain the true character of its nature, and, by
the force of the *claro-obfucro*, and of the
union

union of colours, the feveral painted objects may appear to have a relief, and the whole be harmonious.

In all natural things, this fimple truth difcovers the way by which the painter may gain his end; which is fuch a ftrong and lively imitation of nature, that it may feem poffible for the figures to come out of the picture, as it were, in order to talk with thofe who look at them. But let it be here obferved, that from this idea of the fimple or primary truth I abftract all the beauties that may embellifh it, and which either the painter's genius, or the rules of art, may add to it, in order to make the whole perfect.

The ideal truth is a choice of various perfections, not meeting in any fingle copy, but taken from feveral, and commonly from thofe of the antique.

This kind of truth comprehends an abundance of thoughts, a richnefs of invention, a propriety of attitudes, an elegance of outlines, a choice of fine expreffions, an handfome caft of draperies, and, in a word, every thing that can, without altering the primary truth, make it more moving, and more agreeable. But as all thefe perfections can only fubfift in idea, with regard to painting, they have need of a lawful fubject, both to preferve and fet them off to advantage: And this lawful fubject is fimple truth, in the fame manner as moral virtues

are

are only ideal, if they have not a lawful
fubject, that is, a fubject properly difpofed
to receive and fupport them; without which
they would be but the fhadows of virtue.

SIMPLE truth fubfifts of itfelf, and gives
both relifh and fpirit to the perfections which
attend it; and if it does not alone lead to an
imitation of perfect nature, which depends
upon the choice the painter makes of his
copy, it leads at leaft to an imitation of na-
ture, which, in general, is the end of paint-
ing. Ideal truth, of itfelf, muft be allowed
to lead into a moft agreeable path: yet it is
fuch as does not carry the painter to the end
of his art, but leaves him fhort of it; and
the only affiftance he can expect to come to
the end of his career, muft proceed from the
fimple truth. Hence it appears, that the
fimple and ideal truths together make a
perfect compound, and mutually affift each
other; with this difference, that the former
overpowers and darts its rays through all the
perfections that are joined to it.

THE third truth, as a compound of the
other two, gives the laft hand to art, and the
perfect imitation of fine nature. It carries
fo beautiful a probability, as often appears to
be more true than truth itfelf: And the
reafon is, that, by the aforefaid conjunction,
the primary truth feizes the fpectator, falves
many negligencies, and produces its effect
the firft, without our attending to it.

THIS

THIS third truth is the mark which hitherto no man has hit; we can only say, that those who have come the nearest to it, are the most accomplished. The simple and ideal truths have been divided according to the genius and education of the painters who possessed them: *Giorgione, Titian, Pordenon,* old *Palma,* the *Baffans,* and all the *Venetian* school, had no other merit, but that of possessing the primary truth: And *Leonardo da Vinci, Raphael, Julio Romano, Polydore da Caravaggio, Pouffin,* and some others of the *Roman* school, have gained their greatest reputation by ideal truth; especially *Raphael;* who, besides the beauties of ideal, was master of a considerable part of the simple truth, by which means he came nearer to that truth which is perfect, than any other *Italian:* In effect, it appears, that, in order to imitate nature in its variety, this painter usually made use of as many different natural objects, as he had figures to introduce into his pieces; and if, at the same time, he added some things of his own, it was to make his drawings the more regular, and more expressive, but always preserving truth, and the distinguishing character of what he copied. Though he was not thoroughly master of simple truth in the other parts of painting, yet he had such a taste for truth, that in most of the parts of the human body, which he designed after nature, he drew

C 3 them

them on paper, as they really were, in order
to be testimonies of the most simple truth,
and to be joined to the idea he had of the
beauty derived from the antique. An admirable conduct! in which no painter has
been so succesful as *Raphael*, since the revival of the art.

Now, if perfect truth be compofed of
the fimple and ideal, painters may be faid
to excel, in proportion to the degree wherein
they poffefs thofe feveral truths, and to the
happy facility they have acquired of joining
them into one compound.

After having fettled what truth is in
painting, it is proper to inquire, whether
thofe painters, who exaggerate, or *overdo*
the out-lines of their figures, in order to
feem learned, have not abandoned truth, by
exceeding the bounds of a regular fimplicity.
In this point, painters ufe the word *charge*,
to fignify any thing that exceeds : Now, as
every thing that exceeds, is beyond probability, 'tis certain, that whatever may be
faid to be *charged*, is contrary to the truth
which we would eftablifh. Yet there are
charged out-lines which pleafe, becaufe they
are above the lowlinefs of ordinary nature,
and becaufe they carry with them an air of
freedom, and a certain idea of a great tafte;
which deceives moft painters, who call thefe
exceffes, the *grande maniere*. But thofe
who have a true idea of correctnefs, of regular

gular fimplicity, and of the elegance of nature, will look upon thefe exceffes as fuperfluous, fince they always adulterate the truth: Yet one cannot help praifing fome overcharged things in great works, when the diftance from whence they muft be viewed, foftens them to the eye, or when they are ufed with fuch difcretion, as makes the character of truth more apparent.

Some painters there have been, who, inftead of a reafonable moderation in their defigns, have affected to exprefs their out-lines and mufcling with greater exactnefs than the art of painting requires: Their motive was, to gain to themfelves the reputation of being fkilful in defign and anatomy; but their motive, like their pictures, has a certain air of pedantry, more capable of leffening the beauty of their works, than of increafing their reputation: It muft, indeed, be granted, that the artift ought to underftand anatomy, and the fharp fwells, which are its confequences; becaufe anatomy is the bafis of defigning, and becaufe thefe fwells may lead thofe to perfection, who know how to take and to leave as much of them as is neceffary to make exactnefs and fimplicity of defign agree with good tafte: Such things may alfo be tolerable, and often agreeable, in mere fketches of a picture, and the learned painter may profitably make ufe of them when he begins and dead-colours; but fhould cut them

off when he would have his work appear in perfection; as the architect ſtrikes his centre as ſoon as the arch is ſet.

ON the whole, the antique ſtatues, which have paſſed at all times for the rule of beauty, have nothing charged, nothing affected; nor is there any thing of this kind in the works of thoſe who have always imitated them; as *Raphael, Pouſſin, Dominichino,* and ſome others.

NOT only all affectation is diſpleaſing, but nature, beſides, is obſcured and overcaſt by a bad habit, which painters call *manner.*

THE better to underſtand this principle, 'tis proper to know, that there are two ſorts of painters: Some, and they are but few, paint according to the principles of art, and make truth ſo obvious in their works, as to ſtop and entertain the ſpectator; others work only practically, by an expeditious habit, which they have either taken up without reaſon, or learnt of their maſters without reflection. Though theſe ſometimes do well, either by chance, or by the help of their memories, yet they always ſucceed but indifferently when they work on their own bottom; for as they but rarely make uſe of the natural, or elſe confine themſelves to their habit, they never expreſs that truth, or that probability, which is the ſole object of a true painter, and the end of painting.

<div align="right">FOR</div>

FOR the reft, among all the fine arts, there is certainly none, where truth ought to be fo confpicuous, as in painting: The other arts do but revive the idea of things abfent; whereas this intirely fupplies them, and makes them prefent, by the very effence of it, which confifts not only in pleafing, but deceiving, the eye. *Apelles* drew his portraits fo true and like, both in air, and every thing elfe relating to the face, that a certain horofcope-maker could, on fight of them, tell the temperament or conftitution of the perfon painted, and what would befal him: 'Twas this painter's care, therefore, rather to obferve truth in his portraits, than to embellifh them with falfities. In effect, truth has, in this cafe, fo many charms, that it ought to be always preferr'd to borrow'd beauty; fince, without it, portraits can only preferve a vague and confufed idea of our friends, and not the true character of their perfons.

WHAT can be inferr'd from all this rea- foning, but that there is in painting a pri- mary, an effential truth, which leads the painter directly to his end; an animated truth, which not only fubfifts and lives of itfelf, but alfo gives life to all the embellifhments of which it is fufceptible, and which ought to be joined with it; and that thefe per- fections are but fecondary truths, which, by themfelves, have no force to move, but yet do

do honour to the primary truth, when added
to it? Now this primary truth in painting
is, as we have faid, a fimple and faithful
imitation of the motions which exprefs na-
ture, and of objects, fuch as, at firft fight,
they prefent themfelves to the eye, with all
their varieties, and in their true characters.

I T appears, therefore, that every painter,
who not only neglects the primary truth,
but does not take great pains to make him-
felf thoroughly mafter of it, will only build
upon fand, and will never pafs for a genuine
imitator of nature ; and that the whole per-
fection of painting confifts in the three forts
of truth we have endeavoured to eftablifh.

Copy of a Letter from Monfieur Du
Guet, *to a Lady of Quality, who
had fent him the preceding Difcourfe,
and had afked his Opinion of it.*

19. *March* 1704.

T H E difcourfe of truth in painting,
Madam, has better informed and pleafed
me, than thofe other difcourfes with which
you know I was fo well fatisfied. It appears
to me, not only to be a fummary of the
rules, but alfo to difcover the foundation,
and ultimate end of them ; and I have there
learned, with great pleafure, the fecret of
reconᵃ

reconciling two things, which I took to be
oppofite ; the art of imitating nature, and
that; of going beyond this imitation, by
adding; to her beauties, in order to attain
them ; and of correcting her, to make her
more apparent. The fimple truth gives life
and motion, and the ideal chufes with art
every, thing, that can either adorn or make it
moving ; yet does not chufe but from the
fimple truth, which indeed is barren in fome
parts, but, upon the whole, is rich and
fruitful.

Now; if the fecondary truth does not
fupport the primary, but rather overpowers
it, and hinders it from being more apparent,
than any addition from the fecondary ; art
departs in this cafe from nature ; takes her
place, inftead of reprefenting her; difappoints
the fpectator's expectation; and not his eye;
and warns him of the fnare, inftead of con-
cealing it from him. If, on the other hand,
the primary truth has all the truth of life and
motion, and is wanting in that noblenefs,
exactnefs, and grace, which fometimes are
only to be found elfewhere, if it fubfifts
without any aid from the fecondary, which
is always great and perfect, it pleafes no fur-
ther than it is agreeable and finifh'd, and the
copy has nothing that was miffed in the
original.

THE ufe we are therefore to make of this
fecondary truth is, to fupply every fubject
with

with thofe things which it has not, but
might have, and fuch as nature has diftri-
buted among others, and thus to unite thofe
perfections, which nature has commonly
feparated.

THE fecondary truth is, ftrictly fpeaking,
very near as real as the primary; for it does
not invent; it chufes from all parts; it
ftudies whatever may pleafe, inftruct, or
animate. Nothing efcapes it, not even what
would feem to have efcaped it by chance. It
catches, by means of defign, what does but
once appear, and enriches itfelf with a thou-
fand different beauties, that it may be always
uniform, and never fall into repetitions.

'TIS for this reafon, methinks, that the
union of thefe two truths has fo furprifing
an effect; for this union produces a perfect
imitation of what is moft ingenious, moft
moving, and moft perfect in nature. Every
thing here is probable, becaufe it is true;
but furprifing, becaufe it is rare; every
thing ftrikes, becaufe every thing that is
capable of ftriking has been obferved; yet
nothing appears affected, or overdone, be-
caufe there is nothing here that is wonderful
and perfect, which has not been copied from
nature.

'TIS departing from the rules, and the
end of painting, to let any one beauty over-
power another, or to aim at a reputation for
any one part, and not for the whole: De-
fign,

fign, fkill in anatomy, and even the defire
to pleafe, and be approved, fhould all be
fubfervient to truth. A true painting, in.
fhort, ought to tranfport the fpectator from
the very firft moments he fees it, and not to
give him leave, till afterwards, to think of
the painter, and admire his art.

MONSIEUR DU PILES has, very hap-
pily, difplayed the character of *Titian*, for
the fimple truth in its greateft force; and
that of *Raphael*, for ennobling the fimple
truth with the ideal: And I know not whe-
ther any more refined or more univerfal me-
thod could be found for judging of the
merit of the greateft painters, than going
even beyond their efforts, and their fuccefs,
and pointing out the union of the two truths
which they have endeavoured after, but have
not attained, as the utmoft ftretch of the
art.

I KNOW not, Madam, why I fay fo much
on this fubject, if not to let you fee, how
full I am of what I have been reading, and
what value I fet on fuch things as I can't
help repeating to you, though I am fenfible,
that in fo doing I fpoil and weaken them.

　　I am, Madam,
　　　with all imaginable Refpect,
　　　　your moft humble,
　　　　　and moft obedient Servant.

　　　　　　　** **

　　　　　　　O F

O F

INVENTION.

IN order to obferve fome method in treat-
ing of the feveral parts of painting, we
may confider it in two lights; either
with regard to the young ftudent, or to the
perfect artift: If it is confidered according
to the method in which it is learned, we
muft begin with defigning, then treat of
colouring, and end with compofition; be-
caufe 'tis to no purpofe to think what we
would imitate, if we know not how to
imitate it, and becaufe objects can only be
reprefented by defign and colouring. But
if we confider this art in its perfection, and
according to the order in which it is ex-
ecuted, and if, befides, we fuppofe the
painter to have acquired a perfect habit in
the feveral parts, fo as to execute them with
facility; the firft part that offers itfelf will
be invention; for, before he can reprefent
objects, he muft determine which he would
reprefent. 'Tis in this fecond light I am
here to confider painting, that I may give

an

an idea' of it fuitable to the tafte of ·the greateft number of readers.

SEVERAL authors, who treat of painting, make ufe of the word *invention*, to exprefs different things: Some would convey fuch an idea .by it, as they take to comprehend the whole compofition of a picture; others have afcribed to it fertility of genius, newnefs of thoughts, and the method of expreffing them, and of treating the fame fubject in different ways. But though thefe particulars are extremely proper for fupporting invention, for ornamenting it, and giving it heat and life, they are neither the ground nor the effence of invention; for a painter, who is not mafter of all thefe things, may, neverthelefs, do his part in invention, by the juftnefs of his thoughts, the prudence of his choice, and the folidity of his judgment.

INVENTION, therefore, as it is but a part of compofition, cannot give a perfect idea of it; for compofition implies both invention and difpofition; 'tis one thing to invent objects, and another to place them rightly. I fhall not ftop here, to refute the other ideas which have been entertained of invention; as I. hope to define it in fo true and obvious a manner, that I imagine. there will be no diverfity of opinions on this fubject.

I TAKE invention to be *a choice of the objects that enter into the compofition of the*

the subject which the painter would treat of.
I fay, a *choice* ; becaufe objects ought not
to be brought into a picture inconfiderately,
and without contributing to the expreffion
and character of the fubject. I fay, that
thefe objects ought to enter into the compo-
fition, but not wholly compofe the picture ;
to the end, that invention may not be con-
founded with difpofition, and may leave it
at full liberty to act its part, which confifts
in placing the aforefaid objects to the beft
advantage.

POETS, as well as orators, have their
different ftyles to exprefs themfelves in, ac-
cording to the feveral fubjects they treat of ;
and upon this depends the choice of words,
of harmony, and of the turn which they
give to their thoughts. 'Tis the fame in
painting : When the painter has chofen his
fubject, he muft chufe his figures, and their
dependencies, accordingly. The painter, as
well as the poet, has his fublime ftyle for
things that are elevated, his familiar ftyle
for common things, his paftoral ftyle for the
country, and fo forth. Now, though all
thefe various ftyles fall in with all the parts
of painting, they are, neverthelefs, in a more
particular manner, the province of invention.
But this point would require a treatife of
itfelf.

INVENTION, as it relates to painting,
may be confidered in three refpects ; it is
either

either fimply hiftorical, or allegorical, or myftical.

PAINTERS, with reafon, ufe the word hiftory, to fignify the higheft kind of painting, which confifts in bringing many figures together. And, 'tis ufual to fay, *Such a painter does hiftory, fuch a one paints beafts, fuch a one landfkip, fuch a one flowers,* and fo forth. But there is a difference between the divifion of the kinds of painting, and the divifion of invention. I here take the word *hiftory* in a large fenfe, and mean by it, every thing that can either fix the painter's idea, or inform the fpectator. I fay, therefore, that invention, fimply hiftorical, is fuch a choice of objects as fimply of themfelves reprefent a fubject.

THIS kind of invention comprifes not only all forts of hiftory, whether true or fabulous, as related by authors, or eftablifhed by tradition, but alfo portraiture, views of countries, beafts, and all the productions of art and nature; for in painting a picture, the artift muft not only have his pallet and pencils in readinefs, but, as we have faid, he muft, before he begins, refolve upon what he would paint, though but a flower, fruit, plant, or infect; for though the artift may confine his genius to fuch things, they are often capable of yielding inftruction, as they have their particular virtues and proprieties: Thofe who have written of them, and have fet off

D their

their works with demonftrative figures, are
called hiftorians ; and we fay, The hiftory
of plants, the hiftory of animals, as well as
that of *Alexander* the Great. Invention,
fimply hiftorical, has therefore its degrees,
and is more or lefs valuable according to the
quantity of its matter, the nature of its
choice, and the genius with which it is ma-
naged.

ALLEGORICAL invention is a choice cf
objects that ferve to reprefent in a piece,
either wholly or partly, what in fact they
are not. Such, for inftance, is the painting
of *Apelles*, reprefenting *Slander*, as defcribed
by *Lucian*: Such alfo is the moral painting
of *Hercules*, placed between *Venus* and *Mi-
nerva*, where thofe pagan deities are only
introduced, to fhew the force of virtue.
And fuch is the picture of the *School of
Athens*, in a chamber of the *Vatican*, where
feveral figures, of different times, countries,
and conditions, are brought together to re-
prefent *Philofophy*. The three other pictures
in the fame chamber are drawn in the fame
allegorical manner ; and, if we confider the
tranfactions recorded in the old teftament,
they will appear to be partly *(a)* allegorical,
as well as fimply hiftorical, becaufe they are
the types of what fhould come to pafs under

(a.) I *Cor.* x. 6.

the.

the new law. Thefe are examples of fub-
jects which are wholly allegorical.

THE works, which are but partly alle-
gorical, engage our attention more eafily,
and more agreeably; becaufe the fpectator,
being affifted by the mixture of figures purely
hiftorical, diftinguifhes, with pleafure, the
allegorical figures that are joined with them.
We have an authentick example of this in
the *bas-reliefs* of the *Antonine column*, where
the fculptor, being to exprefs fome rain,
which the chriftian army obtained by their
prayers, *(b)* has introduced, among the fol-
diers, a raining *Jupiter*, having his beard
and hair covered with water, which falls from
thence in abundance. Now, *Jupiter* is not
placed there as a God who makes a part of
the ftory, but as a fymbol of rain, after the
manner of the heathens. Antient authors,
fpeaking of the paintings of their times, re-
late many examples in allegory: And, fince
the revival of the art, painters have made
frequent ufe of them; and, if fome have
abufed them, 'twas becaufe they knew not
that allegory is a kind of language, which
ought to be common among feveral people,

(b) This happened in the reign of the Emperor *Marcus* —
Aurelius, who erected the column here mentioned, on
which were reprefented, in *bas-relief*, the wars he waged
with the *Germans* and *Sarmatians*; and, in gratitude,
placed on it the ftatue of *Antoninus*, who had adopted
him to the empire.

and

and is founded on a received ufage, and the knowledge of books and medals; and chofe, rather than confult them, to invent a particular allegory, which, tho' ingenious, could not be underftood by any but themfelves.

MYSTICAL invention refpects the chriftian religion. Its end is to inftruct us in fome myftery, grounded on fcripture; which myftery is reprefented to us by feveral objects that concur to point out fome truth.

OUR myfteries, and the points of faith, which the church has injoined, furnifh a great many examples. The fecond council of *Nice*, having allowed of fetting before the eyes of the faithful the myftery of the *Trinity*, painters reprefent the *Father* under the figure of a venerable old man; the *Son* in his humanity, as he appeared to his difciples after the refurrection; and the *Holy Ghoft*, in the form of a dove. *The laft judgment, the church triumphant*, matters relating to the law, to faith, and the facrament, come under the fame denomination. Among the many examples which able painters have left us, I fhall mention a moft ingenious one, a colour'd fketch of which I have by me, and prize highly. The fubject is, *The myftery of the incarnation*. Now, had the author of this defign been willing to treat the *Annunciation* hiftorically, he might have only drawn the virgin *Mary* in a plain room, without other company than the angel; but, being

being refolved to treat the fubject myftically,
he has placed her on a kind of throne or
half-pace, where, on her knees, fhe receives
humbly, but with dignity, the angel's em-
baffy, whilft *God the Father*, having fettled
with his Son the price of man's redemption,
affifts, as it were, at the performance of the
contract. The Father is feated majeftically
on the globe of the world, encompaffed by
the celeftial choir, and having, at his right
hand, *Juftification* and *Peace*, which it had
been agreed to beftow on the whole earth.
He fends his Holy Spirit to work this great
myftery. The Holy Spirit is furrounded with
a circle of angels, holding each others hands,
and exulting, becaufe mankind were to fill
up the places of the bad angels. Several
angels, terminating this celeftial part of the
piece, have in their hands different attributes,
which the church afcribes to the holy vir-
gin, to fhew, that of all mankind fhe was
the worthieft of the grace with which fhe
was filled. All this great fight takes up the
upper part of the piece. Beneath are the
Patriarchs, who longed for the coming of
the *Meffiah*; the *Prophets* who foretold it,
the *Sibyls* who fpoke of it, and the little
Genii, reconciling the paffages of the *Sibyls*
with thofe of the *Prophets*. Thus does this
picture myftically difplay the truth and
grandeur of its fubject.

I

I HAVE now gone through the three
ways in which we may conceive invention;
to wit, as either fimply hiftorical, or allego-
rical, or myftical. Let us now fee what
they have in common one with another;
after which we fhall fpeak of the qualities
peculiar to each of them.

A PAINTER of genius finds, in all the
parts of his art, ample matter to make it
appear. But the part that gives him moft
opportunities of fhewing his fenfe, imagin-
ation, and judgment, is, without doubt,
invention. 'Tis by means of invention, that
painting goes hand in hand with poefy; it is
chiefly invention that gains the efteem of the
better fort; I mean, perfons of judgment,
who, not fatisfied with the bare imitation of
objects, would have the choice of them to be
juft, in order to exprefs the fubject.

BUT this very genius muft be cultivated
by the knowledges that relate to painting;
becaufe, let the imagination be ever fo
bright, it can only bring forth fuch things
as the underftanding is already filled with;
and the memory fupplies us with no other
ideas, but thofe of what we know, and have
feen. Accordingly the talents of particular
men are either funk in the lownefs of com-
mon objects, or elfe rife to the fublime, by
fearching for fuch as are extraordinary. For
this reafon, fome painters, who have cul-
tivated their parts, have happily fupplied a
want

want of genius ; and, raiſing themſelves with their ſubject, their ſubject has been obſerved to riſe and grow greater on their hands. Without the neceſſary parts of knowledge, one is liable to many miſtakes ; but when we are poſſeſſed of them, every thing preſents itſelf regularly, and comes inſenſibly into order.

'TIS, neverthelefs, convenient for young people, after having ſtudied the eſſentials of their art, and before they give publick proofs of their abilities, to exerciſe their genius on all ſorts of ſubjects ; becauſe, like new wine, which violently ferments, that it may become in time more palatable, they at firſt give themſelves wholly up to the impetuoſity of their imagination ; but when their firſt ſallies are evaporated, the images of their conceptions, without loſing their force, grow more clear and purified. But if they do not truſt ſo much to their own underſtandings, as not to conſult their knowing friends on the kind and meaſure of their talents, they ought to conſider them as a plant which muſt be ſet in a particular ſort of ground, preferably to any other, in order to yield its fruit in its ſeaſon. In the ſame manner, if the painter can chuſe his own ſubject, he ought to prefer that which beſt ſuits the nature and compaſs of his genius, and affords him matter for exerciſing it in the manner for which he is beſt furniſhed. To give heat to his

D 4 imagination,

imagination, he muſt turn his ideas into dif-
ferent ſhapes, he muſt read his ſubject ſe-
veral times with great attention, that a lively
image of it may be form'd in his mind; and
that, in proportion to the greatneſs of the
matter, he may ſuffer himſelf to be tranſ-
ported, even to enthuſiaſm, which is the
diſtinguiſhing quality both of a great painter,
and a great poet.

A s the painter can repreſent, in the ſame
piece, no more of nature, than what is to
be ſeen at one glance of the eye, he cannot,
for this reaſon, exhibit, in the ſame piece,
what paſſed at different times; and if ſome
have taken the liberty to do otherwiſe, they
are inexcuſable for it, unleſs they were
forced to do it by thoſe who employed them,
or unleſs they meant to compoſe a myſterious
or allegorical ſubject, like the picture of the
School of Athens.

B u t after the ſubject is well fix'd, it is
extremely proper to introduce ſuch circum-
ſtances as ſerve to fortify its character, and
make it known. They muſt not, however,
be ſo numerous as to tire the attention, but
rather ſo judiciouſly choſen, as to give an
agreeable exerciſe to the mind. Theſe cir-
cumſtances relate to place, time, and per-
ſons. Thus, whilſt the artiſt is inſtructing
the ſpectator, he ought, beſides, to divert
him with variety. This variety appears in
the ſexes, ages, countries, conditions, atti-
tudes,

tudes, expreffions, diverfity of animals, ftuffs, trees, buildings, and every thing that can exercife the mind, and properly fet off the fcene of the picture. I would not, however, approve of this abundance of objects, and of this variety, how pleafing foever in other refpects, but fo far as it is fuitable to the fubject, or at leaft has fome inftructive relation to it; for, as fome fubjects breathe nothing but joy and tranquillity, fo there are others which are either mournful or tumultuary; fome require gravity, dignity, refpect, filence, and fometimes folitude, and, confequently, admit but of few figures; as there are others which are fufceptible of a great many, and of fuch a variety of objects as the fkill of the painter thinks proper to introduce: For the whole muft have a tendency to the hero of the fubject, and preferve an unity well expreffed, and well conceived.

THESE are the general properties of the three kinds of invention. It remains to confider, what is peculiar to each of them.

AMONG the properties, of which invention, fimply hiftorical, is fufceptible, I obferve three, fidelity, perfpicuity or clearnefs, and good choice. I have elfewhere obferved, that fidelity in hiftory is not the effence of painting, but only a neceffary appendage to the art; for, though the painter be only an hiftorian by accident, he is, neverthelefs,

verthelefs, to blame, if he does not acquit himfelf well in what he has undertaken. By fidelity I mean an exact imitation of things, whether true or fabulous, as tranf-mitted to us either by authors, or by tra-dition : And it is not to be doubted, but the more fidelity fuch an imitation preferves, the greater force does it give to the invention, and the greater value to the painting. But if the painter has been careful to ftamp his fubject with fome mark of erudition, fuch as may awaken the fpectator's attention, without deftroying the truth of hiftory; if he can blend fome poetical paffage with thofe hiftorical facts that admit of it; in a word, if he can treat his fubject with that moderate licence which is allowed both to painters and poets, he will make his inven-tions fublime, and will gain himfelf a diftin-guifhed reputation. Fidelity, therefore, is the firft property of hiftorical invention.

THE fecond is perfpicuity or clearnefs; fo that the fpectator, if fufficiently acquainted with hiftory, may eafily difcover what par-ticular paffage the painter would reprefent. Whence it follows, that all ambiguity muft be removed by fome peculiar mark of the fubject, that may diftinguifh it from any other. I fpeak here of fubjects which are uncommon; for thefe which are generally known, and are often repeated, have no need of this precaution. If the fubject is

not

not enough known, or if the painter cannot
well bring in fome object to explain it, he
ought to make no difficulty of inferting a
motto or infcription. Of the many ex-
amples of this kind, both antient and mo-
dern, I fhall chufe only two, which are
well known; one of *Raphael*, and the other
of *Hannibal Caracche*. The latter having
painted, in the *Farnefian* gallery, the ftory
of *Anchifes* endeavouring to give proofs of
his love to the goddefs *Venus*; left *Anchifes*
fhould be miftaken for *Adonis*, has artfully
made ufe of *Virgil*'s words, *(c) Genus unde
Latinum*——which he writ beneath the bed,
on the bottom of the alcove. And *Raphael*,
in his *Parnaffus*, having placed *Sappho* among
the poets, has writ the name of that learned
dame, left fhe fhould be taken for one of
the mufes.

THE third property of hiftorical inven-
tion is the choice of the fubject, fuppofing
the painter has the power to chufe; for a re-
markable fubject furnifhes moft opportunities
of enriching the fcene, and commanding
attention. But if the painter beftows his
pencil upon a little fubject, he muft endea-
vour to make it great, by the extraordinary
manner in which he treats it.

ALLEGORICAL invention, in like man-
ner, has three properties. The firft is, that

(c) Alluding to the origin of the *Italian* race.

it

it be intelligible. 'Tis a great fault to keep the attention long in fufpenfe by means of new-invented fymbols, as 'tis a perfection to entertain it, for fome moments, by fuch allegorical figures as are known, generally received, and ingenioufly employed. Obfcurity tires the mind ; but perfpicuity makes it enjoy the difcovery with pleafure.

THE fecond property of allegory is its authority. *Cæfar Ripa* has written a volume upon this point, which is in the hands of the painters : But the beft things in this author are his extracts from the antique medals ; and, indeed, the beft authority for allegories is antiquity, becaufe 'tis inconteftable.

THE third property of allegory is, that it be neceffary. For as far as hiftory can be explained by fimple objects, which belong to it, 'tis needlefs to feek for foreign aids, which ferve rather to embarafs than adorn fuch a fubject.

MYSTICAL invention, as it is intirely devoted to religion, muft be pure, and free from any mixture of objects drawn from fable. It muft be grounded either on fcripture, or the ecclefiaftical hiftory : We have ample matter for this kind of invention in our Saviour's parables, and in the *Apocalypfe (d)*, the obfcurity of which we ought to reverence, but are not obliged to imitate. The Holy Spirit, which breathes where it pleafes,

(d) *Sicut tenebræ ejus, ita et lumen ejus.*

makes

makes itfelf intelligible when it pleafes; but the painter, who can neither penetrate nor alter the fpectator's underftanding, ought to ufe his utmoft efforts to be underftood.

As nothing is more facred, more grand, more permanent, than the myfteries of our religion, they can't be treated in a ftyle that is too majeftick: All that pleafes, does not always pleafe; and the greateft pleafures commonly end in averfion; but that which creates an idea of grandeur and magnificence, endures for ever.

To conclude, in whatever manner the part of invention be difcharged, it muft appear to be the effect of an eafy genius, rather than of laborious reflection: And as there are talents for attaining facility, there are alfo talents for concealing labour; and each have their merit, and their partizans.

HAPPY is the man, on whom nature has beftowed a genius able to run through the vaft race in this part of painting, and to chufe his objects well, in order to make his fubject intelligible, in order to enrich it, and inftruct the fpectator: But ftill more happy is the artift, who, after knowing every thing that contributes to fine invention, knows himfelf ftill better, and makes a proper efti-mate of his own abilities; fince it is the glory of a painter, not fo much to undertake great things, as to execute well what he undertakes.

A

A

DESCRIPTION

OF THE

School of *ATHENS*,

A Painting of *RAPHAEL*,

Referred to in the preceding Discourse of INVENTION.

THIS picture, usually called, *The School of Athens*, has been variously understood by those who have described it ; and it is surprising, that, among others who have published an explication of it, *Vasari*, a Cotemporary of *Raphael*, should have made so great a mistake as to neglect consulting him, that he might draw, from the source itself, those instructions he had occasion for, to explain a work which has made so much *noise* throughout all *Italy*.

THIS author, who first wrote of it, says, that it is *the agreement of philosophy and astrology with divinity*; and yet there appears no mark of *divinity* in the whole composition. The engravers of it have as improperly put an inscription under it, taken

from

from the acts of St. *Paul*, to induce us to be-
lieve, that this apoftle, after having met with
an altar, on which was inscribed, *TO THE
UNKNOWN GOD*, is here prefenting
himfelf before the judges of the *Areopagus*,
to give them the knowledge of the *God* they
were ignorant of, and to inftruct them in
the article of *the refurrection of the dead*,
about which the *Epicureans* and *Stoicks* were
then difputing.

AGOSTINO VENETIANO is yet more
grofly miftaken, when, in his print of five
or fix of the figures, which are towards the
right-hand in the aforefaid piece, he has
fuppofed the philofopher, who is writing, to
be St. *Mark* ; and the young man with one
knee on the ground to be the angel *Gabriel*,
holding a table, on which is engraved the
angel's falutation ——*Ave, Maria*, &c.

As 'tis needlefs to fpend much time here
in refuting thefe errors, which are equally
grofs, I fhall only defcribe the four *cieling
figures*, which correfpond with the four
fubjects painted in the chamber, where this
ftands, and which evidently point them
out.

THE firft reprefents *Theology*, with thefe
words —— *Scientia divinarum rerum*, the
knowledge of things divine.

THE fecond is *Philofophy*, with thefe
words —— *Caufarum cognitio*, the know-
ledge of caufes.

THE

THE third is *Jurisprudence*, or *Knowledge in the law*; with these words ——— *Jus suum unicuique*, doing right to every one : And

THE fourth represents *Poesy*; with these words ——— *Numine afflatur*, inspired by the Deity.

Now, in the piece called *the school of Athens*, the figure of *Philosophy* is placed uppermost; and therefore it cannot be doubted but that this painting represents *Philosophy*, as will appear more clearly from the particular description I am going to give of it.

THE scene opens with a building of magnificent architecture, consisting of arcades and pilasters, and so disposed as to render the prospect of them gradually diminishing, and the break advantageous, and to give a grand idea of the subject. The place is filled with philosophers, mathematicians, and others, who give themselves up to the sciences; and as it is only through a course of time, that philosophy is come to that degree of perfection in which we see it, *Raphael*, who had a mind to represent this science by an assembly of philosophers, could not effect it by putting together only those of one age. The painter's intention was, not to compose a simple history, but an allegory, where the diversity of times and countries, does not hinder the unity of the subject. *Raphael* has taken this method in drawing the three other

other pictures in the fame chamber, to wit, *theology, jurifprudence,* and *poefy.* In the firft of which we fee the feveral fathers of the church; in the fecond, the lawyers; and in the third, the poets of all ages.

FROM the difpofition of the figures in this piece, and from the nature of their feveral employments, we may fafely conclude, that it muft be a meeting and fociety of men, poffeffed of feveral parts of knowledge, fuch as the philofophers; nay, we difcover among them *Pythagoras, Socrates, Plato, Ariftotle,* and their difciples; and mixed with them we fee perfons employ'd in mathematical fciences.

IN the middle of the piece are placed, uppermoft, the two moft celebrated philofophers of antiquity, *Plato* and *Ariftotle*; the former holds, under his left-arm, a book, the *Italian* word for the title of which is written, *Timeo, Plato's* fineft dialogue; and as this book treats myftically of natural things compared to divine, this philofopher has his right-arm raifed, and points with it to heaven, as the fupreme caufe of all things.

ON the left-fide of *Plato* is his difciple *Ariftotle,* holding a book on his thigh, on which is written the word *Ethica,* or, the fcience of manners, to which this philofopher chiefly applied himfelf; and his arm, being ftretched out, gives him the attitude of a

E peace-

peace-maker, and a moderator of the paf-
fions; a character perfectly agreeable to
moral philofophy.

ON each fide of thefe two great philofo-
phers are their difciples, of all ages, fo art-
fully grouped and difpofed, as to fet off the
two heroes of the piece to great advantage;
and tho' the attitudes of thefe difciples are
very different, yet they all fhew a great
attention to the words of their mafters.

BEHIND *Plato's* hearers is *Socrates*,
turned towards *Alcibiades*, who is oppofite
to him; both are in profile: the former is
known by his bald head, and flat nofe; and
the latter is a handfome young man, in
a warrior's drefs, with his flaxen hair flowing
on his fhoulders; his armour edged with a
gold ornament, and one hand on his fide,
and the other on his fword: and as he was
both a philofopher and warrior, he gives
great attention to the difcourfe of *Socrates*;
which the latter enforces with very expreffive
action; he extends both his hands, and takes
with his right the tip of the firft finger of
the left, to fhew that he is explaining and
illuftrating his thoughts, fo as to make them
thoroughly underftood, while all his difciples
are attending to what he fays.

NEXT to *Alcibiades* is *Antifthenes* the
currier, in whom *Socrates* difcovered fo great
a propenfity to philofophy, that he inftructed
him in the principles of it, and *Antifthe-*
nes,

nes, quitting his trade, became a famous
profeſſor of moral philoſophy, upon which
he wrote thirty-three dialogues : 'tis he who
is the chief of the *Cynick* ſect. The painter,
to vary his figures, and give them motion,
has ſet, behind *Alcibiades*, a man turning
about, and holding out his hand, to call,
after the *Italian* manner, and haſten a ſer-
vant, who brings a book, and a great roll
of papers, to which the antients gave the
name of *Volumes*; and behind the ſervant
appears the face of another, who, with his
hand to his cap, ſeems reſpectfully to an-
ſwer the perſon who calls.

Among *Ariſtotle's* diſciples, *Raphael* has,
in like manner, diſplay'd their attention to
their maſter's words : One among the reſt,
having underſtood the demonſtrations of
Archimedes, is leaving, according to the
Greek cuſtom, the *Mathematick* ſchool, to
go to that of *Philoſophy*; and meeting with a
perſon on the way, he inquires of him where
the ſcience may be learnt, and is directed to
Ariſtotle and *Plato*.

Hard by this figure is a ſtudious young
man leaning upon the baſe of a pilaſter;
with his legs acroſs, and writing down, on
paper, what he wants to learn ; while an
old man, learning on the ſame baſe, and
reſting his chin on his hand, is ſeriouſly
weighing what the young man has been
writing.

E 2 AMONG

· Among other figures that terminate this
fide of the picture, is (*a*) *Democritus,* wrapt
up in his cloak; he walks in the affembly,
after the manner of blind men, by the help
of his ftick; for near the end of his life· he
blinded himfelf of his own accord, that he
might not be difturbed in his philofophical
contemplations. The painter may have re-
prefented him in a great old age, to fhew that
a man fhould labour, even to his grave, to
iform and undeceive himfelf.

In the group, on the right-fide of the
piece, and on the firft ground, 'tis eafy to
difcover *Pythagoras* feated, who writes the
principles of his philofophy, taken from
the *harmonick proportions* in mufick. Next
to him is a young man holding a table, on
which are, in *Greek* characters, the accords
and confonances of finging, which are read
thus: —— *Diapente, Diapafon, Diatef-
faron* —— terms well known to able mu-
ficians. It is even faid, that this philo-
fopher is the author of the demonftration
of thefe confonances, of which *Plato,* his
difciple, formed the *accords and harmonick
proportions of the foul.*

Pythagoras fits profile-wife, with a
book in his lap; he appears intent upon
fhewing the relation of mufical numbers to

(*a*) *Cic. de finito bon. et mal.* l. v. v. 29. *Idem*
l. v. Tufc. 29. *Aul. Gel.* x. c. 17. *ex Laborum
mimis.*

the

the fcience of natural things. Near to him
are his difciples *Empedocles, Epicharmes, Ar-
chitas*; one fitting by his mafter, and bald-
headed, writes on his knee, having his ink-
horn in one hand, and his pen held up in
the other, his eyes very open, and mouth
fhut, to fhew him very careful not to let any
of his mafter's writing be loft.

Behind this philofopher, another dif-
ciple, with his hand on his breaft, comes
forward to lcok into the book ; he has a cap
on, his chin is fhaved, but he has a bold
pair of whifkers, and his cloak is clafp'd.
All this decoration probably tends only to
fhew the variety *Raphael* always aimed at
in his works.

Behind this group, are feen the face and
hand of another philofopher, who, fome-
what ftooping, opens his two firft fingers, as
if he was reckoning, after the *Italian* man-
ner, and feeming to explain the *Diapafon*,
which is the double confonance defcribed by
Pythagoras.

In a corner of the piece is a perfon fhaved,
with a book, refting on the pedeftal of a
column, in which he is earneftly writing.
This figure is thought to be the portrait of
fome officer in the pope's palace ; becaufe he
is crowned with oak-leaves, which were the
device of pope *Julius* II. to whom, as his
benefactor, and the reviver of the golden age

E 3 in

in *Italy*, with regard to the fine arts, *Raphael* dedicated this work.

Hard by, and at the extremity of the picture, we fee an old man, with a little boy in his arms, who, in a manner fuitable to his age, reaches out his hand to a book wherein the old man is writing. It looks as if he had brought the boy thither purely to difcover, whether he had any inclination for the fciences ; intimating, that we cannot too foon difcover and cultivate the talent which nature has given us.

On the fide of this group of figures, appears a young man, of a noble mien, in a white cloak fringed with gold, with his hand on his breaft. This is believed to be *Francifco Maria de la Rovere*, the pope's nephew, and that he is introduced into the piece on account of the love he had for the fine arts.

A little more before *Pythagoras*, another of his difciples, with one foot on a ftone, and his knee raifed, appears with a book in one hand, and copying with the other fome remarkable paffages, which he would reconcile with his mafter's fentiments. This man may well be taken for *Terpander*, or *Nicomachus*, or fome other difciple of *Pythagoras*, who believed that the motion of the ftars depended on mufical principles.

More forward, we fee a philofopher by himfelf, leaning with his elbow on a marble bafe ;

bafe; he has a pen in his hand, and looks
ftedfaftly upon the ground, as if be was
intent upon the folution of fome great diffi-
culty; he is coarfely clad, and his ftockings
hang about his heels, to fhew that philo-
fophers little regard drefs, and place all their
pleafure in reflection, and the improvement
of their underftanding.

On the fecond ftep appears *Diogenes* by
himfelf, half naked, and with his cloak
flung back: and by him is his difh, as his
badge of diftinction. His attitude is negli-
gent, and becoming a *Cynick*, who is fo
much taken up with morality, as to defpife
worldly pomp and grandeur.

On the left fide, are feen feveral mathe-
maticians, whofe fcience, though it confifts
of what falls under the fenfes, yet has a re-
lation to philofophy, which confiders things
intellectual. The firft of thefe perfons is
Archimedes, under the likenefs of the archi-
tect *Bramante*; he ftoops, and with arms
bending downwards, is meafuring, with the
compaffes, an *hexagonal figure*, compofed
of two equilateral triangles, and feems to
demonftrate fome property of it to his
fcholars. He has about him four difciples
well-made, who in different actions difcover
either their ardent defire to learn, or the
pleafure they have in conceiving what they
are taught. They are painted youthful, be-
caufe it was neceffary to learn the mathema-
ticks,

ticks, before one could proceed to philofophy.
The firft of them has a knee on the ground,
his' body bent, and his hand on his thigh,
and the fingers fpread ; he is attentive to the
aforefaid demonftrative figure. The fecond
difciple, who ftands behind him, refts his
hand on his companion's back, thrufts out
his head, and earneftly obferves the motion
of the compaffes. The two other difciples,
next to *Archimedes,* are advanced very for-
ward to fee commodioufly : The foremoft,
having a knee on the ground, turns about
and fhews the figure to the perfon behind
him ; who, ftooping, difcovers to us, by his
arms croffed and advanced, his admiration,
and the pleafure he finds in inftruction.
Vafari will have this to be the figure of
Frederick II. duke of *Mantua,* who was
then at *Rome.*

BEHIND *Archimedes* are two philofo-
phers, one holding the celeftial globe, and
the other the terreftrial ; the firft, by his
garb, feems to have fome relation to the
Chaldæans, the inventors of aftronomy ; and
the other, who turns his back, and has a
royal crown on his head, is prefumed to be
Zoroafter, king of the *Bactrians,* who was
a great aftronomer, and great philofopher.
Thefe two fages are converfing with two
young men, who are at the corner of the
picture, one of whom is *Raphael* himfelf.

IN

IN this learned, fublime and judicious manner has *Raphael* chofen his fubjects, and thus produced one of the fineft inventions of the kind that ever appeared: But, not content to illuftrate his fubject by the feveral perfons who enter into it, he was alfo defirous, that the *ftatues* and *bas-reliefs*, which adorn the architecture, fhould contribute to the richnefs and expreffion of his thoughts. Accordingly the two ftatues, one on each fide the picture, are thofe of *Apollo* and *Minerva*, the deities who prefide over arts and fciences. In the *bas-relief*, under *Apollo's* figure, is reprefented the emblem of *irafcible* and *concupifcible paffions*; the one by a *furious man*, who outrageoufly infults all he meets with; and the other by a *Triton*, embracing a nymph on the element which gave birth to *Venus*. And as *vice* is only to be fubdued by *virtue*, which is its oppofite, the painter has, in the *bas-relief*, under *Minerva's* figure, placed *Virtue* fitting on the *clouds*, with one hand on her *breaft*, the feat of valour, and indicating to mortals, by the *fceptre* in her other hand, the *power* of her empire. Near her is the figure of the *Lion* in the *zodiack*, the emblem of *force*, which, in the moral fcience, can only be gained by good habits.

THUS has *Raphael*, with a beauty of genius, delicacy of thought, and folidity of judgment, fet before us the *allegorical fubject of philofophy.* O F

· O F

DISPOSITION.

IN my division of painting, I have assigned to *composition*, which is the first part of it, two things; *to wit, invention* and *disposition*; and in treating of *invention*, I have shewn, that it consists in finding objects proper for the subject the painter would represent. If they are not well distributed, the composition will never give full satisfaction to the unbiassed spectator, nor have a general approbation. But however advantageous the subject be, however ingenious the invention, however faithful the imitation of the objects chosen, œconomy and good order is what gives a value to every thing; and, in the fine arts, draws attention, and fixes it, till the mind is replenished with whatever, in such a work, can both instruct and please: And this œconomy I properly call *disposition*; in which are six parts; *viz.*

 1. The distribution of objects in general:
 2. The grouping:
 3. The choice of attitudes:
 4. The contrast :

<div align="right">5. The</div>

5. The caſt of draperies : And,

6. The effect of the whole together; where I ſhall occaſionally ſpeak of harmony and' enthuſiaſm.

THESE, in their order, I ſhall examine as ſuccinctly and clearly as I poſſibly can.

Of the Diſtribution of Objects in general.

AS the ſubjects which painters may treat of are innumerable, it is not poſſible to relate them all here, much leſs to ſhew their particular *diſpoſitions :* But good ſenſe, and the nature of the matter, muſt, in general, determine the artiſt to aſſign to his objects ſuch places as are proper to make the compoſition good.

IN *compoſition*, the painter ought to contrive, as much as he poſſibly can, that the ſpectator may, at firſt ſight, be ſtruck with the character of the ſubject, or at leaſt may, after ſome moments of reflection, take the principal ſcope of it. It will greatly contribute to this end, that he place the hero, and the principal figures, in the moſt conſpicuous places ; yet this muſt be done without affectation, and in ſuch a manner as the ſubject and probability require; for œconomy, or management, depends upon the nature of the ſubject, which may be either pathetick or gay, heroick or popular, tender or terrible; in ſhort, the picture muſt have more or leſs motion, as its

ſubject

subject is more or lefs ftirring or ftill. As the fubject points out to the artift the proper œconomy in the difpofition of objects, fo diftribution, in its turn, wonderfully contributes to the expreffion of the fubject, gives both force and grace to what is invented, prevents confufion in the figures, and makes every thing in the picture more clear, more apparent, and more capable to produce the effect above-mentioned, *of calling to and detaining the fpectator.*

Of the Grouping.

THE aforefaid diftribution of objects does, in general, refpect *grouping*; and the *groups* proceed from the joining of objects together. Now this joining or combination may be confidered two ways ; either with regard to *defign* alone, or with regard to the *claroobfcuro* ; both of which concur to hinder the eye from being diffipated, and to fix it agreeably.

THE joining of objects with regard only to defign, that is, without taking in the *claroobfcuro*, principally refpects human figures, the actions, converfations, or affinities, of which often require, that they be near one another ; but though thefe circumftances do not always happen where feveral perfons meet together, yet it is fufficient, that the thing be poffible, and that there be figures enough

enough in the compofition of the picture, to give the painter an opportunity of difplaying his art, and pleafing the eye, by joining the figures together, when he thinks it agreeable and probable.

'Tis impoffible to enter into fuch a detail, as to fbew how thefe different kinds of *groups* muft be managed: The painter muft, in this cafe, reft upon his own genius and reflections: Neverthelefs, in order to form a juft idea, and good tafte of them, he ought to confult the fine *grouping* in the pictures of the beft mafters, efpecially *Raphael, Julio Romano,* and *Polydore,* who have often combined feveral figures in fuch manner, as to difcover all the judgment, and all the beauties, that can be defired in *grouping.* But before the artift makes this examination, he muft be apprifed, that the joining or combination we fpeak of, derives its beft principles from the choice of attitudes, and fine contraft.

Of the Choice of Attitudes.

THE part of painting which falls under the word *attitude,* as it comprehends all the motions of the body, and requires a perfect knowledge of ponderation, ought to be thoroughly examined in a particular treatife, that may have a relation to defign. And as it likewife falls within the province of difpofition, with regard to the groups we talk of,

I fhall

I fhall only obferve, upon this occafion, that
whatever *attitude* be given to the figures, let
the fubject be what it will, this *attitude*
muft fhew their beautiful parts, as much as
the fubject will permit; and muft, befides,
have fuch a turn, as without departing from
probability, or from the character of the
figure, may diffufe a beauty over the action.

I N effect, there is nothing in imitation,
but what is fufceptible of fome grace, either
by the choice, or by the manner of imitating.
There is a graceful expreffion of the *vices*,
as well as of the *virtues*. The outward
actions of a foldier have a particular grace,
which would ill become a woman; as the
actions of a woman have a grace, which
would not become the foldier. In fine, the
knowledge of the character which belongs to
each object, and chiefly depends upon its
fex, age, and condition, is the foundation of
good choice, and the fource of the graces
proper for each figure. 'Tis eafy, therefore,
to obferve, that the choice of fine *attitudes*
makes the greateft part of the beauties of
grouping. Let us now fee, what affiftance
the *contraft* affords in this point.

Of the Contraft.

I F in grouping the attitudes muft not be
repeated in the fame view, and if diverfity
be a part of the graces of nature, thofe
<div align="right">graces</div>

graces can't be better difcovered than in the variety and oppofition of motion.

THE word *contraft* is not much in ufe, except among painters, who took it from the *Italians*. It fignifies an oppofition among objects with regard to lines, which either wholly or partly compofe them. It takes in not only the different motions of figures, but alfo the different fituations of the members, and of all other objects which meet together; yet in fuch manner, as to appear without affectation, and only to give more energy to the expreffion of the fubject. Now, the painter who difpofes his objects to advantage, *contraftes* not only his figures, but alfo inanimate objects, that by fuch *contraft*, he may breathe into them a kind of life and motion : *Contraft*, therefore, may be defined to be *fuch an oppofition of lines that form objects, as makes thofe objects fet off one another.*

THIS oppofition, if well expreffed, gives life to objects, commands attention, and increafes that gracefulnefs which is neceffary in groups, at leaft in thofe that relate to defign, and the conjunction of attitudes.

WE have before obferved, that the firft fort of groups, as relating to defign, principally belongs to human figures; but thofe groups which relate to the *claro-obfcuro*, take in all forts of objects. They require not only a knowledge in the lights and fhades

of

of every particular object, but also in the effects which thofe lights and fhades are capahle of producing by their affemblage or union; and it is this which is properly called the art of the *claro-obfcuro*; which I fhall treat of with as much exactnefs as poffible, when I come to fpeak of colouring.

Of the Caft of Draperies.

AS the chief beauty of *draperies* lies in a proper caft or diftribution of the folds, and as they are of frequent ufe in grouping, this fubject muft needs be confidered as depending partly on difpofition: I therefore refer to what I fhall fay hereafter on the fubject of *Draperies.*

Of the Whole together.

THE laft point depending on difpofition is, *the whole together,* which is the refult of the parts that compofe the piece; but the whole, arifing from the combination of feveral objects, muft not be like a number made up of feveral unities, independent and equal among themfelves, but like one poetical whole, where the great have need of the lower people, and thefe have need of the great. All the objects, lines, colours, lights and fhades, of a picture, are great or fmall, ftrong or weak, only by comparifon; but,

let

let their natures, qualities, or conditions, be what they will, they have such a relation to one another in their combination, as no one in particular can superfede : For the effect of the whole confifts in a general fubordination, where the darks heighten the lights, and the lights fet off the darks, and where the merit of each part is founded on a mutual dependence. So that we may define *the whole together* to be, *Such a general fubordination of objects one to another, as makes them all concur to conftitute but one.*

N o w this fubordination, by which feveral objects concur to make but one, is founded on two principles, *viz. The fatiffaction of the eye,* and *the effect of vifion.* And this I fhall explain.

THE eye has this in common with the other organs of fenfe, that it cares not to be obftructed in its office ; and it muft be agreed, that a great many people, met in one place, and talking together at the fame time, and with the fame tone of voice, fo as that no one in particular could be diftinguifhed, would give pain to thofe who heard them : It is juft fo in a picture, where many objects, painted with equal force, and illuminated by the fame light, would divide and perplex the fight, which, being drawn to feveral parts at once, would be at a lofs where to fix ; or elfe, being defirous to take in the

F whole

whole at one view, muſt needs do it imper-
fectly.

Now, to hinder the eye from being dif-
ſipated, we muſt endeavour to fix it agree-
ably, by a combination of lights and ſhades,
by an union of colours, and by oppoſitions
wide enough to ſupport the groups, and give
them repoſe. But where the picture has
ſeveral groups, one of them muſt predomi-
nate in force and colour; and beſides, de-
tached objects muſt be ſo united with their
ground, as to make but one maſs, that may
ſerve as a repoſe to the principal objects:
The ſatisfaction of the eye is therefore one
of the foundations upon which the unity of
objects in painting depends.

The other foundation of this ſame unity
is, the effect of viſion, and the manner of
its operation. Now the eye is at liberty to
ſee all the objects about it, by fixing ſuccef-
ſively on each of them; but, when 'tis once
fix'd, of all thoſe objects, there is but one
which appears in the centre of viſion, that
can be clearly and diſtinctly ſeen; the reſt,
becauſe ſeen by oblique rays, become obſcure
and confuſed, in proportion as they are out
of the direct ray. This truth appears as oft
as we direct our eye to any object: I ſuppoſe
my eye, for inſtance, at *A*, plate *I*, directed
to the object *B*, by the ſtrait line *A B*. 'Tis
certain, that if I do not move my eye, and
yet would obſerve the other objects, which

can

Plate I

A Demonstration of the unity of the Object.

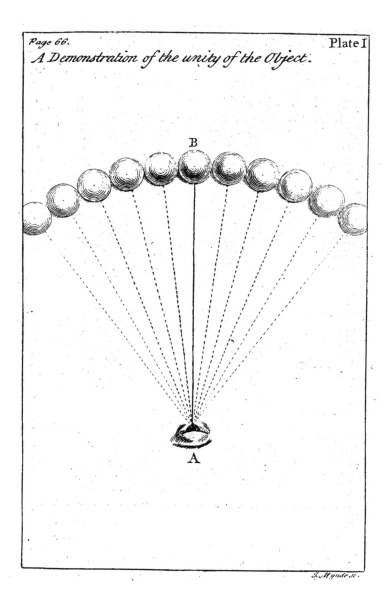

J. Mynde Sc.

can only beeen by oblique lines to the right
and left of *A B*, I fhall find, that though
they are all in the fame circular line, and at
the fame diftance from my eye, yet they
decreafe, both in force and colour, in pro-
portion as they recede from the ftrait line,
which is the centre of vifion: Whence it
follows, that vifion proves the unity of an
object in nature.

Now if nature, which is wife, and which
in fupplying our wants accompanies thofe
fupplies with pleafure, thus brings feveral
objects into one glance of the eye, fo as to
make them but one, fhe inftructs the painter
to take the fame method, in fuch manner as
his art, and the nature of the fubject, will
permit. This obfervation feems to me not
unworthy of his notice, if he would employ
his art for the fatisfaction of the eye, after
the example of nature, whom he imitates.

Another experiment may be made by
the *convex mirrour*, which improves upon
nature as to the unity of the object in vifion:
All objects that are feen there with one
glance of the eye, make together one whole,
and a whole much more agreeable than that
which the fame objects would produce in an
ordinary glafs, or, I will venture to fay, even
in nature itfelf. I fuppofe this *convex mir-
rour* to be of a reafonable fize, and not one of
thofe, which, being fegments of a fmall circle,
impair the forms of objects too much. Let

me

me obferve, by the way, that glaffes of this fort, which are become pretty rare, might be ufefully confulted, for particular objects, as well as in general, for *the whole together*.

AFTER all, the painter muft confult himfelf in his undertakings ; for if his work be large, he may compofe it of feveral groups, which may, after the firft view, be capable of fixing the eye, by the help of well-managed repofes, and become in their turn fo many centres of vifion. Thus the judicious painter ought to contrive fo, that after the firft view, let his work be ever fo large, the eye may take it in fucceffively.

IT remains that we now fpeak of a wonderful effect, which the *whole together* produces, and it is that of putting all the objects into harmony. For harmony, where-ever it appears, proceeds from arrangement and good order. There is a harmony in moral as well as in natural philofophy; in the conduct of human life, as well as in the proportions of the human body ; and, in fhort, in every thing that confifts of parts, which, however different from one another, yet agree to make but one *whole*, more or lefs general. Now, as this order muft be fuppofed to exift in all parts of painting feparately, we muft infer, that each part has its particular harmony. But it is not enough, that each part has its particular arrangement and propriety ; they muft all agree together

in

in the picture, and make but one harmo-
nious whole; in the fame manner as it is
not enough, in a concert of mufick, that
each part be heard diftinctly, and follow the
particular arrangement of its notes; they
muft all agree together in a harmony which
unites them, and which, out of feveral par-
ticular *wholes*, makes but one *whole* that is
general. This is what painting does, by the
fubordination of objects, groups, colours, and
lights, in the general, of a picture.

THERE are in painting feveral forts of
harmony; the fweet and the temperate, as
ufually practifed by *Correggio*, and *Guido
Reni*; and the ftrong and great, as that of
Giorgione, *Titian*, and *Caravaggio*. And
thefe may be in different degrees, according
to *places*, *times*, *light*, and *the hours of the
day*. Great light, in a clofe place, produces
ftrong fhades; the fame, in an open country,
requires broken colouring, and fweet fhadow-
ing. In fhort, the fkilful painter knows
what ufe he ought to make, not only of the
feafons of the year, but of the times of the
day, and of the accidents that happen, either
in the fkies, or on the earth, in order to
bring all, as we have faid, into one har-
monious whole.

THIS is the idea I have conceived of what
is called, in painting, *the whole together*:
And I have endeavoured to make it under-
ftood as a machine, whofe wheels give each

F 3 other

other mutual affiftance, as a body, whofe members have a mutual dependence ; and, in fhort, as an harmonious œconomy, which ftops and entertains the fpectator, and invites him to pleafe himfelf with contemplating the particular beauties of the picture.

IF we do but a little reflect on what I have faid of difpofition, we fhall find, that this part of painting, as it includes a great many others, is of very great confequence ; becaufe it gives a value to every thing that invention has fupplied it with, and to every thing that is moft proper to make an impreffion upon the eye and the mind of the fpectator.

ABLE painters may know, by their own experience, that, in order to fucceed in fo refined a part, they muft rife higher than ordinary, and, as it were, be tranfported out of themfelves; which gives me occafion to fay fomething here of *enthufiafm,* and *the fublime.*

Of Enthufiafm.

ENTHUSIASM is a tranfport of the mind, which makes us conceive things after a fublime, furprifing, and probable manner. Now as he who confiders a work, is raifed to that degree of elevation, which he finds in it, fo the tranfport of mind, which comes

up

up to *enthufiafm*, is common both to the painter, and the fpectator; yet, with this difference, that it has coft the painter a courfe of labour, and repeated efforts, to heat his imagination, and bring his work to the perfection of *enthufiafm*; whereas the fpectator, without having the trouble to examine particulars, finds himfelf tranfported at once, without his knowledge, and, as it were, without his confent, to that degree of *enthufiafm*, which the painter infpires.

THOUGH truth always pleafes, becaufe 'tis the bafis of all perfection, yet 'tis often infipid when it ftands alone; but, joined to *enthufiafm*, it raifes the foul to a kind of admiration, mix'd with aftonifhment; and ravifhes the mind with fuch violence, as leaves it no time to bethink itfelf.

I HAVE comprehended the *fublime* in the definition of *enthufiafm*, becaufe it is the effect and production of it: *Enthufiafm* comprehends the *fublime*, in the fame manner as the trunk contains the branches, which it fends forth on all fides: Or rather, *enthufiafm* is, as it were, the fun, which by its heat, and vivifying influence, produces elevated thoughts, and brings them to fuch a ftate of maturity, as we call the *fublime*. But as *enthufiafm*, and the *fublime*, both tend to elevate the underftanding, we may conclude them to be of the fame nature; with

this

this difference, that *enthufiafm* is a rapture that carries the foul above the *fublime*, of which it is the fource, and has its chief effect in the thoughts and *the whole together* of a work : Whereas the *fublime* is perceived equally, both in the general, and in the particulars, of all the parts. *Enthufiafm*, befides, has this peculiarity, that its effect is more inftantaneous ; whereas the *fublime* requires, at leaft, fome moments before it can be feen in all its force.

ENTHUSIASM elevates infenfibly, and tranfports us, as it were, from one country to another, without our perceiving it, otherwife than by the pleafure it caufes. In fhort, *enthufiafm*, methinks, feizes us, and we feize the *fublime*. 'Tis therefore to this furprifing, but juft and reafonable pitch, that the painter, as well as the poet, muft raife his work, if he would attain to that extraordinary probability which fhakes the heart, and gives both painting and poefy their greateft merit.

SOME fiery genius's have miftaken the fallies of their imagination for real *enthufiafm*, though, at bottom, the abundance and vivacity of their productions are but the dreams of fick perfons. Some whimfical dreams would, indeed, if a little tempered, give much genius to the compofition of a picture, and agreeably roufe the attention: Poetick fictions, as *Plutarch* fays, are but
the

the dreams of a waking man : But we may
say likewise, that some productions are only
the dreams of a man in a burning fever,
which have no connexion, and the dan-
gerous extravagance of which ought to be
avoided.

I т is certain, that men of a fiery genius
easily give into *enthusiasm*, because their
imagination is almost always upon the
stretch ; but such as burn with gentle fire,
and have but a moderate vivacity, joined
with a sound judgment, may slide into *enthu-
siasm* by degrees, and even make it more
regular by the solidity of their parts. If
they do not so easily and so readily enter
into this fury of the painter, they suffer it
at least to seize them by little and little ;
because their reflections have enabled them
to see and to feel every thing, and because
there are not only many degrees of *enthu-
siasm*, but likewise many ways of attaining
it. If painters of this sort have a written
subject to handle, they ought to read it over
and over with application ; and, if it be not
written, it is proper they should chuse,
from among the qualities of the subject, such
as will best furnish them with circumstances
for setting their parts at work, and keeping
them in motion. And when they have thus
warmed their imagination, by the elevation
of their conceptions, they will at length
arrive

arrive at *enthufiafm*, and fill the fpectator
with admiration.

To difpofe the mind to *enthufiafm*, ge-
nerally fpeaking, nothing is better, than to
view the works of great mafters, and to read
good authors, either hiftorians or poets, be-
caufe of the elevation of their thoughts, the
noblenefs of their expreffion, and the power
which examples have over the human mind.

LONGINUS *, in his treatife on the
Sublime, advifes thofe who are to write any
thing that requires the *great* and the *wonder-
ful*, to look upon great authors, as a taper to
enlighten them ; and to afk themfelves ——
How would Homer *have expreffed this ?*
How would Plato, Demofthenes, *or* Thucy-
dides, *have turned it?* The painter accord-
ingly may, upon the like occafions, afk
himfelf —— *How would* Raphael, Titian, *or*
Correggio, *have conceived, defigned, ordered,
and painted, what I am going to reprefent?*
Or elfe, as the fame *Longinus* fays, *Let us
fuppofe a tribunal of the greateft mafters,
before whom we muft give an account of our
performance; what ardor would not the
painter feel on the bare thought of feeing fuch
excellent men, who are the objects of his ad-
miration, and confidering them as his judges?*

THESE hints are of ufe to all painters;
they will inflame thofe who are born with a

* *Chap.* 12.

power-

powerful genius; and even thofe, to whom nature has not been fo liberal, will by this means feel at leaft fome degree of heat diffufing itfelf in their works.

I HAVE endeavoured to fhew, in difcourfing of invention, after what manner we muft chufe objects fuitable to the fubject; and I have now, fpeaking of difpofition, fhewn the order in which thofe objects muft be ranged, fo as to compofe one advantageous whole: Thus, by joining together invention and difpofition, I have endeavoured to give the beft idea I could of that important part of painting which is called *compofition.*

Anfwers to fome Objections.

AMONG the objections which may be made to what I have been obferving, I find two, which it is very proper to anfwer; one is againft the unity of the object, and the other againft enthufiafm.

WITH regard to the former, it may be urged, that the demonftration which has been given of vifion, to eftablifh the unity of the object, intirely deftroys it, becaufe 'tis not neceffary to confine the eye; fince, in any part of the picture, to which it is carried; it will naturally fix itfelf, and thereby make an unity of object, without the aid of the principles of art.

T o

To this I make two anfwers: *Firſt,*
That 'tis not proper to leave the eye at li-
berty to gaze at random; becaufe if it fhould
happen to be detained on any one fide of the
picture, this will fruſtrate the painter's in-
tention, who, according to the beſt ap-
proved probability, muſt needs have placed
his chief objects in the middle, and the by-
objects towards the fides of the picture: And
with good reafon; fince upon fuch difpo-
fition often depends the knowledge of the
whole thought of the picture: Whence it
follows, that the eye muſt be fixed, and that
the painter ought to determine it to fettle on
that part of his piece, which he thinks moſt
proper for the effect of the whole.

THE *fecond* anfwer is, That, with refpect
to the fenfes, all objects of pleafure require
not only the agreeablenefs they have received
from nature, but alfo the help of art, to
make their effects more lively.

BY the fecond objection it may be infi-
nuated, that enthufiafm often carries fome
genius's too far, and makes them infenfibly
pafs over many faults. But the anfwer is
eafy; fuch a tranfport is not true enthufiafm,
becaufe it exceeds the bounds of that exact-
nefs and probability which I lay down. I
own, indeed, that one of the effects of en-
thufiafm is, that it often hides fome fault
by means of the tranfport it generally caufes:
But this is no great misfortune; for, in fact,
enthufiafm,

enthufiafm, with fome faults, will always be preferred to a correct mediocrity; becaufe it ravifhes the foul, without giving it time to examine any thing, or to reflect on particulars; and yet, properly fpeaking, this effect proceeds not fo much from enthufiafm, as from our minds, which fometimes, when they are tranfported, exceed the bounds of probability.

I f it be ftill objected, that all I fay of enthufiafm may be afcribed to the fublime, I anfwer, That this depends on the idea which every one fixes upon thefe two words; and I fhall at all times be ready to grant, that they are much the fame, notwithftanding any difference I have made between them.

O F

O F

DESIGN.

THE word *defign*, as it relates to
painting, is taken in three different
fenfes : Firft, it fignifies the *intire thought*
of a work, lighted, fhaded, and fometimes
even-coloured ; and, in this fenfe, it is not
confidered as one of the parts of painting,
but only as the *idea* of the picture which the
painter has in his thoughts. Secondly, it
fignifies the reprefentation of fome part of an
human figure, or of an animal, or of a
piece of drapery ; all taken from the life,
in order to be put into fome part of a
picture, and to ftand for an *evidence* of
truth ; and, in this fenfe, it is called *ftudy*.
Laftly, it is taken for the boundary or *out-
line* of objects, for the *meafures* and *pro-
portions* of exterior forms : And then 'tis
reputed one of the parts of painting.

Now, if *defign* be, as it really is, the
circumfcribing of exterior forms, and if it
reduce them to fuch *meafures* and *propor-
tions* as are proper for them, we may truly
fay, that 'tis a *fort of creation*, which begins
to

to fetch, as out ·of *nothing*, the vifible *pro-
ducts of nature*, which are the object of
painting.

UPON the fubject of *invention*, we ob-
ferved, that it was the *firft* in the order of
execution : But it is not the fame in the
order of *ftudy* ; for defign muft be learned
before every thing, as it is the *key* of the
fine arts, as it gives admittance to the other
parts of painting, and is the *organ* of the
thoughts, the *inftrument* of our demonftra-
tions, and the *light* of our underftanding. The
young painter therefore ought not only to
begin with this *part*, but to be thoroughly
mafter of it, that he may the more eafily ac-
quaint himfelf with the *other parts*, of which
this is the *foundation*. Now, if *defign* be
the *bafis* of painting, it follows that we can-
not beftow too much pains on making it
folid, that it may be able to fuftain a
building which confifts of fo *many parts* as
that of painting.

I CONSIDER *defign* as confifting of
feveral parts, extremely neceffary for every
one who defires to be an *able artift* ; the
chief of which are, *correctnefs, good tafte,
elegance, character, variety, expreffion*, and
perfpective.

Of Correctnefs.

CORRECTNESS is a term commonly ufed by painters to exprefs the *condition* of a defign which is *faultlefs in its meafures.* This correctnefs depends on *the exactnefs of proportions,* and the knowledge of *Anatomy.*

THERE is a *general proportion,* founded on the meafures which are moft proper to conftitute a good figure: We ought therefore to ftudy thofe authors who treat of *proportions,* and have laid down the general meafures of human figures ; fuch authors, I mean, as have thoroughly confulted nature, and the fculptures of the antients.

BUT, as in each *fpecies* which nature produces, fhe is not limited to one fort of object only, and as *diverfity* conftitutes one of her greateft beauties ; fo there are particular proportions, which principally relate to *fexes, ages* and *conditions* ; and which, even in thefe, admit of an infinite variety. As to *particular proportions,* nature has furnifhed as many as there are men in the world ; but in order to make them juft and agreeable, we muft have recourfe to the antique only, which is derived originally from nature itfelf, and therefore may be fet up as a model, and will give a folid idea of the beautiful variety.

SEVE-

SEVERAL able painters have meafured the antique ftatues in all their parts, and have imparted to their pupils their ftudies on this fubject; but if their remarks have not been made either publick or exact enough, we have, in *France*, a more than fufficient number of elegant antiques, either originals, or moulded copies; where every one may find the lights and particulars neceffary for his inftruction.

THIS, however, is certain, that it is impoffible to reap any benefit from the meafures of the antiques, till we have ftudied them with exactnefs, drawn after them with attention, and, after obftinate practice, committed them to our memory. *Vafari* reports a faying of *Michael Angelo*; *That the compaffes ought to be in the eye, not in the hand.* This fine remark has met with good reception among all the painters; but neither could he have made it, nor they have propagated it, if they had not previoufly fuppofed a thorough knowledge in the fineft proportions.

BUT we muft not only take from the antique the fineft proportions, but every thing elfe that may tend to the fublime, and to perfection. 'Tis therefore neceffary to form as clear an idea of it as poffible, fupported by reafon: For this purpofe I fhall confider the antique in its origin, beauty, and ufefulnefs.

G

Of the Origin of the Antique.

THE word *Antique* originally fignifies any thing that is antient ; but we fhall here confine it to the works in fculpture, made in the age when great men flourifhed, which was that of *Alexander the Great,* when the fine arts and fciences were in their per-fection. I fhall forbear to trouble the reader with the names of the firft fculptors, who, through a long feries of time, brought fculpture from its cradle, to fuch a perfection as merits the name of *Antique,* which it now bears.

THE praifes which were in thofe times beftowed on fine works, increafed the num-ber of good fculptors ; and the many ftatues erected to the honour of fuch perfons as diftinguifhed themfelves by their merit, as well as the idols with which they adorned their temples, furnifhed ftill more matter for great geniufes to work on, and to finifh their works in emulation of each other.

IT was in thofe days that *Polycletus,* one of the greateft of the antient *Greek* fculptors, refolved to make a ftatue which fhould have all the proportions of a man perfectly well fhaped : For this purpofe he made ufe of many patterns of nature. After he had brought his work to the laft perfection, it was fo rigoroufly examined by men of fkill, and there-

thereupon celebrated with fo many encomi-
ums, that, by common confent, this ftatue
was called *The Rule* ; and became a general
model to all thofe who wanted to perfect
themfelves in the art. And 'tis very pro-
bable, that this experiment having fucceeded
in one fex, gave birth to feveral effays, not
only in the other, but even in the different
ages and conditions of perfons.

I F I am not miftaken, it is to this *Poly-
cletus* we may reafonably afcribe thofe mar-
velous works which we call *Antiques,* fince
they were then brought to the degree of per-
fection in which we now fee them. The
fculptors of thofe times continued to give
proofs of their fkill, down to the reign of
the Emperor *Gallienus,* about the year 360 ;
when the *Goths,* who had no knowledge of
the fine arts, nor any regard for them,
ravaged all *Greece.* But fince we look upon
the proportions of the antique as the
models of perfection, this naturally leads us
to fpeak

Of the Beauty of the Antique.

S O M E have afferted, that the beauty of
the human body lies in a juft agreement of
the members with each other, fo as to make
a *perfect whole.* Others place it in a good
conftitution, and vigorous health of body ;
where the motion and purity of the blood
diffufe

diffuse on the skin such colours as are both lively and fresh: But, according to general opinion, there is no definition of the beautiful: Beauty, say they, is nothing real; every one judges of it according to his own taste, and 'tis nothing but what pleases.

BE it as it will, people are very little divided in their sentiments about the beauty of the *Antique*. Men of understanding, and lovers of the fine arts, have always had a value for these incomparable works; that is, not only in our days, when they are become scarce, but even in those times, when all places were full of them, and when, as it were, they peopled *Greece* and *Rome*. We find, in antient authors, many passages, which, in order to praise living beauties, compare them to statues. The sculptors, says *Maximus Tyrius*, *by an admirable artifice, chuse out of several bodies those parts which seem to them the most beautiful, and put all this variety together into one statue; but this mixture is made with so much judgment and propriety, that those artists seem to have no other model than one whole and perfect beauty. And we must not think,* says the same author, *ever to find a natural beauty that can dispute the prize with statues.* Art has also something more perfect than nature. *Ovid,* in the XIIth book of his *Metamorphosis,* describing *Cyllarus,* the handsomest of the centaurs,

taurs, fays, That *fo great was the vivacity
of his countenànce, and his neck, fhoulders,
hands, and breaft were fo handfome, that
whatever he had of* man, *might be affirmed to
be of the fame beauty which is obferved in the
moft perfeft ftatues.* And *Philoftratus,* fpeak-
ing of *Euphorbus,* fays, *That his beauty had
won the hearts of the* Greeks ; *and that it
came fo near to the beauty of a ftatue, that
he might be taken for* Apollo. And lower,
mentioning the beauty of *Neoptolemus,* and
his likenefs to his father *Achilles,* he inti-
mates that, *in beauty, his father was as
much fuperior to him, as ftatues are to
handfome men.*

I T was not among the *Greeks* alone, that
ftatues were erected to men of merit, and
converted into idols ; the *Romans* took the
fame way to reward great actions, and to
honour their gods. The *Romans,* after con-
quering *Greece,* brought away not only their
fineft ftatutes, but alfo their beft workmen:
Thefe inftructed others, and have left to
pofterity everlafting proofs of their fkill ;
as appears from many admirable ftatues,
bufts, vafes, and bas-reliefs ; and from the
fine *Trajan* and *Antonine* columns: All
thefe antiquities we muft look upon as
the genuine fources to which both painters
and fculptors muft have recourfe, in order to
diffufe a folid beauty over what their own
genius may fuggeft to them.

<center>G 3</center>

Mo-

MODERN authors entertain the fame
fentiments of the beauty of the antique : I
fhall only quote *Scaliger* : *Is it poffible,*
fays he, *to fee any thing come up to the per-*
fection of fine ftatues, fince art has a liberty
of chufing, retrenching, adding and directing;
whereas nature has been always changing for
the worfe ever fince the creation of the firft
man, in whom God joined the beauty of
form to that of innocence ?

Ex Rubenio.

Extract of a Latin
MS. *of* Rubens,
concerning the Imi-
tation of the An-
tique Statues.

Aliis utiliſſima, aliis
damnofa ufque ad ex-
terminium artis. Con-
cludo tamen ad fum-
mam ejus perfectionem
effe neceffariam earum
intelligentiam , imò
imbibitionem : Sed ju-
diciosè applicandum
earum ufum, & omninò
citra faxum. Nam
plures imperiti &
etiam periti non di-
ftinguunt materiam à
formâ,

To fome painters
the imitation of the
antique ftatues has
been extremely ufe-
ful, and to others per-
nicious, even to the
ruin of their art. I
conclude, however,
that in order to attain
the higheft perfection
in painting, it is ne-
ceffary to underftand
the antiques, nay, to
be fo thoroughly pof-
feffed of this know-
ledge,

formâ, faxum à figu-. rà, nec neceffitatem marmoris ¹ *ab artificio.*

ledge, that it may diffufe itfelf every-where. Yet it muft be judicioufly applied, and fo that it may not

in the leaft fmell of the ftone. For feveral ignorant painters, and even fome who are fkilful, make no diftinction between the matter and the form, the ftone and the figure, the neceffity of ufing the block, and the art of forming it.

Una autem maxima eft ftatuarum optimas utiliffimas, ut viles in-utiles effe, vel etiam damnofas: Nam tyrones ex iis nefcio quid crudi, terminati & difficilis, moleftaque a-natomiæ dum trahunt, videntur proficere, fed in opprobrium naturæ, dum pro carne marmor coloribus tantum re-præfentant. Multa funt enim notanda, imò & vitanda etiam in opti-mis, accidentia citra culpam artificis, præ-cipuè differentia um-brarum, cum caro, pellis,

IT is certain, how-ever, that as the fineft ftatues are extremely beneficial, fo the bad are not only ufelefs, but even pernicious. For beginners learn from them I know not what, that is crude, liny, ftiff, and of harfh anatomy; and while they take them-felves to be good pro-ficients, do but dif-grace nature; fince in-ftead of imitating flefh they only reprefent marble tinged with various colours. For there are many things

G 4
to

pellis, cartilago sua diaphanitate multa leniant præcipitia in statuis nigredinis & umbræ quæ sua densitate saxum duplicat inexorabiliter obvium. Adde·quasdam maccaturas ad omnes motus variabiles, & facilitate pellis aut dimissas aut contractas, à statuariis vulgò evitatas, optimis tamen aliquando admissas, picturæ certò, sed cum moderatione, necessarias. Lumine etiam ab omni humanitate alienissimæ differunt, lapideo splendore, & asperà luce, superficies magis elevante ac par est, aut saltem oculos fascinante.

to be taken notice of, and ·avoided, which happen even in the best statues, without the workman's fault: especially with regard to the difference of shades ; where the flesh, skin, and cartilages, by their diaphanous nature, soften, as it were, the harshness of a great many out-lines, and wear off those rugged breaks, which in statues, by the force and depth·of their shade, make the stone, tho' very opaque, appear still more opaque and impenetrable to light, than it really is. There are, besides, certain places in the *natural,* which change their figure according to the various motions of the body, and, by reason of the flexibility of the skin, are sometimes dilated, and at other times contracted. These are avoided by the generality of sculptors ; yet are sometimes admitted into use by the most excellent,

lent, and are certainly neceſſary to painting; but muſt be uſed with moderation. To this we muſt add, that not only the ſhade, but alſo the lights of ſtatues are extremely different from the *natural*; for the gloſs of the ſtone, and ſharpneſs of the light that ſtrikes it, raiſe the ſurface above its proper pitch, or, at leaſt, faſcinate the eye.

Ea quiſquis ſapientis diſcretione ſeparaverit; ſtatuas cominùs amplectetur; nam quid in hoc erroneo ſæculo degeneres poſſumus? quàm vilis genius nos humi detinet ab heroico illo imminutos ingenio, judicio! ſeu patrum nebulâ fuſci ſumus, ſeu voluntate Dei ad pejora lapſi, poſtquam lapſi, non remittimur, aut veteraſcente mundo indeboliti irrecuperabili damno, ſeu etiam objectum naturali antiquitùs origini perfectionique propiùs offerebat, ultrò compactum, quod nunc ſeculorum

H E who has, with diſcernment, made the proper diſtinctions in theſe caſes, cannot conſider the antique ſtatues too attentively, nor ſtudy them too carefully; for we of this erroneous age, are ſo far degenerate, that we can produce nothing like them: Whether it is, that our groveling genius will not permit us to ſoar to thoſe heights which the antients attained by their heroick ſenſe, and ſuperior parts; or that we are wrapt up in the darkneſs that overclouded our fathers; or that it is the will

culorum senescentium defectu ab accidentibus corruptum nihil sui retinuit, delabente in plura perfectione succedentibus vitiis: ut etiam statura hominum multorum sententiis probatur paulatim decrescentis: quippe profani sacrique de heroum, gigantum, · Cyclopumque ævo, multa quidem fabulosa, aliqua tamen vera narrant sine dubio.

will of God, becaufe we have neglected to amend our former errors, that we fhould fall from them into worfe ; or that the world growing old, our minds grow with it irrecoverably weak; or, in fine, that nature herfelf furnifhed the human body, in thofe early ages, when it was nearer its origin and perfection, with every thing that could make it a perfect model ; but now being decay'd and corrupted by a fucceffion of fo many ages, vices, and accidents, has loft its efficacy, and only fcatters thofe perfections among many, which it ufed formerly to beftow upon one. In this manner, the human ftature may be proved from many authors to have gradually decreafed : For both facred and profane writers have related many things concerning the age of heroes, giants, and *Cyclopes*, in which accounts, if there are many things that are fabulous, there is certainly fome truth.

Caufa

Caufa præcipua quâ noftri ævi homines differunt ab antiquis eft ignavia & inexercitatum vivendi genus; quippe effe, bibere, nulla exercitandi corporis cura. Igitur prominet depreffum ventris onus, femper affiduâ repletum ingluvie, crura enervia, & brachia otii fui confcia. Contrà, antiquitùs omnes quotidie in palæftris & gymnafiis exercebantur violenter, ut verè dicam, nimis ad fudorem, ad laffitudinem extremam ufque. Vide Mercurialem de arte gymnafticâ, *quàm varia laborum genera, quàm difficilia, quàm robufta habuerint. Ideò partes illæ ignavæ abfumebantur tantoperè, venter reftringebatur, abdomine in carnem migrante. Et quidquid in corpore humano mano*

THE chief reafon why men of our age are different from the antients, is floth, and want of exercife; for moft men give no other exercife to their body but eating and drinking. No wonder therefore, if we fee fo many paunch-bellies, weak and pitiful legs and arms, that feem to reproach themfelves with their idlenefs : Whereas the antients exercifed their bodies every day in the academies, and other places for that purpofe, and exercifed them fo violently as to fweat and fatigue them, perhaps, too much. See in *Mercurialis de arte gymnafticâ,* how many various exercifes they took, how difficult, and what vigour of conftitution they required. Thus all thofe parts

mano excitando paf-
five fe habent: nam
brachia, crura, cer-
vix, fcapuli, & omnia
quæ agunt auxiliante
naturâ, & fuccum ca-
lore attractum fubmi-
niftrante, in immen-
fum augentur &
crefcunt; ut videmus
terga gerulorum, bra-
chia gladiatorum, cru-
ra faltantium, & to-
tum ferè corpus re-
migum.

parts of the body
which are fed by idle-
nefs were worn away;
the belly was kept
within its bounds, and
what would have
otherwife fwelled it
was converted into
flefh and mufcles:
For the arms, legs,
neck, fboulders, and
whatever works in the
body, are affifted by
exercife, and nourifh'd
with juice, drawn in-
to them by heat, and
thus increafe exceedingly both in ftrength and
fize; as appears from the backs of porters,
the arms of prize fighters, the legs of dan-
cers, and almoft the whole body of watermen.

THUS far *Rubens*; and I have given his
own words for authorizing the truth of what
I have extracted from his manufcript, which
is in my poffeffion.

IN fine: The praifes of the knowing,
the teftimonies of authors, and the general
efteem of the moft famous ages, which are
the ftrongeft vouchers for the antique, tend
all to eftablifh this fingle reafon for the
beauty of it; towit, becaufe it is founded

on

on the imitation of beautiful nature, fuited
to the object which is to be reprefented.
The feveral characters obferved in the fineft
antiques are, thofe of a God, an Hero, and
an ordinary perfon ; accordingly, we fee in
Apollo, divinity ; in *Hercules*, extraordinary
ftrength ; and in *Antinous*, human·beauty.

SOME may fay, that the tafte for antique, which appears to be founded on the
common confent of knowing men, did,
however, fuffer a change in the times of the
Goths. I anfwer, that the *Gothick* manner
was introduced at a time when the wars
having·deftroyed the fine arts, workmen had
no other objects to revive them by, than the
imitation of fuch natural ones as cafually
offered ; and as to embellifhing them, they
employed their imaginations rather in fuch
difficult things as they believed would gain
them repute, than in cultivating good tafte,
to which they were utter ftrangers.

THE *Goths* cannot therefore be faid to
have departed from the antique, becaufe
they rejected, but becaufe they were not at
all acquainted with it. All arts began with
the imitation of nature, and have been
brought to perfection only by good choice.
This choice, which is found in the antique,
has been made by men of excellent judgment,
who aimed at glory, by the way of fcience;
and, in order to attain it, examined the moft
perfect natural patterns, in a country productive
of

of handfome men, and at a time that abounded
with great genius's, when the fine arts were
affiduoufly ftudied, thoroughly examined,
and brought to a degree of perfection, which
is at this day the object of our aftonifh-
ment.

WHAT more could be done to give pof-
terity a great idea of the antique? An idea
not derived from an infipid practice, or
from an overdoing manner which fcholars
take from mafters of a narrow mind, and
middling capacity; but fpringing originally
from nature, where truth appears in all
its purity, elegance, grace, and force, with-
out ever departing from its fimplicity. It is
therefore the intereft of all thofe who defign
to look upon the naked antique, as nature
purified, and as the moft certain rule of
perfection.

BUT as 'tis in vain to defire to profit by a
bare fight of fine things, if we do not well
conceive them, fo it is impoffible thoroughly
to underftand the beauty of the antique,
any more than the truth in nature, without
the help of anatomy. We may, indeed, by
feeing and defigning the antique, acquire a
certain greatnefs of defign, and, in the main,
get a practice tending to good tafte and de-
licacy; but thefe advantages, if void of
knowledge and principles, can only dazzle
the fpectator by a fpecious fhew, and by ill-
placed remembrances of things. A man
may

may be in raptures on feeing the fine works of antiquity, and yet be far from knowing the genuine fource of thofe beauties which he admires, at leaft, if he be ignorant of that fundamental part of defign, anatomy.

I F then anatomy be the bafis of defign, and enable us to difcover the beauties of the antique, I cannot but obferve, that, the knowledge of fo much of it as the painter and fculptor require, is eafily attained; and that the neglect of this attainment proceeds only from its being thought to lead towards drynefs of defign, and pedantry of manner. But a little reflection will make it appear to be far from corrupting the folid bafis of truth, and of correctnefs of out-line purity, or fpoiling the connexion of the mufcles.

I FORMERLY writ, under a borrowed name (*a*), *An abridgment of anatomy*, for the ufe of painters and fculptors, where the demonftrations are very plain : I fhall here give fome part of it, in order to facilitate this fcience; and the rather, becaufe thofe who have need of it, imagine it to be difficult.

Of Anatomy.

ANATOMY is a knowledge of the parts of the human body; but that re-

(*a*) Abregé d'Anatomie, par Tortebat.

<div align="right">lates</div>

lates only to painters, who have need of the bones, and the principal mufcles that cover them; two points which are eafily demonftrable. Nature has furnifhed us with bones for the folidity of the body, and ftrength of the members : To them fhe has fixed the mufcles, as exterior agents, to draw them whither fhe pleafes : The bones determine the meafures of length, and the mufcles thofe of bignefs in the parts of nature ; at leaft, 'tis the office of the mufcles to fettle the form and exactnefs of outlines.

'T i s indifpenfably neceffary to be well acquainted with the forms and joints of the bones, becaufe motion often alters their meafures ; and likewife to underftand the fituation and office of the mufcles, fince the moft ftriking truth in defign depends upon them.

- T h e bones of themfelves are motionlefs, and ftir only by the help of the mufcles. The mufcles have their origins and infertions. By their origins they are faftened to a bone, which they were never intended to ftir ; and, by their infertions, to another bone, which they draw when they pleafe towards their origins.

E v e r y mufcle has its oppofite mufcle; when one acts, the other yields, like wellbuckets, one of which defcends as the orher comes up; the acting mufcle fwells, and

con-

contracts next to its origin, the other that obeys, dilates and relaxes.

T h e largeſt bones, and which are moved with the greateſt difficulty, are covered with the largeſt muſcles; theſe are often aided by others, which are deſigned for the ſame office, and thereby increaſe the force of motion, and make the part more apparent.

S e v e r a l painters, by overſwelling the muſcling, have thought to gain the reputation of being ſkilful in anatomy, or at leaſt would ſhew, that they were maſters of it; but they have ſhewn, by this means, that they little underſtood it; ſince they ſeem to be ignorant, that there is a ſkin which covers the muſcles, makes them appear more tender and eaſy, and is a part of the human body, and conſequently of anatomy. This truth is ſufficiently proved by the bodies of women and children, which are as fully muſcled as thoſe of the moſt robuſt perſons.

T h e authors of the antique figures have not made a wrong uſe of their profound knowledge in this part, by making the muſcles appear more than was prudent and neceſſary; and their exactneſs, in this reſpect, ſhews the attention they thought due to anatomy. In ſhort, how is it poſſible to judge of the truth or falſity of an out-line, if we know not for certain to what degree the muſ- cle, which makes it, ought either to ſwell

H
or

or relax, according to its office and degree of action. We often fee, as has been faid before, that, for want of this knowledge, fome perfons, who admire an antique ftatue, do it for no other reafon, than becaufe 'tis antique. And if you afk, why the outline of a figure of their own making is thus or thus, they can only anfwer, that they faw it fo in nature. And this is the cafe of young people, and of thofe who have no more knowledge than what they have derived from bare practice.

WE often obferve, in the naked parts of antique figures, and even in nature itfelf, certain fwells, the reafon of which we cannot difcover, without confidering the fituation and office of the mufcle which is the caufe of them. But the fkilful in anatomy, fee all in feeing a part, and know how to remove from the eye what the fkin and fat feem to conceal, and what is hid to thofe who are ignorant of this fcience.

I HAVE now faid enough to fhew, that 'tis impoffible to be truly fkilful in defign, without a clear and diftinct knowledge in anatomy, as it relates to painting and fculpture ; and this may be attained with little trouble, - if we would not rather produce monfters, than beftow fome attention on fo neceffary a point. As for the demonftrations, I refer the reader to my aforefaid *Abridgment of anatomy.*

Of

Of Taſte in Deſign.

THE goût or taſte is an idea, either ſuiting the natural inclination of the painter, or formed by education. Every ſchool has its taſte in deſign; and, ſince the re-eſtabliſhment of the fine arts, that of *Rome* has always been thought the beſt, as being founded on the antique; which is moſt proper for forming a taſte in deſign, as I have a little before endeavoured to prove.

Of Elegance.

ELEGANCE in general is a manner either of ſpeaking or making things with good choice, politeneſs and agreeableneſs: With good choice, in riſing above what nature and painters uſually produce; with politeneſs, in giving ſuch a turn to things, as may ſtrike men of delicate taſte; and with agreeableneſs, in diffuſing ſuch a general reliſh, as may pleaſe, and be within the reach of every one.

ELEGANCE is not always founded on correctneſs, as appears from the antique, and from the works of *Raphael.* 'Tis often ſeen in works, either incorrect, or otherwiſe ſlighted; as in *Correggio*, where, notwith-ſtanding his incorrectneſs in deſign, his ele-

gance

gance in the tafte of it, and in the turn
which he has given to his actions, muft needs
be admired: In fhort, *Correggio* rarely de-
parts from elegance.

But the elegance which is fupported by
correctnefs of defign, as it prefents to us an
image of perfection, fo it anfwers fully our
expectation, fixes our attention, and elevates
the mind, after having ftruck it with an
agreeable aftonifhment.

Elegance of defign may be further
defined to be a manner of embellifhing ob-
jects, either in form or colour, or both,
without deftroying the truth.

Elegance, with refpect to defign, ap-
pears more eminently in the antiques, than
in any of the great painters who have imi-
tated them ; among whom, by general con-
fent, *Raphael* is the chief.

Of the Characters.

'T I S not correctnefs only that gives fpirit
to painted objects, but 'tis alfo the manner in
which they are defigned. Every kind of object
requires a different mark of diftinction ;
ftones, waters, trees, hair, feathers, and,
in fhort, all kinds of animals, muft have
their different touchings, in order to exprefs
the fpirit of their characters ; and even
naked human figures have their particular
marks of diftinction. Some, to imitate flefh,
 give,

give, in the extremities, an inflective ftroke, which has this fpirit: Others, to imitate the antique, fhew, in their extremities, the regularity of ftatues, that they may not lofe any of their beauty: We even obferve in the defigns of the great mafters, that, in order to exprefs the paffions of the foul, they had made certain ftrokes familiar to them, which exhibited their ideas in a more lively manner than the painting itfelf.

THE word *expreffion*, in painting, is ufually confounded with paffion ; but their difference is, that *expreffion* is a general term, fignifying the reprefentation of an object, according to its character and nature, and according to the turn which the painter has a mind to give it, for the benefit of his work: And *paffion*, in painting, is an emotion of the body, attended with certain ftrokes or lines in the face, denoting an agitation of the foul. Thus, all paffion is expreffion, but all expreffion is not paffion: From hence we muft conclude, that there is no object in a picture which has not its expreffion.

I MIGHT here treat of the paffions of the foul, but have found it impoffible to give fuch particular demonftrations of them, as might be of much fervice to painters; on the contrary, I conceive, that if they were fixed by certain ftrokes, which the painter fhould be obliged to make ufe of as effential rules,

this

this would be depriving the art of that ex-
cellent variety of expreſſion; which has no
other principle than diverſity of imaginations,
the number of which is infinite, and pro-
ductions as new as the thoughts of men are
various. The ſame paſſion may be finely
expreſſed ſeveral ways, yielding each more
or leſs pleaſure in proportion to the painter's
underſtanding, and the ſpectator's diſcern-
ment.

IN the paſſions, there are two ſorts of
emotion; one lively and violent, and the other
ſweet and moderate : *Quintilian* calls the
former pathetick, and the latter moral : The
pathetick commands, and the moral per-
ſuades: The one brings trouble, and ſhakes
the heart; and the other calms the mind;
and both require much ſkill to be well
expreſſed.

THE pathetick is founded on the moſt
violent paſſions; as hatred, wrath, envy,
compaſſion : The moral inſpires mildneſs,
tenderneſs, and humanity. The former pre-
vails in combats, and unforeſeen and mo-
mentary actions; and the latter in conver-
ſations; and both require a decorum and
propriety in the figures which compoſe the
ſcene.

LE BRUN has publiſhed a treatiſe of the
paſſions; the definitions of which he has
taken moſtly from what *Deſcartes* has writ-
ten of them. But that philoſopher treated
only

only of the emotions of the heart, whereas painters want what appears in the face. Now, even if those emotions of the heart did always produce the paffions, according to the definitions that are given of them, it's hard to know, how those emotions conftitute the lines in the face, by which they are reprefented to the eye : Befides, the definitions of *Defcartes* are not always accommodated to the capacities of painters ; who are not all philofophers, though, in other refpects, they may not want fenfe, and good natural parts. It is fufficient for them to know, that the paffions are the emotions of the foul, which is feized with certain fentiments at the fight of fome object, without waiting for order, or the judgment of reafon. The artift ought to confider this object with attention, and endeavour to make it always prefent in his mind, and to afk himfelf, What he would naturally do, if feized with the fame paffion? Nay, he fhould do more ; he ought to put himfelf in the place of the perfon who is thus tranfported, and to heat or cool his imagination to fuch a degree of livelinefs or calmnefs, as that paffion requires after it is thoroughly felt. The looking-glafs is a great help in this matter, and a perfon, duly informed of the cafe, might very well ferve for a model or figure.

But it is not enough, that the painter himfelf feel the paffions of the foul ; he muft

H 4 make

make them, felt by others; and, among the many characters by which one particular paffion may be exprefs'd, he muft chufe fuch as he judges moft proper to affect chiefly men of underftanding; which cannot be done, in my opinion, without exquifite fenfe, and found judgment; for nothing interefts the fpectator more in favour of the picture, than the painter's hitting his tafte.

Le Brun's demonftrations are certainly very learned and fine, but too general: They may indeed be of fervice to moft painters; but yet other expreffions of the paffions may be found as beautiful as *Le Brun's*, though, in this refpect, he has been very happy.

General expreffions are therefore ufe-ful, becaufe the particular ones proceed from them, as the branches of a tree fhoot from the trunk. I would therefore advife every painter to ftudy them, and to mark on paper, with a *crayon*, the lines or ftrokes which form them; and, for this purpofe, to copy after the antique, and after nature, in order to form fuch a general idea of the principal paffions as may fuit his genius: For we all think differently, and our imaginations are according to the nature of our conftitutions.

Tho' the paffions of the foul are moft vifible in the lines of the face, they often require the affiftance of the other parts of the body; for, when the fubject requires the expreffion of fome effential part, if you

touch

touch the fpectator but faintly, you give him
a coldnefs that difgufts him; whereas, if you
touch him to the quick, you give him an
infinite pleafure.

THE head contributes more to the ex-
preffion of the paffions, than all the other
parts of the body put together. Thefe fepa-
rately can only fhew fome few paffions, but
the head fhews them all. There are fome,
however, peculiar to the head; as humility,
when it hangs down; arrogance, when
it lifts itfelf up; languifhing, when it leans
on one fide; obftinacy, when, with a ftub-
born and rigid air, it ftands upright, fixed,
and ftiff, between the two fboulders. Others
may be more eafily exprefs'd than defcribed;
as fhame, admiration, indignation, and doubt.

THE head beft fhews our fupplications,
threats, mildnefs, haughtinefs, love, hatred,
joy, fadnefs, humility: In fhort, the face
difcovers things in half-fpeech; its rednefs
and palenefs, as it were, fpeak to us, as well
as the mixture of both.

ALL parts of the face contribute towards
expreffing the fentiments of the heart: But
the eyes efpecially; which are, as *Cicero*
fays, *the windows of the foul.* The paffions
they moft particularly difcover are, pleafure,
languifhing, fcorn, feverity, mildnefs, ad-
miration, and anger; to which we might
add joy and grief, if they did not proceed
more particularly from the eye-brows and
mouth: But, when thofe two paffions fall

in alfo with the language of the eyes, the harmony will be wonderful.

THE nofe fhews no paffion in particular, but affifts the other parts of the body by raifing the noftrils; which is as much an expreffion of joy as of fadnefs. Yet fcorn raifes the tip, and fwells the noftrils, drawing the upper lip up to the corners of the mouth. The antients made the nofe the feat of derifion —— *Eum fubdolæ irrifioni dicaverunt* —— fays *Pliny*. They alfo placed anger there; as in *Perfius* —— *Difce; fed ira cadat nafo, rugofaque fanna* —— But I take the nofe to be the feat of anger rather in beafts than men; and that it is only becoming in the god *Pan*, who partakes very much of the nature of the beaft, to wrinkle up his nofe when he is angry, as other animals do, and as *Philoftratus* reprefents him, when the nymphs tied him, and offered him a thou- fand infults.

THE motion of the lips ought, in com- mon difcourfe, to be moderate; becaufe a man rather fpeaks with his tongue than with them; and the mouth muft not be very open, unlefs to exprefs fome violent paffion.

A s for the hands, they obey the head, and become its weapons and aid in time of need: Action is weak, and, as it were, half dead, with- out their affiftance; their motions, which are almoft infinite, create numberlefs expref- fions: Is it not by them that we defire, hope,

<div align="right">promife;</div>

promife, call, fend back·? Are they not the inftruments of threatening, prayer, horror, and praife ? Do we not by them approve, refufe, fear, afk, exprefs our joy and grief, our doubts, regrets, pain, and admiration ? In a word, we may affirm, fince they are the language of the dumb, that they contribute not a little to fpeak a language common to all nations, which is that of painting.

To fay how thefe parts muft be difpofed for expreffing the various paffions, is impoffible ; nor can any exact rules be given for it, both becaufe the tafk would be infinite, and becaufe every one muft be guided in this by his own genius, and the particular bent of his ftudies. Let it be only remembered, that the actions of the figures muft be perfectly natural. *I cannot but think,* fays *Quintilian,* fpeaking of the paffions, *that this part, though fo fine and great, may poffibly be attained, and that there is a road which leads eafily to it ; and it is the ftudy and imitation of nature : for the fpectators are fatisfied, when, in artificial things, they fee nature as fhe ufually appears to them. In effect, it is not to be doubted, but that the emotions of the foul, as feen in art, are never fo natural as thofe in the heat of a real paffion.*

THE beft way to exprefs the motions naturally is, for the artift to entertain the fame
fentiments,

sentiments, and to fancy himself in the same circumstances with the person he would represent. *For nature, says Horace, lays our mind open to all sorts of chances; sometimes we have content; at other times we are swelled with anger; sometimes we are intirely weighed down with mortal disquiets, and then the motions of the heart swell outwardly by means of the tongue, which is its interpreter.* Instead of the tongue, let the painter say, *by means of the actions, which are her interpreters.*——*How is it possible, says Quintilian, to give warmth to any thing, if you have not that warmth in yourself? We must first be touched ourselves with a passion, before we can affect others with it.* And how *must we move and affect ourselves,* continues he, *since the passions are not in our power? It is thus, if I mistake not: We must form to ourselves the appearances and images of things absent, as if they were really before our eyes; and he who forms and conceives those images with the greatest force, will express the passions with most advantage and facility.* But let the artist take care, as we have already said, that, in these images, the motions be natural; for some think they give much life to their figures, in giving them violent and forced actions, which we may rather call contorsions of the body, than passions of the soul : Thus are they at great pains to find out

<div align="right">some</div>

fome violent paffion, where only a moderate one was proper.

A D D to what is above, that great regard muft be had to the qualities of the perfons that are paffioned : The joy of a king muft not be like that of a footman, nor a foldier's mettle like that of a captain. And, in thefe diftinctions, confifts the true difcernment of the paffions.

E V E R Y body is fenfible, that the imitation of the vifible objects in nature lies in defign and colouring. I have explained my thoughts of the former in fpeaking of correctnefs of defign, founded on the beauties of nature, and the antique, and on the affiftance of anatomy. I have touched on tafte, diverfity, elegance, character, and the expreffion of the paffions, according to the relation which all thefe bear to defign. It only remains now to fpeak of colouring, and to add what I have to fay at prefent to what I have formerly written on this head : For the reft, if I have omitted any thing that has a relation to defign, I have done it, becaufe others have treated of thofe things with fuccefs ; and becaufe it would be tirefome to repeat what they have written, unlefs I could better illuftrate it.

O F

O F

D R A P E R I E S.

DIVERSITY of climates, change of seasons, and their inconstancy, have laid men under the necessity of cloathing themselves : This necessity has been accommodated to the rules of decency, and decency has given rise to various ornaments, invented for enriching dress, according to the taste of different nations, and the mode of different times. But as the use of stuffs has been applied to many other things besides clothing, painters have comprised them all under the word *Drapery*; and when they would describe an artist who makes a proper distribution of the folds, they say, He knows how to cast a drapery well. Now this phrase of *casting a drapery* is the more just, as the disposition of the folds ought rather to seem the effect of mere chance, than of labour and study : As there is skill therefore in the adjustment of the draperies, we shall endeavour to shew where it lies, and of what consequence it is in painting.

<div align="right">THE</div>

4

THE art of drapery is chiefly obſerved in three things; *viz.*

1. The order of folds.
2. The diverſity of ſtuffs.
3. The variety of colouring in ſtuffs.

Of the Order of Folds.

AS the eye muſt never be in doubt of its object, the chief effect of draperies is, to make us underſtand what they cover; eſpecially the naked parts of figures; in ſuch manner, that the outward characters of perſons, and the exactneſs of proportions, may appear through them, at leaſt in the main, and as far as probability and art will permit: Accordingly, after the example of the greateſt maſters, the painter, before he diſpoſes his draperies, ought to draw his figures naked, in order to prevent any doubtful meaning in the folds, and that the eye may imagine it ſees what he conceals by the caſt of his draperies. He muſt alſo take care, that the drapery ſit not too cloſe to the parts of the body, but that it ſeem to flow round, and, as it were, careſs them, and that the figure be eaſy, and have a free motion.

LET not the draperies which cover thoſe members, that are expoſed to great light, be ſo deeply ſhaded, as to ſeem to pierce them; nor let thoſe members be croſſed

by

by folds, which are too ftrong; left, by the too great darknefs of their fhades, the members look as if they were broken; but, retaining a fmall number of folds, let the painter nicely diftribute among them fuch a degree of light as fuits the whole mafs, of which they are a part.

FOLDS fhould be great, and as few as poffible: a maxim that chiefly contributes to what is called *the grand manner*; be-caufe great folds do not fo much divide the fight, and their rich fimplicity is moft fuf-ceptible of great lights. We muft never-thelefs except fuch drapery as requires much plaiting; as it often happens in that of women, and as we fee in many an-tiques; for, in fuch cafes, the painter ought to groupe his folds, and range them at the fide of the members, which are thus rendered more apparent and more pleafing.

CONTRAST, which is fo neceffary in the motion of figures, is as proper in the order of the folds; for contraft, by break-ing the lines which would otherwife have too great tendency one way, raifes in the dra-peries, as well as in the figures, a fort of contradiction, that feems to animate them: The reafon is, that contraft is a kind of war, that puts the oppofite parts in motion. Accordingly, in proper places, the folds
 ought

5

ought not only to contraſte themſelves, but alſo the members of the figures, when thoſe folds are great, and a part of a large drapery; for as to the under draperies, which ſtick more cloſely to the naked figure, they are more apt to take the ſhape of it, than to give it any contraſt.

WHATEVER life the contraſt may add to draperies, and however neceſſary it may be to make them pleaſing, the painter muſt yet make uſe of it with great prudence and precaution: For, in upright figures, it often happens, that the contraſt cannot be practiſed, without departing from probability. And in ſuch caſes, the painter, who knows to turn every thing to his advantage, betakes himſelf to other principles.

FOLDS well imagined give much ſpirit to any kind of action; becauſe their motion implies a motion in the acting member, which ſeems to draw them forcibly, and makes them more or leſs ſtirring, as the action is more or leſs violent.

FOLDS, ſhould be great according to the quantity and quality of the drapery; and when, through the ſlightneſs of ſtuffs, we are obliged to uſe much folding, it muſt be ſo grouped, that the *claro-obſcuro* may not ſuffer by it.

A JUDICIOUS repetition of folds, in a circular manner, is a great help to the effect of fore-ſhortenings.

IT's ſometimes proper, in certain parts, to put out ſome folds, and put in others

I more

more fuitable to the painter's intention, either for fpreading of light, or for filling up the vacancies of fome attitudes, or for accompanying the figures, or for making a fweet ground to them, or for hindering their turnings from ending too quick, and looking too harfh and unfinifhed.

RICH ornaments make a part of the beauty of draperies, when ufed with difcretion. But fuch ornaments ill become divinities, and are always beneath the ftate and dignity of heavenly figures; whofe draperies ought rather to be rich in the greatnefs and noblenefs of the folds, than in the quality of the ftuff.

FOLDS made by mere practice, and without the help of the natural, are ufually proper only for a fingle defign; but, in order to perfection, the painter fhould always confult the ftuffs themfelves; becaufe in them the folds are true, and the lights agreeable to the nature of the ftuffs. I would not however, blame thofe who have acquired fo great an experience in the nature of folds and qualities of ftuffs, as to be capable, by memory, to exprefs moft of them well.

To imitate truth juftly, draperies ought either to be fet on a layman as big as the life, or elfe upon the life itfelf; but care muft be taken, that fuch draperies have nothing of the immobility of the layman.

SOME

SOME painters make ufe of fmall lay-men, on which they fet either thin ftuffs, or wet paper : But tho' this method may be ufeful to able artifts, and is very good, where a whole ftory is to be put together, it can't be fo ufeful for particular draperies ; becaufe the ftuffs, not having the fame weight as in the larger laymen, can't fhew the folds in their true fhapes.

LIGHT and flying draperies become only figures in great motion, or in the wind ; but when in a clofe place, and free from violent action, their draperies muft be large ; and by their contraft, and fall of the folds, fhew grace and majefty.

'TIS a great fault to make draperies too heavy and cumberfome : they ought to be fuitable to the figures ; and 'tis wrong to think, as fome have done, that the larger they are, the more they are grand and majeftick. A profufion of ftuffs, on the contrary, is an hindrance to the motion of the figures, and rather embaraffes them, than makes them majeftick.

Thefe, I think, are the principal obfer-vations relating to the order of folds : I pro-ceed, *fecondly,* to fpeak

Of the Diverfity of Stuffs.

AMONG the many different things that pleafe in the compofition of a picture,

variety

variety of draperies is not the leaft confi-
derable. The order and contraft of folds
have indeed their fhare ; but it is not enough,
that the ftuffs themfelves be varioufly caft,
they muft alfo be of various forts, as far
as the fubject will admit : Wool, linen,
cotton, and filk, as they are manufactured
a thoufand different ways, afford the artift a
large field for choice ; by which means he
may introduce into his work a diverfity,
which is the more neceffary, as it makes
him avoid a tirefome repetition of folds of
the fame kind, efpecially when his piece
confifts of many figures : Some ftuffs natu-
rally make broken folds, others more foft
and round : Some ftuffs are rough-wrought,
others fmooth and gloffy : Some are thin
and tranfparent, others more firm and fub-
ftantial. And this variety, whether di-
fperfed among many figures, or brought into
one, according to the fubject, never fails to
produce a moft agreeable fenfation.

THE general ufe of the fame kind of ftuff
in the figures of one picture; is a fault into
which moft painters of the *Roman* fchool
have fallen, and which all thofe are guilty of,
who either paint by dint of practice only,
or reduce the imitation of nature to an habit
which they have contracted. But the in-
genious painter will feek all opportunities
of introducing into his draperies that happy
diverfity I have been mentioning : Let him
re-

remember, however, that it is, above all things, indifpenfable, with regard to the difference of ages, fexes, and conditions.

THE antient fculptors were very fkilful in cafting their draperies: But, as the matter they work'd on was of one colour, and the large folds, which receive the greateft light, would have often appeared undiftinguifhable from the naked parts, or at leaft have divided the eye, they were obliged to fix it upon the naked parts of their figures; becaufe, in this cafe, nothing better could be done for the advantage of their art. For this purpofe, they made ufe of wetted linen, or thin ftuffs, which is the ufual drapery of their ftatues. This remedy, by the good order of their folds, was certainly very ingenious, and affords much light to thofe who can apprehend the reafon of it. I could produce many examples from antiquity in this point; but fhall only mention that of the bas-relief, commonly called, *The Dancing Women.* The draperies which cover the naked parts of thofe figures, and fhew, in many feeming folds, thofe parts agreeably, terminate behind the body, the repetition of which would appear a fault, to an eye which cannot confider the finenefs and excellence of the work: But if we regard the fculptor's purpofe, which was, to fhew the naked parts of thofe figures with elegance, thefe repetitions will be fo far from appearing a fault

in

in fculpture, that they will feem to make a kind of hatched fhading, fo dextroufly managed as to fet off the naked parts, and to give, at the fame time, a repofe to the eye.

Thus have the antient fculptors, with great fkill and genius, invented feveral ways to remedy the inconveniences in the matter they work'd on, whether they proceeded from the largenefs of folds, or the variety of the ftuffs with which their figures were cloathed; having in all other refpects, generally fpeaking, given perfect fatisfaction.

But painters, who may ufe all forts of ftuffs, and, by means of colours and lights, can fkilfully imitate truth, would be as much to blame, if they followed fculptors in the multitude and repetition of their folds, as fculptors would be, if they imitated painters in the extent of their draperies. I proceed in the laft place to treat

Of the Variety of Colouring in Stuffs.

IF order, contraft, and variety of ftuffs and folds, conftitute the elegance of draperies, diverfity of colours in thofe ftuffs contributes extremely to the harmony of the whole together, in hiftorical fubjects. The artift, who has it generally in his power to imagine them as he pleafes, muft particularly ftudy the values of his colours when entire, their effects when placed by one another, and their

their harmony when broken. But thefe
points I fhall handle in treating of *colouring*;
and, in the mean time, only here obferve,
that the colouring of draperies gives the
painter an opportunity of fhewing all his
fkill and addrefs in the *claro-obfcuro*. *Titian*
made ufe of this artifice in moft of his
pictures; becaufe he was thereby at liberty
to give his draperies what colour he thought
moft proper, either for making his ground,
or for fpreading light, or for characterizing
objects by comparifon.

Bu t, after all, the management of dra-
peries is not fo fettled, but the painter may
give fcope to his genius, in venturing on
unufual folds, which may have their merit.
There is not any effect in nature, where
chance fhews more variety than in the caft
of the draperies : And tho' art has ufually
fomething to correct in their difpofition, yet
chance often furnifhes with folds more beau-
tiful and proper, than rules could ever
have produced. In fine, art cannot forefee
every thing: Art goes but a little way be-
yond general things, and leaves to men of
tafte the care of fupplying every thing elfe.
It is the painter's part to make a good choice
of the effects which nature prefents, and to
ufe them fo as to diffufe over his performance
the marks of a happy felicity.

A mong the painters who beft underftood
draperies, *Raphael*, in my opinion, is the
I 4　　　　beft

beſt copy for the order of folds; yet I would not derogate by this from the merit of thoſe, who, without departing wholly from *Raphael's* principles, have ſuccefsfully taken greater liberties in the characters of their folds, and have even accompanied thoſe freedoms with grandeur and truth. The *Venetian* and *Flemïſh* ſchools have excelled in ſhewing the variety of ſtuffs; and *Paolo Veroneſe* is an inexhauſtible ſource of examples for an harmonious variety of colours.

I SAY little of the other great maſters in draperies; the conſideration of whoſe works will make it evident, that the folds require both order, and a proper choice; that the difference of ſtuffs enriches a work, and ſupports a neceſſary probability; and that variety of colouring in draperies may contribute very much to the effect of the *claro-obſcuro*, and to the harmony of the whole together. In ſhort, the works of thoſe excellent maſters will better demonſtrate, than all I can ſay, wherein the knowledge of draperies lies, and of what importance it is in painting.

An Abſtract of the preceding Obſervations *relating to* DRAPERIES.

BY the word *drapery*, in painting, is meant all ſorts of ſtuffs, whether for cloathing or other uſe; but, generally

speak-

speaking, it relates to cloathing : In which art confiders,

;1. The order of folds. -
2. The diverfity of ftuffs,
3. The variety of colouring in ftuffs,

Of the Order of Folds.

T H E figure muft be defigned, before it be cloathed.

T H E drapery muft not fit too clofe to the parts of the body; but flow about them, and, · as it were, carefs them.

T H E members muft not feem to be broken by folds too ftrongly fhaded. .

, T H E folds muft be great· and few, as far as the nature of the ftuff will admit.

T H E folds muft contrafte one another, and alfo contrafte the members.

T H E folds, on many occafions, give life to the action of a figure.

A N Y great vacancies in draperies muft be filled up with well adapted folds.

M A S T E R S may fhew practical folds; but, for perfection's fake, we fhould always confult the life.

D R A P E R I E S fet on little laymen may be ufeful, but they are falfifying. ·

F L Y I N G draperies are proper only in open places, or where the figure is in great· motion.

· T o o much ftuff in a drapery encumbers the figure. C H A N C E

CHANCE often creates fuch beauties in the cafting of draperies, as art could not forefee.

PAINTERS are much obliged to the antient fculptors for the art of cafting draperies; but the ufe which either makes of them, is very different.

Of the Diverfity of Stuffs.

IT caufes a diverfity of folds.

IT delights the eye.

IT ought to be generally practifed, as well in a fingle figure as among many, efpecially to fhew the different ages, fexes, and conditions of figures.

THE *Roman* painters, and thofe who paint practically, are ufually guilty of repeating the fame ftuffs.

Of the Variety of Colouring in Stuffs.

IT gives a picture harmony.

IT characterizes the objects.

IT fhews the *claro-obfcuro.*

RAPHAEL is the beft copy for the order of folds.

THE *Venetian* and *Flemifh* fchools are beft for the diverfity of ftuffs. And

PAOLO VERONESE, for the harmonious variety of their colouring.

O F

OF
LANDSKIP.

LANDSKIP is a kind of painting that reprefents the fields, and all the objects that belong to them. Among all the pleafures which the different talents of painting afford to thofe who employ them, that of drawing landfkips feems to me the moft affecting, and moft convenient ; for, by the great variety, of which it is fufceptible, the painter has more opportunities, than in any of the other parts, to pleafe himfelf by the choice of his objects. The folitude of rocks, frefhnefs of forefts, clearnefs of waters, and their feeming murmurs, extenfivenefs of plains and offfkips, mixtures of trees, firmnefs of verdure, and a fine general fcene or opening, make the painter imagine himfelf either a hunting, or taking the air, or walking, or fitting, and giving himfelf up to agreeable mufings. In a word, he may here difpofe of all things to his pleafure, whether upon land, or in water, or in the fky, becaufe there is not

any

any production either of art or nature, which may not be brought into such a picture. Thus painting, which is a kind of creation, is more particularly so with regard to landskip.

AMONG the many different styles of landskip, I shall confine my self to two ; *the heroick,* and *the pastoral* or *rural* ; for all other styles are but mixtures of these.

THE heroick style is a composition of objects, which, in their kinds, draw, both from art and nature, every thing that is great and extraordinary in either. The situations are perfectly agreeable and surprising. The only buildings, are temples, pyramids, antient places of burial, altars consecrated to the divinities, pleasure-houses of regular architecture: And if nature appear not there, as we every day casually see her, she is at least represented as we think she ought to be. This style is an agreeable illusion, and a sort of inchantment, when handled by a man of fine genius, and good understanding, as *Poussin* was, who has so happily expressed it. But if, in the course of this style, the painter has not talent enough to maintain the sublime, he is often in danger of falling into the childish manner.

THE *rural style* is a representation of countries, rather abandoned to the caprice of nature than cultivated: We there see nature simple, without ornament, and with-
out

out artifice ; but with all thofe graces with which fhe adorns herfelf much more, when left' to herfelf, than when conftrained by art.

I n' this ftyle, fituations bear all forts of varieties : Sometimes they are very extenfive and open, to contain the flocks of the fhep- herds ; at others, very wild, for the retreat of folitary perfons, and a cover for wild beafts.'

I t 'rarely happens, that a painter has a genius extenfive enough to embrace all the parts of painting : there is commonly fome one part that pre-engages our choice, and'fo fills our mind, that we forget the pains that are due to the other parts; and we feldom fail to fee, that thofe whofe inclination leads them to the *heroick ftyle*, think they have done all, when they have introduced into their compofitions fuch noble objects as will raife the imagination, without ever giving'themfelves the trouble to ftudy the effects of good colouring. Thofe, on the other hand, who practife the paftoral, apply clofely to colouring, in order to reprefent truth more lively. Both thefe ftyles have their fectaries and partifans. Thofe who follow the heroick, fupply by their imagi- nation, what it wants of truth, and they look no farther.

. As a counterbalance to heroick landfkip, I think it would be proper to put into the
paftoral,

paftoral, befides a great character of truth, fome affecting, extraordinary, but probable effect of nature, as was *Titian's* cuftom.

THERE is an infinity of pieces wherein both thefe ftyles happily meet; and which of the two has the afcendant, will appear from what I have juft been obferving of their refpective properties. The chief parts of landfkip are, I think, their openings or fituations, accidents, fkies and clouds, off-fkips and mountains, verdure or turfing, rocks, grounds or lands, terraces, fabricks, waters, fore-grounds, plants, figures and trees: Of all which in their places.

Of Openings or Situations.

THE word *fite*, or fituation, fignifies the view, profpect or opening of a country: It is derived from the *Italian* word *fito*; and our painters have brought it into ufe, either becaufe they were ufed to it in *Italy*, or becaufe, as I think, they found it to be very expreffive.

SITUATIONS ought to be well put to-gether, and fo difengaged in their make, that the conjunction of grounds may not feem to be obftructed, tho' we fhould fee but a part of them.

SITUATIONS are various, and repre-fented according to the country the painter is thinking of: As, either open or clofe,

moun-

4

mountainous or watery, tilled and inhabited, or wild and lonely; or, in fine, variegated by a prudent mixture of fome of thefe. But if the painter be obliged to imitate nature in a flat and regular country, he muft make it agreeable by a good difpofition of the *claro-obfcuro*, and fuch pleafing colouring as may make one foil unite with another.

'T is certain, that extraordinary fituations are very pleafing, and chear the imagination by the novelty and beauty of their makes, even when the local colouring is but moderately performed; becaufe, at worft, fuch pictures are only look'd on as unfinifh'd, and wanting to be completed by fome fkilful hand in colouring: Whereas common fituations and objects require good colouring, and abfolute finifhing, in order to pleafe. It was only by thefe properties, that *Claud Lorrain* has made amends for his infipid choice in moft of his fituations. But in whatever manner that part be executed, one of the beft ways to make it valuable, and even to multiply and vary it without altering its form, is properly to imagine fome ingenious accident in it.

Of Accidents.

A N accident in painting is an obftruction of the fun's light by the interpofition of clouds, in fuch manner, that fome parts of
the

the earth fhall be in light, and others in
fhade, which, according to the motion of
the clouds, fucceed each other, and pro-
duce fuch wonderful effects and changes of
the *claro-obfcuro*, as feem to create fo many
new fituations. This is daily obferved in
nature. And as this newnefs of fituations
is grounded only on the fhapes of the clouds,
and their motions, which are very inconftant
and unequal, it follows, that thefe accidents
are arbitrary; and a painter of genius may
difpofe them to his own advantage, when
he thinks fit to ufe them; for he is not
abfolutely obliged to do it. And there have
been fome able landfkip-painters, who have
never practifed it, either thro' fear or cuftom;
as *Claude Lorrain*, and fome others.

Of the Sky and Clouds.

THE fky, in painters terms, is the ethe-
real part over our heads; but more parti-
cularly the air in which we breathe, and that
where clouds and ftorms are ingendered. Its
colour is blue, growing clearer as it approaches
the earth, becaufe of the interpofition of va-
pours arifing between the eye and the hori-
zon; which, being penetrated by the light,
communicates it to objects in a greater or lefs
degree, as they are more or lefs remote.
 BUT we muft obferve, that this light be-
ing either yellow or reddifh in the evening,

at

at fun-fet, thefe fame objects partake not only of the light, but of the colour : Thus the yellow light, mixing with the blue, which is the natural colour of the fky, alters it, and gives it a tint more or lefs greenifh, as the yellownefs of the light is more or lefs deep.

THIS obfervation is general and infallible; but there is an infinity of particular ones, which the painter muft make upon the natural, with his pencil in his hand, when occafion offers ; for there are very fine and fingular effects appearing in the fky, which it is difficult to make one conceive by phyfical reafons. Who can tell, for example, why we fee, in the bright part of fome clouds, a fine red, when the fource of the light which plays upon them, is a moft lively and diftinguifhing yellow ? Who can account for the different reds feen in different clouds, at the very moment that thefe reds receive the light but in one place ? for thefe colours and furprifing appearances feem to have no relation to the rainbow, a phænomenon for which the philofophers pretend to give folid reafons.

THESE effects are all feen in the evening, when the weather is inclining to change, either before a ftorm, or after it, when it is not quite gone, but has left fome remains of it, to draw our attention.

THE property of clouds is to be thin and airy, both in fhape and colour: their fhapes,

K tho'

tho' infinite, muft be ftudied and chofen after nature, at fuch times as they appear fine. To make them look thin, we ought to make their grounds unite thinly with them, efpecially near their extremities, as if they were tranfparent: And if we would have them thick, their reflections muft be fo managed, as, without deftroying their thinnefs, they may feem to wind and unite, if neceffary, with the clouds that are next to them. Little clouds often difcover a little manner, and feldom have a good effect, unlefs, when being near each other, they feem all together to make but one object.

IN fhort, the character of the fky is to be luminous; and, as it is even the fource of light, every thing that is upon the earth muft yield to it in brightnefs: If however there is any thing that comes near it in light, it muft be waters, and polifh'd bodies, which are fufceptible of luminous reflexions.

BUT, whilft the painter makes the fky luminous, he muft not reprefent it always fhining throughout.

ON the contrary, he muft contrive his light fo, that the greateft part of it may fall only upon one place; and, to make it more apparent, he muft take as much care as poffible to put it in oppofition to fome terreftrial object, that may render it more lively, by its dark colour; as a tree, tower, or fome other building, that is a little high.

THIS

THIS principal *light* might alſo be heightened by a certain diſpoſition of clouds having a ſuppoſed light, or a light ingeniouſly incloſed between clouds, whoſe ſweet obſcurity ſpreads itſelf by little and little, on all hands. We have a great many examples of this in the *Flemiſh* ſchool, which beſt underſtood landſkip; as *Paul Bril, Brugel, Saveri* : And the *Sadelers* and *Merian*'s prints give a clear idea of it, and wonderfully awaken the genius of thoſe who have the principles of the *claro-obſcuro.*

Of Off-ſkips and Mountains.

OFF-SKIPS have a near affinity with the ſky; it is the ſky which determines either the force or faintneſs of them : They are darkeſt when the ſky is moſt loaded, and brighteſt when it is moſt clear. They ſometimes intermix their ſhapes and lights; and there are times, and countries, where the clouds paſs between the mountains, whoſe tops riſe and appear above them. Mountains that are high, and covered with ſnow, are very proper to produce extraordinary effects in the off-ſkip, which are advantageous to the painter, and pleaſing to the ſpectator.

THE diſpoſition of off-ſkips is arbitrary; let them only agree with the *whole together* of the picture, and the nature of the country we would repreſent. They are uſually blue,

K 2 be-

becaufe of the interpofition of air between
them and the eye: But they lofe this colour
by degrees, as they come nearer the eye, and
fo take that which is natural to the objects.

In diftancing mountains, we muft ob-
ferve to join them infenfibly by the *roundings
off*, which the reflections make probable;
and muft, among other things, avoid a cer-
tain edginefs in their extremities, which
makes them appear in flices, as if cut with
fciffors, and ftuck upon the cloth.

We muft further obferve, that the air,
at the feet of mountains, being charged
with vapours, is more fufceptible of light
than at their tops. In this cafe, I fuppofe
the main light to be fet reafonably high,
and to enlighten the mountains equally, or
that the clouds deprive them of the light of
the fun. But if we fuppofe the main light
to be very low, and to ftrike the mountains;
then their tops will be ftrongly enlighten'd,
as well as every thing elfe in the fame de-
gree of light.

Tho' the forms of things diminifh in
bignefs, and colours lofe their ftrength, in
proportion as they recede from the firft plan,
of the picture, to the moft remote off-
fkip; as we obferve in nature and common
practice; yet this does not exclude the ufe
of the accidents. Thefe contribute greatly
to the wonderful in landfkip, when they are
properly introduced, and when the artift has
a juft idea of their good effects. *Of*

Of Verdure, or Turfing.

I CALL turfing, the greenneſs with which the herbs colour the ground : This is done ſeveral ways ; and the diverſity proceeds not only from the nature of plants, which, for the moſt part, have their particular verdures, but alſo from the change of ſeaſons, and the colour of the earth, when the herbs are but thin ſown. By this variety, a painter may chuſe or unite, in the ſame tract of land, ſeveral ſorts of greens intermixed and blended together, which are often of great ſervice to thoſe who know how to uſe them ; becauſe this diverſity of greens, as it is often found in nature, gives a character of truth to thoſe parts, where it is properly uſed. There is a wonderful example of this part of landſkip, in the view of *Mechlin*, by *Rubens*.

Of Rocks.

THOUGH rocks have all ſorts of ſhapes, and participate of all colours, yet there are, in their diverſity, certain characters which cannot be well expreſſed without having recourſe to nature. Some are in banks, and ſet off with beds of ſhrubs ; others in huge blocks, either projecting or falling back ; others conſiſt of large broken parts, conti

guous

guous to each other; and others, in fhort,
of an enormous fize, all in one ftone, either
naturally, as free-ftone, or elfe through the
injuries of time, which in the courfe of many
ages has worn away their marks of feparation.
But, whatever their form be, they are ufually
fet out with clefts, breaks, hollows, bufhes,
mofs, and the ftains of time; and thefe par-
ticulars, well managed, create a certain idea
of truth.

ROCKS are of themfelves gloomy, and
only proper for folitudes; but, where accom-
panied with bufhes, they infpire a frefh air;
and, when they have waters, either pro-
ceeding from, or wafhing them, they give
an infinite pleafure, and feem to have a foul
which animates them, and makes them fo-
ciable.

Of Grounds or Lands.

A GROUND or land, in painters terms,
is a certain diftinct piece of land, which is
neither too woody nor hilly. Grounds con-
tribute, more than any thing, to the gra-
dation and diftancing of landfkip; becaufe
they follow one another, either in fhape, or
in the *claro-obfcuro*, or in their variety of
colouring, or by fome infenfible conjunction
of one to another.

MULTIPLICITY of grounds, though it
be often contrary to grand manner, does not
quite

quite deſtroy it; for, beſides the extent of country which it exhibits, 'tis ſuſceptible of the accidents we have mentioned, and which, with good management, have a fine effect.

THERE, is one nicety to be obſerved in grounds, which 'is, that in order to characterize them well, care muſt be taken, that the trees in them have a different verdure and different colours from thoſe grounds; though this difference, withal, muſt not be too apparent.

Of Terraces.

A TERRACE, in painting, is a piece of ground, either quite naked, or having very little herbage, like great roads and places often frequented. They are of uſe chiefly in the foregrounds of a picture, where they ought to be very ſpacious and open, and accompanied, if we think fit, with ſome accidental verdure, and alſo with ſome ſtones, which, if placed with judgment, give a terrace a greater air of probability.

Of Buildings.

PAINTERS mean by buildings any ſtructures they generally repreſent, but chiefly ſuch as are of a regular architecture, or at leaſt are moſt conſpicuous. Thus building is not ſo proper a name for the houſes of

K 4　　　country-

country-people, or the cottages of ſhepherds,
which are introduced into the rural taſte, as
for regular and ſhowy edifices, which are
always brought into the heroick.

BUILDINGS in general are a great orna-
ment in landſkip, even when they are
Gothick, or appear partly inhabited, and
partly ruinous : they raiſe the imagination
by the uſe they are thought to be deſigned
for ; as appears from antient towers, which
ſeem to have been the habitations of fairies,
and are now retreats for ſhepherds and owls.

POUSSIN has very elegantly handled the
Roman manner of architecture in his works,
as *Bourdon* has done the *Gothick*; which,
however *Gothick*, fails not to give a ſub-
lime air to his landſkips. *Little Bernard*
has introduced into his ſacred ſtory, what I
may call a *Babylonian* manner; which, ex-
traordinary as it is, has its grandeur and mag-
nificence. I would not quite reject ſuch
pieces of architecture; they raiſe the ima-
gination, and I am perſuaded, they would
ſucceed in the heroick ſtyle, if they were
placed among half-diſtant objects, and if
we knew how to uſe them properly.

Of Waters.

MUCH of the ſpirit of landſkip is owing
to the waters which are introduced in it.
They appear in divers manners ; ſometimes
impetuous,

impetuous, as when a ftorm makes them
overflow their banks ; at other times re-
bounding, as by the fall of a rock ; at other
times through unufual preffure, gufhing out
and dividing into an infinity of filver ftreams,
whofe motion and murmuring agreeably de-
ceive thoth the eye and ear ; at other times
calm and purling in a fandy bed ; at other
times fo ftill and ftanding, as to become a
faithful looking-glafs, which doubles all the
objects that are oppofite to it ; and, in this
ftate, they have more life than in the moft
violent agitation. Confult *Bourdon*'s works,
or at leaft his prints, on this fubject : he is
one of thofe who have treated of waters
with the greateft fpirit, and beft genius.

WATERS are not proper for every fitu-
ation : But, to exprefs them well, the artift
ought to be perfect mafter of the exactnefs
of watry reflexions ; becaufe they only
make painted water appear as real : For
practice alone, without exactnefs, deftroys
the effect, and abates of the pleafure of the
eye. The rule for thefe reflexions is very
eafy, and therefore the painter is the lefs
pardonable for neglecting it.

BUT it muft be obferved, that tho' water
be as a looking-glafs, yet it does not faith-
fully reprefent objects, but when 'tis ftill ;
for if it be in any motion, either in a natural
courfe, or by the driving of the wind, its
furface, becoming uneven, receives, on its
furges,

furges, fuch lights and fhades, as, mixing
with the appearance of the objects, con-
found both their fhapes and colours.

Of the Foreground of a Picture.

A S it is the part of the foreground to
ufher the eye into the piece, great care muft
be taken, that the eye meet with good re-
ception; fometimes by the opening of a
fine terrace, whofe defign and workmanfhip
may be equally curious; at other times, by
variety of well diftinguifhed plants, and thofe
fometimes flowered; at other times, by
figures in a lively tafte, or other objects,
either admirable for their novelty, or intro-
duced, as by chance.

IN a word, the artift cannot too much
ftudy his foreground objects, fince they at-
tract the eye, imprefs the firft character of
truth, and greatly contribute to make the
artifice of a picture fuccefsful, and to anti-
cipate our efteem for the whole work.

I AM fenfible, that there are very fine
landfkips, with foregrounds, appearing to be
well chofen, and carrying a great idea, but
which are, neverthelefs, very flightly fi-
nifhed: I own, indeed, that this flightnefs
ought to be pardoned, when it is ingenious,
when it fuits with the nature of the ground,
and bears the character of truth: But it
muft be owned likewife, that this effect is
very

very rare, and that it is to be feared, left this flight working fhould give fome idea of poverty, or of too great negligence : So that in whatever manner the foregrounds of a picture be difpofed, I would have the artift prefcribe it as a law to himfelf, to finifh them with fkill, and accurate workmanfhip.

Of Plants.

PLANTS are not always neceffary in foregrounds, becaufe, as we have obferved, there are feveral ways of making thofe grounds agreeable. But, if we refolve to draw plants there, we ought to paint them exactly after the life ; or, at leaft, among fuch as we paint practically, there ought to be fome more finifhed than the reft, and whofe kinds may be diftinguifhed by the difference of defign and colouring, to the end, that, by a probable fuppofition, they may give the others a character of truth. What has been faid here of plants, may be applied to the branches and barks of trees.

Of Figures.

IN compofing landfkip, the artift may have intended to give it a character agreeable to the fubject he has chofen, and which his figures ought to reprefent. He may alfo, and it commonly happens, have only thought

of

of his figures, after finishing his landskip : The truth is, the figures, in most landskips, are made rather to accompany than to suit them.

I KNOW there are landskips so disposed and situated, as to require only passing figures; which several good masters, each in his style, have introduced, as *Poussin* in the heroick, and *Fouquier* in the rural, with all possible probability and grace : I know also, that resting figures have been made to appear inwardly active. And these two different ways of treating figures are not to be blamed, because they act equally, though in a different manner. It is rather inaction that ought to be blamed in figures; for in this condition, which robs them of all connexion with the landskip, they appear to be pasted on. But, without obstructing the painter's liberty in this respect, I am persuaded, that the best way to make figures valuable is; to make them so to agree with the character of the landskip, that it may seem to have been made purely for the figures. I would not have them either insipid or indifferent, but to represent some little subject to awaken the spectator's attention, or else to give the picture a name of distinction among the curious.

GREAT care must be taken to proportion the size of the figures to the bigness of the trees, and other objects of the landskip : If
they

they be too large, the picture will difcover
a little manner; and, if too fmall, they will
have the air of pygmies, which will deftroy
the worth of them, and make the landskip
look enormous. There is, however, a greater
inconvenience in making figures too large,
than too fmall; becaufe the latter at leaft
gives an air of greatnefs to all the reft. But
as landskip figures are generally fmall, they
muft be touch'd with fpirit, and fuch lively
colours as will attract, and yet preferve pro-
bability, and a general union. The artift
muft, in fine, remember, that as the figures
chiefly give life to a landskip, they muft be
difperfed as conveniently as poffible.

Of Trees.

I ALWAYS thought, that the beauty of
trees was one of the greateft ornaments of
landskip; becaufe of the variety of their
kinds, and their frefhnefs, but chiefly their
lightnefs, which makes them feem, as being
expofed to the air, to be always in motion.

THOUGH diverfity be pleafing in all the
objects of landskip, 'tis chiefly in trees that it
fhews its greateft beauty. Landskip confiders
both their kinds, and their forms. Their kinds
require the painter's particular ftudy and
attention, in order to diftinguifh them from
each other; for we muft be able at firft fight
to difcover which are oaks, elms, firs, fy-
<div align="right">camores,</div>

camores, poplars, willows, pines, and other
fuch trees, which, by a fpecifick colour, or
touching, are diftinguifhable from all other
kinds. This ftudy is too large to be required
in all its extent; and, indeed, few painters
have attained fuch a competent exactnefs in
it as their art requires. But it is evident,
that thofe who come neareft to perfection in
it, will make their works infinitely pleafing,
and gain a great name.

BESIDES the variety which is found in
each kind of tree, there is in all trees a ge-
neral variety. This is obferved in the dif-
ferent manners in which their branches are
difpofed by a fport of nature, which takes
delight in making fome very vigorous and
thick, others more dry and thin ; fome more
green, others more red or yellow. The ex-
cellence of practice lies in the mixture of
thefe varieties : But if the artift can diftin-
guifh the forts but indifferently, he ought at
leaft to vary their makes and colours ; be-
caufe repetition in landskip is as tirefome
to the eye, as monotony in difcourfe is to
the ear.

THE variety of their makes is fo great,
that the painter would be inexcufable not to
put it in practice upon occafion, efpecially
when he finds it neceffary fo awaken the
fpectator's attention ; for, among trees, we
difcover the young and the old, the open
and clofe, tapering and fquat, bending up-
wards

wards and downwards, ſtooping and ſhoot-
ing : In ſhort, the variety is rather to be
conceived than expreſſed. For inſtance, the
character of young trees is, to have long
ſlender branches, few in number, but well
ſet out; boughs well divided, and the foliage
vigorous and well ſhaped : Whereas in old
trees, the branches are ſhort, ſtocky, thick,
and numerous ; the tufts blunt, and the
foliage unequal and ill ſhaped : But a little
obſervation and genius will make us perfectly
ſenſible of theſe particulars.

In the various makes of trees, there muſt
alſo be a diſtribution of branches, that has a
juſt relation to, and probable connexion with,
the boughs or tufts, ſo as mutually to aſſiſt
each other in giving the tree an appearance
of thickneſs and of truth. But, whatever
their natures or manners of branching be,
let it be remembred, that the handling muſt
be lively and thin, in order to preſerve the
ſpirit of their characters.

Trees likewiſe vary in their barks,
which are commonly grey ; but this grey,
which in thick air, and low and marſhy
places, looks blackiſh, appears lighter in a
clear air : And it often happens, in dry
places, that the bark gathers a thin moſs,
which makes it look quite yellow ; ſo that,
to make the bark of a tree apparent, the
painter may ſuppoſe it to be light upon a
dark ground, and dark on a light one.

THE

THE obfervation of the different barks merits a particular attention ; for it will appear, that, in hard woods, age chaps them, and thereby gives them a fort of embroidery; and that, in proportion as they grow old, thefe chaps grow more deep. Any other accidents in barks may arife either from moifture, or drinefs, or green moffes, or white ftains of feveral trees.

THE barks of white woods will alfo afford much matter for practice, if their diverfity be duly ftudied : And this confideration leads me to fay fomething of the ftudy of landfkip, which I will do according to my own notion of it, without pretending to prefcribe my fentiments to others.

Of the Study of Landfkip.

THE ftudy of landfkip may be confidered either with refpect to beginners, or to thofe who have made fome advances in it.

BEGINNERS will find, in practice, that the chief trouble of landfkip lies in handling trees ; and it is not only in practice methinks, but alfo in fpeculation, that trees are the moft difficult part of landfkip, as they are its greateft ornament. But it is only propofed here, to give beginners an idea of trees in general, and to fhew them how to exprefs them well. It would be needlefs to point out to them the common effects of trees

and

5

and plants, becaufe they are obvious to every
one, yet there are fome things, which, tho'
not unknown, deferve our reflection. We
know, for inftance, that all trees require air,
fome more, fome lefs, as the chief caufe of
their vegetation and productions ; and for this
reafon all trees (except the cyprefs, and
fome others of the fame kind) feparate in
their growth from one another, and from
other ftrange bodies as much as poffible, and
their branches and foliage do the fame :
Wherefore, to give them that air and thin-
nefs, which is their principal character, the
branches, boughs, and foliage, muft appear
to fly from each other, to proceed from op-
pofite parts, and be well divided. And all
this without order ; as if chance aided na-
ture in the fanciful diverfity. But to fay
particularly how thefe trunks, branches, and
foliages, ought to be diftributed, would
be needlefs, and only a defcription of
the works of great mafters : a little re-
flection on nature will be of more fervice
than all I can fay on this head. By great
mafters, I mean, fuch as have publifhed
prints ; for thofe will give better ideas to
young copyifts, than even the paintings
themfelves.

AMONG the many great mafters of all
fchools, I prefer *Titian's* wooden prints, where
the trees are well-fhaped ; and thofe which
Cornelius Cort, and *Agoftino Carracche*, have

<div align="center">L</div>

engraved.

engraved. And I fay again, that beginners can
do no better than contract, above all things,
an habit of imitating the touches of thefe
great mafters, and of confidering, at the fame
time, the perfpective of the branches and
foliages, and obferving how they appear,
either when rifing, and feen from below; or
when finking, and feen from above; or
when fronting, and viewed from a point; or
when they appear in profile; and, in a word,
when fet in the various views which nature
prefents them in, without altering their
characters.

AFTER having ftudied and copied, with
the pen or crayon, firft the prints, and then
the defigns, of *Titian* and *Carracche*, the ftu-
dent fhould imitate with the pencil thofe
touches which they have moft diftinctly
fpecified, if their paintings can be procured;
but fince they are fcarce, others fhould be
got which have a good character for their
touching; as thofe of *Fouquier*, who is a
moft excellent model: *Paul Bril, Breugel,*
and *Bourdon*, are alfo very good; their
touching is neat, lively, and thin.

AFTER having duly weighed the nature
of trees, their fpread and order, and the
difpofition of their branches, the artift muft
get a lively idea of them, in order to keep
up the fpirit of them throughout, either by
making them apparent and diftinct in the
fore-

fore-grounds, or obfcure and confufed in proportion to their diftance.

AFTER having thus gained fome knowledge in good manner, it will next be proper to ftudy after nature, and to chufe and rectify it, according to the idea which the aforefaid great mafters had of it. As to perfection, it can only be expected from long practice and perfeverance. This, methinks, is what concerns thofe, who, having an inclination for landfkip, would take the proper methods for beginning it well.

As for thofe who have made fome advances in this part of painting, it is proper they fhould collect the neceffary materials for their further improvement, and ftudy thofe objects at leaft, which they fhall have moft frequent occafion to reprefent.

PAINTERS ufually comprife, under the word *ftudy*, any thing whatever, which they either defign or paint feparately, after the life; whether figures, heads, feet, hands, draperies, animals, mountains, trees, plants, flowers, fruits, or whatever may confirm them in the juft imitation of nature : The drawing of thefe things, I fay, is what they call *ftudy* ; whether they be for inftruction in defign, or only to affure them of the truth, and to perfect their work. Be it as it will, this word *ftudy* is the more properly ufed by painters, as in the diverfity of

nature

nature they are daily making new difcoveries, and confirming themfelves in what they already know:

As the landfkip-painter need only ftudy fuch objects as are to be met with in the country, I would recommend to him fome order, that his drawings may be always at hand when he wants them. I could wifh, for inftance, that he copied after nature, on feparate papers, the different effects of trees in general, and the different effects of each kind in particular, with their trunks, foliage, and colours. I would have him alfo take the fame method with fome forts of plants; becaufe their variety is a great ornament to terraces on fore-grounds.

I WOULD have him likewife ftudy the effects of the fky in the feveral times of the day, and feafons of the year, in the various difpofitions of clouds, both in ferene, thundering, and ftormy weather. And in the off-skip, the feveral forts of rocks, waters, and other principal objects.

THESE drawings, which may be made at times, fhould be collected together; and all that relate to one matter, be put into a book, to which the artift may have recourfe at any time for what he wants.

Now, if the fine effects of nature, whether in fhape or colour, whether for an intire picture, or a part of one, be the artift's ftudy, and if the difficulty lies in chufing
those

thofe effects well, he muft for this purpofe
be born with good fenfe, good tafte, and a
fine genius ; and this genius muft be culti-
vated by the obfervations which ought to be
made on the works of the beft mafters,
how they chofe nature, and how, while
they corrected her, according to their art,
they preferved her character. With thefe
advantages, derived from nature, and per-
fected by art, the painter can't fail to make
a good choice ; and, by diftinguifhing be-
tween the good and the bad, muft needs
find great inftruction, even from the moft
common things.

To improve themfelves in this kind of
ftudies, painters have taken feveral methods:
And, I believe, it will not be here imper-
tinent to mention thofe I have feen practifed,
and of which I myfelf have fome experi-
ence.

THERE are fome artifts who have de-
figned after nature, and in the open fields ;
and have there quite finifhed thofe parts,
which they had chofen, but without adding
any colour to them.

OTHERS have drawn, in oil-colours,
in a middle tint, on ftrong paper ; and found
this method convenient, becaufe, the colours
finking, they could put colour on colour,
tho' different from each other. For this
purpofe they took with them a flat box,
which commodioufly held their pallet, pen-

cils, oil, and colours. This method, which indeed requires several implements, is doubt-less the best for drawing nature more particularly, and with greater exactness, especially if, after the work be dry and varnish'd, the artist return to the place where he drew, and retouch the principal things after nature.

OTHERS have only drawn the out-lines of objects, and flightly wash'd them in colours near the life, for the ease of their memory. Others have attentively observed such parts as they had a mind to retain, and contented themselves with committing them to their memory, which upon occasion gave them a faithful account of them. Others have made drawings in pastil and wash together. Others, with more curiosity and patience, have gone several times to the places which were to their taste : The first time they only made choice of the parts, and drew them correctly ; and the other times were spent in observing the variety of colouring, and its alterations through change of light.

Now these several methods are very good, and each may be practised as best suits the student and his temper : But they require the necessaries of painting, as colours, pencils, pastils, and leisure. Nature, however, at certain times, presents extraordinary, but transient beauties, and such as can be of no service to the artist, who has not as much time as is necessary to imitate what he ad-mires.

mires. The beft way, I think, to make
advantage of fuch momentary ccafions, is
this :

T H E painter being provided with a
quire of paper, and a black lead pencil,
let him quickly, but flightly, defign what
he fees extraordinary ; and, to remember
the colouring, let him mark the princi-
pal parts with characters, which he may
explain at the bottom of the paper, as far as
is neceffary for himfelf to underftand them:
A cloud, for inftance, may be mark'd *A*,
another cloud *B*, a light *C*, a mountain *D*,
a terrace *E*, and fo on. And having re-
peated thefe letters at the bottom of the
paper, let him write againft each, that 'tis
of fuch or fuch a colour ; or for greater bre-
vity, only *blue, red, violet, grey*, &c. or
any other fhorter abbreviation. After this
he muft go to painting as foon as poffible ;
otherwife moft of what he has obferved will,
in a little time, flip out of his memory.
This method is the more ufeful, as it not
only prevents our lofing an infinity of fud-
den and tranfitory beauties, but alfo helps,
by means of the aforefaid marks and cha-
racters, to perfect the other methods I have
mentioned.

I F it be afk'd, Which is the propereft
time for thefe ftudies ? I anfwer, that na-
ture fhould be ftudied at all times, becaufe
fhe is to be reprefented at all feafons ; but

autumn yields the moſt plentiful harveſt for her fine effects : the mildneſs of that ſeaſon, the beauty of the ſky, the richneſs of the earth, and the variety of objects, are powerful inducements with the painter, to make the proper inquiries for improving his genius, and perfecting his art.

B u t as we cannot ſee nor obſerve every thing, 'tis very commendable to make uſe of other mens ſtudies, and to look upon them as if they were our own. *Raphael* ſent ſome young men into *Greece*, to deſign ſuch things as he thought would be of ſervice to him, and accordingly made uſe of them to as good purpoſe as if he himſelf had deſigned them on the ſpot : For this, *Raphael* is ſo far from deſerving cenſure, that he ought, on the contrary, to be commended ; as an example, that painters ought to leave no way untried for improving in their profeſſions. The landſkip-painter may accordingly make uſe of the works of all thoſe who have excelled in any kind, in order to acquire a good manner ; like the bees, which gather their variety of honey from flowers.

General

General Remarks on LANDSKIP.

AS the general rules of painting are the bafis of all the feveral kinds of it, we muſt refer the landſkip-painter to them, or rather, fuppofe him to be well acquainted with them. We ſhall here only make fome general remarks on this kind of painting.

1. LANDSKIP fuppofes the knowledge and practice of the principal rules in *perſpective*, in order to maintain probability.

2. THE nigher the leaves of trees are to the earth, the larger they are, and the greener ; as being apteſt to receive, in abundance, the fap which nouriſhes them : and the upper branches begin firſt to take the rednefs or yellownefs which colours them in autumn. But 'tis otherwife in plants ; for their ſtocks renew all the year round, and their leaves fucceed one another, at a confiderable diſtance of time, infomuch that nature, employed in producing new leaves to adorn the ſtock as it rifes, does by degrees defert the under ones ; which, having firſt performed their office, are the firſt that die : But this effect is more vifible in fome than others.

3. THE under parts of all leaves are of a brighter green than the upper, and almoſt
always

always incline to the filverifh ; and thofe
which are wind-fhaken are known from
others by that colour : But if we view them
from beneath, when penetrated by the fun's
rays, they difcover fuch a fine and lively
green as is far beyond all comparifon.

4. T H E R E are five principal things which
give fpirit to landfkip, *to wit*, figures, ani-
mals, waters, wind-fhaken trees, and thin-
nefs of pencilling ; to which add fmoke,
when there's occafion to introduce it.

5. W H E N one colour predominates
throughout a landskip, as one green in
fpring, or one red in autumn, the piece
will look either as of one colour, or
elfe as unfinifh'd. I have feen many of
Bourdon's landskips, which, by handling
the corn one way throughout, have loft
much of their beauty, tho' the fituations
and waters were very pleafant. The ingeni-
ous painter muft endeavour to correct, and,
as they fay, redeem the harfh unfightly
colouring of winter and fpring by means of
figures, waters, and buildings ; for fummer
and autumn fubjects are of themfelves ca-
pable of great variety.

6. T I T I A N and *Carracche* are the beft
models for infpiring good tafte, and leading
the painter into a good track, with regard
to forms and colours. He muft ufe all his
efforts to gain a juft idea of the principles
 which

which thofe great men have left us in their
works; and to have his imagination filled
with them, if he would advance by degrees
towards that perfection, which the artift
fhould always have in view.

7. THE landfkips of thefe two mafters
teach us a great many things, of which dif-
courfe can give us no exact idea, nor any
general principle. Which way, for example,
can the meafures of trees in general be deter-
mined, as we determine thofe of the human
body? The tree has no fettled proportions;
moft of its beauty lies in the contraft of its
branches, an unequal diftribution of boughs,
and, in fhort, a kind of whimfical variety,
which nature delights in, and of which the
painter becomes a judge, when he has tho-
roughly relifhed the works of the two
mafters aforefaid. But, I muft fay, in *Ti-
tian*'s praife, that the path he ftruck out is
the fureft; becaufe he has exactly imitated
nature in its variety with an exquifite tafte,
and fine colouring: Whereas *Carraache*, tho'
an able artift, has not, more than others,
been free from manner in his landfkip.

8. ONE of the greateft perfections of
landfkip, in the variety it reprefents, is a
faithful imitation of each particular cha-
racter: As its greateft fault is, a licentious
practice, which brings us to do things by
rote.

9. AMONG

9. A M O N G thofe things which are painted practically, we ought to intermix fome done after nature, to induce the fpectator to believe, that all are fo.

10. A s there are ftyles of thought, fo there are alfo ftyles of execution. I have handled the two relating to thought, *to wit*, the heroick and paftoral; and find that there are two alfo with regard to execution, *to wit*, the firm ftyle, and the polifhed; thefe two concern the pencil, and the more or lefs ingenious way of conducting it. The firm ftyle gives life to work, and excufes for bad choice; and the polifhed finifhes and brightens every thing; it leaves no employment for the fpectator's imagination, which pleafes itfelf in difcovering and finifhing things which it afcribes to the artift, though, in fact, they proceed only from itfelf. The polifhed ftyle degenerates into the foft and dull, if not fupported by a good opening or fituation; but when thofe two characters meet, the picture is fine.

11. H A V I N G thus taken a furvey of the principal parts of landfkip, having fpoken of the ftudy proper for it, and made fome general remarks on this kind of painting; I queftion not but feveral readers, that this work may be made lefs defective, wifh me to fay fomething of the practice and ufe of colours. But as every man has his own

particular

particular practice, and the ufe of colours comprehends a part of the fecrets in painting; we muft expect a minute account of them only from the friendfhip and converfation of the ableft painters, and join their opinions to our own experience.

OF

O F

PORTRAITURE.

IF painting be an imitation of nature, 'tis doubly so in a portrait; which not only reprefents a man in general, but fuch an one as may be diftinguifhed from all others. And as the greateft perfection of a portrait is extreme likenefs, fo the greateft of its faults is to refemble a perfon for whom it was not made; fince there are not in the world two perfons quite like one another. But before we proceed to the particulars which let us into the knowledge of this imitation, 'tis neceffary, for fhortening this difcourfe, to take a view of fome general propofitions, which are preparatory to what I am going to fay, and will make amends for what I fhall omit.

I.

IMITATION is the effence of painting, and good choice is to this effence what the virtues are to a man; they raife the value of it. For this reafon, 'tis extremely the painter's intereft to chufe none but good heads, or favourable moments for drawing them,

them, and fuch pofitions as may fupply the
want of a fine natural.

II.

There are views of the natural, more
or lefs advantageous ; all depends upon turn-
ing it well, and taking it in the favourable
moment.

III.

There is not a fingle perfon in the world
who has not a peculiar character, both in
body and face.

IV.

Simple and genuine nature is more pro-
per for imitation, and is a better choice, than
nature much formed, and embellifhed too
artificially.

V.

To adorn nature too much is doing it a
violence ; and the action which attends it
can never be free, when its ornaments are
not eafy. In fhort, in proportion as we
adorn nature, we make it degenerate from
itfelf, and bring it down to art.

VI.

Some means are more advantageous than
others, to come to the fame end.

VII.

We muft not only imitate what we do
fee in nature, but alfo what we may poffibly
fee, that is advantageous in art.

VIII.

VIII.

THINGS are valuable by comparifon; and it is only by this we are enabled to make a right judgment of them.

IX.

PAINTERS eafily accuftom themfelves, to their own tints, and the manner of their mafters: And after this habit is rooted in them, they view nature not as fhe really is, but as they are ufed to paint her.

X.

'TIS very difficult to make a picture, the figures of which are as big as the life, to have its effect near, as at a diftance. A learned picture pleafes the ignorant only when it is at fome diftance; but judges will admire its artifice near, and its effect at a diftance.

XI.

KNOWLEDGE makes work pleafant and eafy. The traveller who knows his road, comes to his journey's end with more fpeed and certainty than he who inquires, and gropes it out.

XII.

'TIS proper, before we begin a work, to meditate upon it, and to make a nice colour'd fketch of it, for our own fatisfaction, and an help to the memory.

WE cannot too much reflect on thefe propofitions; and it is neceffary to be fo well acquainted with them, that they may

prefent

prefent themfelves to our mind, of their own accord, without our being at the trouble to recal them to our memory, when we are at work.

There are four things neceffary to make a portrait perfect; air, colouring, attitude, and drefs.

1. *Of Air.*

THE air refpects the lines of the face, the head-attire, and the fize.

The lines of the face depend upon exactnefs of draught, and agreement of the parts; which all together muft reprefent the phyfiognomy of the perfon painted, in fuch manner, that the picture of his body may feem to be alfo that of his mind.

It is not exactnefs of defign in portraits, that gives fpirit and true air, fo much as the agreement of the parts at the very moment when the difpofition and temperament of the fitter are to be hit off. We fee feveral portraits, which, though correctly defigned, have a cold, languifhing, and ftupid air; whilft others, lefs correct in defign, ftrike us however, at firft fight, with the fitter's character.

Few painters have been careful enough to put the parts well together: Sometimes the mouth is fmiling, and the eyes are fad; at other times, the eyes are chearful, and the cheeks lank; by which means their work

M has

has a falfe air, and looks unnatural. We ought therefore to mind, that, when the fitter puts on a fmiling air, the eyes clofe, the corners of the mouth draw up towards the noftrils, the cheeks fwell, and the eyebrows widen : But in a melancholy air thefe parts have a contrary effect.

THE eyebrows, being raifed, give a grave and noble air ; but if arch'd, an air of aftonifhment.

OF all the parts of the face, that which contributes moft to likenefs is the nofe ; 'tis therefore of great moment to fet and draw it well.

THOUGH the hair of the head feem to be part of the drefs, which is capable of various forms, without altering the air of the face; yet the head-attire, which one has been moft accuftomed to, creates fuch a likenefs, that we fcarce know a familiar acquaintance on his putting on a periwig fomewhat different from that which he ufed to wear. 'Tis neceffary, therefore, as far as poffible, to take the air of the head-ornament, and make it accompany and fet off that of the face, if there be no reafon to the contrary.

AS to the ftature, it contributes fo much to likenefs, that we very often know people without feeing their face ; 'tis therefore extremely proper to draw the fize after the fitter himfelf, and in fuch an attitude as we

think

think fit; which was *Vandyke's* method. Here let us remark, that, in fitting, the perfon appears to be of a lefs free make, through the heaving of his fhoulders; wherefore, to adjuft his fize, 'tis proper to make him ftand for a fmall time, fwaying in the pofture we would give him, and then make our obfervation. But here occurs a difficulty, which I fhall endeavour to examine:

Whether 'tis proper, in Portraiture, to correct the Defects of Nature.

LIKENESS being the effence of portraiture, it would feem, that we ought to imitate defects as well as beauties, fince by this means the imitation will be more complete: It would be even hard to prove the contrary, to one who would undertake the defence of this pofition. But ladies and gentlemen do not much approve of thofe painters who entertain fuch fentiments, and put them in practice. I have known ladies frankly own, that they had no value for a painter who made a ftrong likenefs; and that they had rather their pictures had much lefs refemblance, and more beauty. It is certain, that fome complaifance, in this refpect, is due to them; and I queftion not, but their pictures may be made to refemble, without difpleafing them: for the effectual likenefs is a juft agreement of the parts that

M 2 are

are painted, with thofe of nature; fo that we may be at no lofs to know the air of the face, and the temper of the perfon, whofe picture is before us. This being laid down, I fay, that all deformities, when the air and temper may be difcovered without them, ought to be either corrected or omitted in womens and young mens portraits. A nofe fomewhat awry may be help'd, or a fhriveled neck, or high fhoulders, adapted to good air, without going from one extreme to another: But this muft be done with great difcretion; for by endeavouring to correct nature too much, we infenfibly fall into a method of giving a general air to all our portraits; juft as, by confining ourfelves too much to the defects and littlenefs of nature, we are in danger of falling into the low and taftelefs manner.

BUT in the faces of heroes, and men of rank, diftinguifhed either by dignities, virtues, or great qualities, we cannot be too exact, whether the parts be beautiful or not: for portraits of fuch perfons are to be ftanding monuments to pofterity; in which cafe, every thing in a picture is precious that is faithful. But after whatever manner the painter acquits himfelf in this point; let him never forget good air nor grace, and that there are, in the natural, advantageous moments for hitting them off.

2. *Of*

2. *Of Colouring*.

COLOURING, in portraiture, is an effufion of nature, difcovering the true tempers of perfons; and the temper being effential to likenefs, it ought to be handled as exactly as the defign. This part is the more valuable, as 'tis rare and difficult to hit. A great many painters have come to a likenefs by ftrokes and outlines; but, certainly, they are few, who have fhewn in colours the tempers of perfons.

Two points are neceffary in colouring; exactnefs of tints, and the art of fetting them off. The former is acquired by practice, in examining and comparing the colours we fee in life, with thofe by which we would imitate it: and the art of thefe tints confifts in knowing what one colour will produce when fet by another, and in making good what either diftance or time may abate of the glow and frefhnefs of the colours.

A PAINTER who does nothing more than what he fees, will never arrive at a perfect imitation; for though his work may feem, on the eafel, to be good to him, it may not appear fo to others, and perhaps even to himfelf, at a diftance. A tint, which, near, appears disjoined, and of one colour, may look of another at a diftance,

M 3 and

and to be confounded in the mafs it belongs
to. If you would have your work, there-
fore, to produce a good effect in the place
where 'tis to hang, both the colours and
lights muft be a little loaded, but learnedly,
and with difcretion. In this point confult
Titian, Rubens, Vandyke, and *Rembrant's*
methods ; for, indeed, their art is won-
derful.

THE tints ufually require three times of
obfervation. The firft is, at the perfon's firft
fitting down, when he has more fpirit and
col'our than ordinary ; and this is to be noted
in the firft hour of his fitting. The fecond
is, when, being compofed, his look is as
ufual; which is to be obferved in the fecond
hour. . And the third is, when, through
tirefomenefs by fitting in one pofture, his
colour alters to what wearinefs ufually
creates. On which account, 'tis beft to
keep to the fitter's ufual tint a little im-
proved. He may alfo rife, and take fome
turns about the room, to gain frefh fpirits,
and fhake off or prevent tirefomenefs.

IN draperies, all forts of colours do not
fuit all forts of perfons. In mens portraits,
we need only obferve great truth, and great
force; but, in womens, there muft alfo be
charms; whatever beauty they have, muft
appear in a fine light, and their blemifhes
muft by fome means or other be foftened.
For this reafon, a white, lively, and bright
tint,

tint, ought never to be fet off by a fine yel-
low, which would make it look like plafter,
but rather by colours inclining to green,
blue, or grey, or fuch others as, by their
oppofition, may make the tint appear more
flefhy than ufual in fair women. *Vandyke*
often made a fillemot-colour'd curtain for
his ground ; but that colour, is foft and
brown. Brown women, on the other hand,
who have yellow enough in their tints to
ˈfupport the character of flefhinefs, may very
well have yellowifh draperies, in order to
bring down the yellow of their tints, and
make them look the frefher; and, near very
high-colour'd and lively carnations, linen does
wonders.

IN grounds, two things are obfervable,
the tone, and the colour. The colour is to
be confidered in the fame manner as thofe
of draperies, with refpect to the head. The
tone muft be always different from the mafs
it fupports, and of which it is the ground,
that the objects coming upon it may not
feem tranfparent, but folid and raifed. The
colour of the hair of the head ufually de-
termines the tone of the ground ; and, when
the former is a bright chefnut, we are often
embaraffed, unlefs help'd by means of a
curtain, or fome accident of the *claro-
obfcuro,* fuppofed to be behind, or unlefs
the ground is a fky.

M 4 WE

WE muft further obferve, that where a ground is neither curtain nor landfkip, or fuch-like, but is plain and like a wall, it ought to be very much party-colour'd, with almoft imperceptible patches or ftains; for, befides its being fo in nature, the picture will look the more grand.

3. *Of Attitude, or Pofture.*

ATTITUDES ought to fuit the ages and qualities of perfons, and their tempers. In old men and women they fhould be grave, majeftick, and fometimes bold : And generally in women, they ought to have a noble fimplicity, and modeft chearfulnefs ; for modefty ought to be the character of women ; a charm infinitely beyond coquetry ! and indeed coquets themfelves care not to be painted fuch.

ATTITUDES are of two kinds ; one in motion, the other at reft. Thofe at reft may fuit every perfon, but thofe in motion are proper for young people only, and are hard to be expreffed ; becaufe a great part of the hair and drapery muft be moved by the air; motion, in painting, being never better expreffed than by fuch agitations. The attitudes at reft muft not appear fo much at reft, as to feem to reprefent an inactive perfon, and one who fits for no other purpofe but to be a copy. And though the figure
that

that is reprefented be at reft, yet the painter, if he thinks fit, may give it a flying drapery, provided the fcene or ground be not a chamber, or clofe place.

I T is above all things neceffary, that the figures which are not employed, fhould appear to fatisfy the fpectator's curiofity; and for this purpofe fhew themfelves in fuch an action as fuits their tempers and conditions, as if they would inform him what they really were : and as moft people pretend to fincerity, honefty, and greatnefs of mind, we muft avoid, in attitudes, all manner of affectation; every thing there muft appear eafy and natural, and difcover more or lefs fpirit, noblenefs, and majefty, in proportion to the perfon's character and dignity. In fhort, the portraits, in this fort of attitudes, muft feem to fpeak to us of themfelves, and, as it were, to fay to us —— *Stop, take notice of me : I am that invincible king, furrounded with majefty —— I am that valiant commander who ftruck terror every-where ; or who, by my good conduct, have had fuch glorious fuccefs —— I am that great minifter, who knew all the fprings of politicks —— I am that magiftrate of confummate wifdom and probity —— I am that man of letters who is abforbed in the fciences —— I am that wife and fedate perfon, whom the love of philofophy has raifed above defires and ambition —— I am that pious, learned, and vigilant prelate*
late

late —— *I am that protector of the fine arts,
and lover of virtue* —— *I am that famous
artisan, who was so singular in his profession,*
&c. And, in women, the language ought to
be —— *I am the wife princess, whose grand
air inspires respect and confidence* —— *I am
that high-spirited lady, whose noble manners
command esteem,* &c. —— *I am that virtuous,
courteous, and modest lady,* &c. —— *I am
that chearful lady, who delight in smiles
and joy,* &c. And so of others. In a word,
the attitudes are the language of portraits,
and the skilful painter ought to give great
attention to them.

BUT the best attitudes, in my opinion,
are such as induce the spectator to think,
that the sitter took a favourable opportunity
of being seen to advantage, and without
affectation. There is only one thing to be
observed, with regard to womens portraits,
in whatever attitude they are placed; which
is, that they sway in such a manner, as to
give their face but little shade; and that we
carefully examine, whether the lady appears
most beautiful, in a smiling, or in a serious
air, and conduct ourselves accordingly. Let
us now proceed to the next article.

4. *Of Dress.*

BY the word *dress* I understand the
drapery which cloathes a person painted, and
the

the manner in which it is fitted. Every perfon muft be cloathed according to his quality; and, in painting, it is only the drefs that can make a diftinction of perfons: But, befides keeping to the rank and quality of the perfon who is drawn, his drapery muft alfo be well chofen, and well caft.

VERY rich cloaths feldom become men, and much lacing is beneath their gravity. Women ought to be adorned in a negligent manner, but without departing from their dignity and noblenefs; and when men and women infift on other management, the artift muft feek his pleafure in imitating what they would have done.

VARIETY of ftuffs gives a work the character of truth; but imaginary draperies deftroy it. At this time, moft portraits are drapered in a very odd manner; but whether this is proper, we fhall here endeavour to examine.

THE partifans for this new kind of drapery alledge, that the *French* modes, being very changeable, portraits become ridiculous in five or fix years after they are drawn; whereas the dreffes, that are made after the painter's fancy, always ftand: that womens habits have ridiculous fleeves, which keep their arms locked up, in a manner that is very ftiff, and neither favourable to nature nor painting; and that the cuftom which has prevailed, by little and little, of paint-
ing

ing draperies in this manner, ought to be no more followed in this particular, than in any other.

OTHERS, on the contrary, maintain, that modes are effential to portraiture, and are not only of fervice to the perfon painted, but alfo monuments of the times: that portraits, as they are a part of hiftory, ought to be faithful in every refpect; which, fay they, is fo true, that we fhould, at this day, be very forry to fee, in medals, bas-reliefs, and other antiquities, the *Romans* cloathed in different habits from thofe they wore; and that it would appear ridiculous to fee their portraits in a *Greek* drefs, as ours are often fo by being in a *Roman*; at leaft we fhould be led by this means into an error. As to modes growing ridiculous in fix years, they anfwer, That we muft not impute it to the mode, fince 'twas once thought handfome; but rather to the underftanding, which is apt to judge of things, not by their relation to the time when they exifted, but by their agreement with the prefent. They add, that although this averfion to mode may be excufable in real drefs, 'tis, neverthelefs, in painting, a weaknefs which the underftanding takes in at the eye; and that it ought rather to be an ufeful diverfion, and a pleafing inftruction, to fee, that at fuch times people wore broad bands; at others, ruffs, bonnets, hanging fleeves, caps, fhort hair, flafhed doublets,

doublets, fcallop'd point-bands, and the like; which modes inform us of the times when thofe perfons flourifh'd, as the perfons fhew us the times when thofe modes prevailed. They alledge alfo the authority of antient painters of repute; as *Titian, Raphael, Paol Veronefe, Tintoret,* the *Carracchis, Van-dyke,* and, in fhort, all portraitifts before this fhifting of modes came into ufe, which the women have introduced into *France* within thefe twenty or thirty years.

Now to give fome decifion between thefe two parties, the truth appears to me to be this; that 'tis more difficult to give modifh habits fome agreeable air in painting, than to. cloathe portraits handfomely, when the painter is left to his own liberty. I think alfo, that modifh habits might fometimes be proper for family portraits, and fometimes the drapery of fome virtue, or attribute, or *Pagan* divinity.

Of Practice in Portraiture.

I CANNOT but think, that every man, having a peculiar caft of mind, has alfo a peculiar manner of purfuing his ends; and that one may have the fame fuccefs, by taking different ways: It is alfo my opinion, that every man ought in this refpect to fol-low the bent of his own genius, and take the road he finds the fhorteft, and moft con-venient.

venient. I fhall therefore fay nothing particular upon this fubject, but only obferve in general, that portraiture requires three different fittings and operations; *to wit*, dead-colouring, fecond-colouring, and retouching or finifhing. Before the painter dead-colour, he muft attentively confider what afpect will beft fuit the fitter, by putting him in different pofitions, if we have not any fettled defign before us; and, when we have determined this, 'tis of the laft confequence to put the parts well together, by comparing always one part with another; for not only the portrait acquires a greater likenefs, when well defigned, but 'tis troublefome to make alterations at the fecond fitting, when the artift muft only think of painting; that is, of difpofing and uniting his colours.

EXPERIENCE tells us, that the dead-colouring ought to be clean, becaufe of the flope and tranfparency of the colours, efpecially in the fhades; and when the parts are well put together, and become clammy, they muft be judicioufly fweetened and melted into each other, yet without taking away the air of the picture, that the painter may have the pleafure of finifhing it, in proportion as he draws. But if fiery genius's do not like this method of fcumbling, let them only mark the parts flightly, and fo far as is neceffary for giving an air.

IN

'IN dead-colouring, 'tis proper to put in rather too little than too much hair about the forehead; that, in finifhing, we may be at liberty to place it where we pleafe, and to paint it with all poffible foftnefs and delicacy. If, on the contrary, you fketch upon the forehead a lock which may appear to be of a good tafte, and becoming the work, you may be puzzled in finifhing it, and not find the life exactly in the fame pofition as you would paint it. But this obfervation is not meant for men of fkill, and confummate experience, who have nature in their heads, and make her fubmit to their ideas.

THE bufinefs of the fecond fitting is, to put the colours well in their places, and to paint them in a manner that is fuitable to the fitter, and to the effect we propofe: But before they are made clammy, we ought to examine afrefh, whether the parts are rightly placed, and here and there to give fome touches towards likenefs, that, when we are affured of it, the work may go on with greater fatisfaction. If the painter underftands what he is about, and the portrait be juftly defigned, he ought, as much as poffible, to work quick; the fitter will be better pleafed, and the work will by this means have the more fpirit and life. But this readinefs is only the effect of long ftudy and experience; for we may well be allowed a

considerable

confiderable time to find out a road that is eafy, and fuch as we muft often travel in.

BEFORE we retouch or finifh; 'tis proper to terminate the hair, that, on finifhing the carnations, we may be abler to judge of the effect of the whole head.

I F, at the fecond fitting, we cannot do all we intended, which often happens ; the third makes up the lofs, and gives both fpirit, phyfiognomy, and character.

I F we would paint a portrait at once, we muft load the colouring, but neither fweeten, nor drive, nor very much oil it; and, if we dip the pencil in varnifh as the work advances, this will readily enable us to put colour on colour, and to mix them without driving.

THE ufe and fight of good pictures give greater light into things than words can exprefs : What hits one artift's underftanding and temper, may be difagreeable to another's ; and almoft all painters have taken different ways, though their principles were often the fame.

THE famous *Jabac*, a man well known to all the lovers of the fine arts, and a friend of *Vandyke*, who thrice drew his picture, told me, that, as he once obferved to him, how little time he beftowed on his portraits,

Vandyke

Vandyke anfwered †, *That at firft he work'd hard, and took great pains, to acquire a reputation, and alfo to get a fwift hand, againft the time he fhould work for his kitchen.* *Vandyke*'s cuftom, as *Jabac* told me, was this: He appointed both the day and hour for the perfon's fitting, and work'd not above an hour on any portrait, either in rubbing in or finifhing; fo that as foon as his clock informed him, that the hour was out, he rofe up, and made a bow to the fitter, to fignify, that he had done enough for that day, and then appointed another hour fome other day; whereupon his fervant came to clean his pencils, and brought a frefh pallet, whilft he was receiving another fitter, whofe day and hour he had before appointed. By this method he work'd on feveral pictures the fame day, with extraordinary expedition.

AFTER having lightly dead-colour'd the face, he put the fitter into fome attitude which he had before contrived; and on grey paper, with white and black crayons, he defigned, in a quarter of an hour, his fhape and drapery, which he difpofed in a grand manner, and an exquifite tafte. After this

† *Jabac*'s obfervation has, according to *Englifh* tradition, been made to *Vandyke* by others; and his anfwer then was, *That he at firft work'd for reputation, but now for his kitchen.* If both reports be true, *Vandyke* feems to have had a very early view of his kitchen.

N he

he gave the drawing to the fkilful people he had about him, to paint after the fitter's own cloaths, which, at *Vandyke*'s requeft, were fent to him for that purpofe. When his difciples had done what they could, to thefe draperies, he lightly went over them again; and fo, in a little time, by his great knowledge, difplayed the art and truth which we at this day admire in them. As for hands, he had in his houfe people of both fexes, whom he paid, and who ferved as models.

I MENTION this conduct of *Vandyke,* rather to gratify the reader's curiofity, than to excite his imitation; he may chufe as much of it as he pleafes, and fuits his own genius, and leave the reft. For my part, I diflike no part of it, except that of fitting only one hour, which I think too little.

I MUST obferve by the way, that there is nothing fo rare as fine hands, either in defign or colouring. 'Tis therefore convenient to cultivate, if we can, a friendfhip with fome woman, who will take pleafure in ferving for a copy : The way to win them is, to praife their beauty exceedingly. But if an opportunity ferves of copying hands after *Vandyke*, it muft not be let flip; for he drew them with a furprifing delicacy, and an admirable colouring.

'Tis of great fervice to copy after the manners which come neareft to nature; as are
<div style="text-align: right">thofe</div>

thofe of *Titian* and *Vandyke*. We muſt, at
ſuch times, believe them to be nature itſelf,
and, at ſome diſtance, conſider them as
ſuch, and ſay to ourſelves —— *What colour
and tint ſhall I uſe for ſuch a part?* And
then, coming near the picture, we ought to
examine, whether we are right, or not; and
to make a fixed rule of what we have diſ-
covered, and did not practiſe before with-
out uncertainty. But to return to por-
traiture :

I BELIEVE 'tis proper, before we begin
colouring, to catch the very firſt moments,
which are commonly the moſt agreeable,
and moſt advantageous, and to keep them
in our memory for uſe, when we are finiſh-
ing : For the ſitter, growing tired with be-
ing long in the ſame place, loſes thoſe ſpirits,
which, at his firſt ſitting down, gave beauty
to the parts, and convey'd to the tint more
lively blood, and a freſher colour. In ſhort,
we muſt join to truth a probable and advan-
tageous poſſibility, which, far from abating
likeneſs, ſerves rather to ſet it off. For
this end, we ought to begin with obſerving
the ground of a tint, as well what it is in
lights, as in ſhades : For the ſhades are only
beautiful as they are proportioned to the
light. We muſt, I ſay, obſerve, if the tint
be very lively, whether it partake of yel-
lowneſs, and where that yellowneſs is placed ;
becauſe uſually, towards the end of the

fitting,

fitting, fatigue diffufes a general yellownefs, which makes us forget what parts were of this colour, and what were not, unlefs we had taken due notice of it before. For this reafon, at the fecond fitting, the colours muft be every-where readily clapp'd in, and fuch as appear at the firft fitting down; for thefe are always the fineft.

THE fureft way to judge of colours is by comparifon; and to know a tint, nothing is better than to compare it with linen placed next it, or elfe placed next to the natural object, if there is occafion. I fay this only to thofe who have little practifed nature.

THE portrait being now fuppofed to be as much finifh'd as you are able, nothing remains, but, at fome reafonable diftance, to view both the picture and fitter together, in order to determine with certainty, whether there is any thing ftill wanting to perfect the work.

Of political Conduct in Portraiture.

BUT it is not enough, that all thefe precautions be taken, for making the portrait perfect; others muft alfo be taken, for making it thought fo. In *France,* let a portrait be ever fo wonderful, if it has not ftood the criticifm of the women, and had their approbation, 'tis thought to be paltry, and continues in oblivion; for the complai-
fance

ſance that is ſhewn them, makes the men echo back what they have determined. In *France*, the ladies command and decide like ſovereigns; and the trifles which are to their taſte, are deſtructive to the great manners in painting. They would even pervert *Titian* and *Vandyke*, if they were ſtill living, and obliged to work for them. In order, therefore, to avoid the vexation which ſuch inconſiderate judgments may occaſion, 'tis neceſſary to uſe ſome political conduct with regard to perſons and times.

THE artiſt muſt never ſhew his work in dead-colour to any but painters, who are his friends, in order to have their opinion upon it; nor indeed is it proper to ſhew any thing finiſh'd, unleſs it be fram'd and verniſh'd.

NOR muſt we, in the ſitter's preſence, aſk the opinion of people who are ſtrangers to the art; becauſe, ſeeing him in one view, and the picture in another, they will adviſe the mending what they take to be amiſs. It will be in vain for the artiſt to offer his reaſons; for, as people ſeldom care to retract, and by that means to own, that they may be miſtaken, they will never be favourable. 'Tis beſt, therefore, not to give them any handle for deciſion; or, if they will offer their opinion, of their own accord, let ſome artifice be employed to elude a long, tireſome, and uſeleſs reaſoning: Make them believe, for

inſtance,

inſtance, that the picture is not quite finiſh'd ; or tell them, they are partly in the right, and that you are going to retouch it ; or any thing of this kind, that may be able to ſilence them immediately. You know what *Vaſari* relates of *Michael Angelo* on the like occaſion. The *Pope* had been at *Michael Angelo's* work-ſhop to ſee a marble figure he had carved for him ; and, having no ſkill himſelf, he ſoftly aſk'd his groom of the chamber, How he lik'd it ? He anſwer'd, *That the noſe was too large.*————Whereupon the *Pope*, raiſing his voice, ſaid, as of his own accord ———— *The noſe is too large.* *Michael Angelo*, who perceived what had paſſed, told the *Pope*, *That his criticiſm was juſt, and that he would go and mend the fault in his preſence.* Accordingly, with his mallet in one hand, and a chiſel and ſome marble-duſt in the other, he put himſelf into a working poſture before the ſtatue ; and, after having knocked upon his chiſel, without touching the marble, and let the duſt fall by degrees out of his hand, he turned about, and ſaid to the *Pope* —— *Adeſſo, ſantiſſimo Padre, che gliene pare?* What does your Holineſs think of it now ? *O ! Signor Michel Angelo*, ſaid the *Pope*, *Gli avete dato la vita.* O ! now, my dear Sir, you have made the figure alive. *Apelles* would aſk nobody's opinion ; but, as *Pliny* ſays, kept behind the cloth, and finding a ſhoe-

shoemaker's criticism, on the sandal-strap of
a figure, to be reasonable, he mended it;
which elated the poor mechanick so much,
that, he began to joke the artist for something
in the thigh, which was not to his liking:
This obliged *Apelles* to tell him scornfully,
*That a shoemaker's judgment should not exceed
the sandal.* Thus, when those who pretend
to judge, shall justly find a fault in your work,
'tis wisdom to profit by it, without hearken-
ing to them too much, or encouraging their
criticism, because they will abuse your do-
cility; and your praising them for the good
hints they may give, will provoke them to
offer bad ones. But in this the painter must
employ both art and good breeding, by
making proper distinctions between the per-
sons who talk and give their opinion of his
works.

OF

OF

COLOURING.

I FORMERLY publiſhed *A Dialogue on Colouring*, where I endeavour'd to ſhew its value, and rank in painting : But what I now write being handled by way of *principles*, I thought *colouring* ought to be treated in the ſame manner ; that this part of painting, which is ſo neceſſary to all the reſt, might join with them in making *one whole*, and that the reader might the more eaſily judge of it.

THERE are ſeveral people, who, ſpeaking of painting, uſe the words *colour* and *colouring*, indifferently, to ſignify the ſame thing and tho' theſe two parts are diſtinguiſhable enough, yet it may not be improper to explain what we mean by each of them.

COLOUR is what makes objects perceptible to ſight : And,

COLOURING is one of the eſſential parts of painting, by which the artiſt imitates the appearance of colours in all natural objects, and gives to artificial objects the colour that is moſt proper to deceive the ſight. THIS

This part includes the knowledge of particular colours, their fympathies and antipathies; their manner of working, and the knowledge of the *claro-obfcuro*. And as I think this branch of art has been very little, if at all, underftood by a great many of the ableft painters of the two laft centuries, I think myfelf obliged to give here as true an idea of it as I can, in order to fhew its merit.

Some alfo confound the fimple or capital colour with the local, tho' their difference be great; for the fimple colour is that which does not by itfelf reprefent objects; as pure white, *i. e.* without mixture; or pure black, or pure yellow, or pure red, blue, green, or other colours, firft put on the pallet, to make mixtures for a faithful imitation of an object: whereas the local colour, by its agreement with the place it poffeffes, and by the affiftance of fome other colour, reprefents a fingle object; as a carnation, linen, ftuff, or any object, diftinct from others. And it is called *local*, becaufe the place it fills requires that particular colour, in order to give the greater character of truth to the feveral colours about it. But to proceed :

The painter ought to confider, that as there are two forts of objects, the natural, or that which is true; and the artificial, or that which is painted; fo there are two forts of colours, the natural and the artificial.

ficial. The natural colour is that which makes all the objects in nature vifible to us ; and the artificial is, a judicious mixture of the fimple colours on the pallet, in order to imitate thofe of natural objects.

THE painter muft therefore have a perfect knowledge of thefe two forts of colours : Of the natural, in order to know which of them he ought to imitate ; and of the artificial, in order to compofe a tint proper for reprefenting perfectly the natural colour. He muft know, befides, that the natural colour is of three forts : 1. The true colour of the object. 2. The reflected colour. 3. The colour of the light. As to artificial colours, he ought alfo to know their value, force, and fweetnefs, both feparately and by comparifon, that he may either exaggerate by fome colours, or attenuate by others, as his fubject requires.

FOR this purpofe it muft be confidered, that a picture is a flat fuperficies; that, fome time after the colours are laid, they lofe their frefhnefs ; and that the diftance of the picture takes from it much of its brightnefs and vigour ; and therefore, that 'tis impoffible to make up thefe three deficiencies without the artifice which colouring teaches, and which is its chief object.

A KNOWING painter ought not to be a flave to nature, but a judge, and judicious
imitator

imitator of her. Let a picture but have
its effect, and agreeably deceive the eye, and
'tis' all, that can be expected in this point;
but this can never be attained, if the painter
neglects colouring. As it is certain, that
the whole cannot be perfect, if any part is
wanting ; and that he is not an able painter,
who is ignorant of fome of the parts of
his art.; fo I would as much blame a painter
for neglecting colouring, as for ill defigning,
or ill difpofing his figures.

THERE is, however, no part of paint-
ing where nature is always proper to be
imitated, that is, fuch nature as offers it-
felf by chance. Though fhe is miftrefs of
arts, yet fhe feldom fhews us the beft
road ; fhe only hinders us from going
aftray. The painter muft chufe her accord-
ing to the rules of art, and if he does not
find her to be fuch as he looks for, he muft
correct what offers to him. As he who
defigns, does not imitate all he fees in a
defective copy, but changes the faults into
the juft proportions : So the artift muft not
imitate all the colours which indifferently
prefent themfelves to the eye ; but chufe the
moft proper for his purpofe; adding others,
if he think fit, in order to fetch out the
effect and beauty of his work. His objects
muft not only be, each of them, fine, na-
tural, and true, but there muft be alfo an
union of the whole together. Sometimes he
muft

muſt leſſen the vivacity of the life, at other times he muſt exaggerate or improve upon the brightneſs and force of the colours he meets with, that he may thus expreſs, with greater ſpirit and truth, the character of his object, without altering it. There are none but great painters, and thoſe are but few, who have arrived at this art; and this learned exaggeration, or improvement, is ſo far from weakening the truth of imitation, that it gives more truth to what the artiſt imitates after nature.

L e t me here appriſe the reader, that ſpeaking in general of painting, deſign, or colouring, I always ſuppoſe them to be in their perfection.

T h o s e who object to colouring ſay, that we muſt needs aſcribe to deſign a correctneſs of proportions, an elegance of out-lines, and a delicacy of expreſſion; and that the *Roman* ſchool, which was *Raphael's*, has always endeavoured principally after theſe three points, as the firſt and moſt perfect intentions of nature, and made little account of colouring: wherefore the artiſt, ſay they, ought to look upon deſign as his principal object; and upon colouring, as only acceſſary.

I a n s w e r, that the original intentions of nature are not leſs viſible in colouring, than in deſign; that indeed theſe three qualities aſcribed to deſign, enhance its value; but, on the other hand, that the artiſt

<div align="right">muſt</div>

muſt have begun his ſtudies with acquiring them, and muſt be ſuppoſed to be a perfect maſter of them : and yet they alone do not conſtitute the painter ; they only begin him, and wait for their perfection from colouring, with regard to the whole compoſition.

GOD, in the creation of bodies, has furniſhed his creatures with ample matter for praiſing him, and diſcovering him to be their author ; and, having ſtamped viſible colours on them, he has given room to painters to imitate his omnipotency, and to produce, as it were, out of nothing, a ſecond nature, which exiſts only in their ideas. In fact, all things on earth would be in confuſion, and bodies only perceptible by touch, if diverſity of colours did not diſtinguiſh them. The painter therefore who is a perfect imitator of nature, and ſuppoſed to be a good deſigner, ought to make colouring his chief object, ſince he only conſiders nature as ſhe is imitable ; and ſhe is only imitable by him, as ſhe is viſible ; and ſhe is only viſible, as ſhe is coloured. For this reaſon, we may conſider colouring as the *difference* in painting, and deſign as its *kind* *: juſt as reaſon is the *difference* of man ; becauſe it conſtitutes his being, diſtinguiſhes him from other creatures, and

* Alluding to the logical terms *genus* and *differentia*.

ſets

fets him above them. For fince the ideas of things ought to ferve only for bringing them out of confufion, 'tis neceffary to conceive them by fomething which each has in particular, and which cannot agree with any thing elfe. If we confider the painter by his invention, we rank him among the poets ; if by perfpective, (as fome fay) he is not diftinguifhable from the mathematician; and if by the proportions and meafures of bodies, we confound him with the fculptor and geometer. So, tho' the perfect idea of the painter depends on defign and colouring jointly, yet he muft form a fpecial idea of his art only by colouring, fince, by this difference, which makes him a perfect imitator of nature, we diftinguifh him from fuch as have only defign for their object, and whofe art cannot come up to this perfect imitation which painting leads to ; and wo can only be underftood to mean a painter.

AMONG the arts which have defign in common with painting, we may reckon fculpture, architecture, and engraving ; which are thus defined :

PAINTING is an art, which, on a flat fuperficies, imitates all vifible objects : 'Tis of many kinds, and ufually divided into

MOSAICK, FRESCO, DISTEMPER, OIL, CRAYON, MINIATURE, and ENAMEL.

SCULPTURE is an art, which, by means of defign and folid matter, imitates the

<div align="right">palpable</div>

4

palpable objects of nature : 'Tis usually divided into

WHOLE-RELIEF, and BAS-RELIEF.

ARCHITECTURE is an art, that by design, and suitable proportions, imitates and erects all sorts of edifices. 'Tis usually divided into

CIVIL and MILITARY.

ENGRAVING is an art, that, by means of design, and incision into an hard matter, imitates the lights and shades of visible objects: and is divided into

WOOD, ENGRAVING, ETCHING, and BLACK MANNER.

THE * *black manner*, which is of late invention, is so called, because instead of

pre-

* This being, it seems, but a late invention in *France*, and our author very backward in doing justice to *English* productions of that kind, we think ourselves obliged to give the reader a small sketch of what we call *mezzotinto*. This invention is owing to prince *Rupert*, who, after King *Charles* II.'s restoration, made several prints in that manner. The Prince laid his grounds on the plates with a chanell'd roller, as the *French* do theirs by close and cross-hatching ; perhaps, the only difference between their method and ours. His success gave occasion to one *Sherwin* to make some attempts in the same way ; but he laid his grounds with an half-round file, weighted with an heavy piece of lead. The Prince, on sight of *Sherwin's* prints, thinking his servants had divulged his secret, sent for him ; who satisfying his Highness to the contrary, by shewing him his file, the Prince thereupon gave him one of his rollers. To *Sherwin* succeeded *Isaac Becket*, and *William Faithorn :*

And

preparing the plate, by polifhing it, a ground
is laid upon it of clofe engraving, croffing
every way uniformly ; fo as, on taking a
proof, it fhall appear very ftrong, and in-
tirely black.

THE black graving therefore is that,
where, inftead of a graver to form the ftrokes
and fhades, they ufe a burnifher, to fetch
the objects out of darknefs, and give them,
by degrees, their proper lights.

THE cutting of precious ftones the reader
may afcribe either to fculpture or engraving :
yet people ufually fay, *grave-ftones* ; and 'tis

And after them, were *Van Somer, Lens, Smith, Williams,*
and *Symons,* old and *young Faber, George White,* &c.
Among thefe, *Smith* and *White* feem to be the moft
excellent. The former is ftill living ; and his collection
of prints (moftly after Sir *Godfrey Kneller*'s paintings)
perhaps the fineft in *Europe* ; and his *Duke Schomberg*'s
Head, and *The Holy Family,* after a picture of *Carlo
Maratti,* are thought to be his beft performances.
White died middle-aged, a few years ago ; and though
his prints are but few, they are obferved to have a fine
paint-like expreffion, (for he was a painter, and beftowed
much time on his plates) not to be found any-where
elfe. His beft print is, *John Baptift Monoyer* the
flower-painter's head.

N. B. Both Prince *Rupert*'s and *Sherwin*'s grounding
tools have been laid afide fome years ; and the
grounds are now laid with an hand-tool, fome-
what like a fhoemaker's cutting-board-knife, the
edge whereof, having a fort of fine crenelling, raifes
a thick imperceptible ftipping, or ground on the
plate ; and was the invention of one *Edial,* a
fmith by trade, who afterwards became a *mezzo-
tinto* printer.

very

very probable, that the workmen employed in this were both sculptors and engravers.

WITHOUT, my being at the trouble to define all these divisions, 'tis easy to observe, that design, which is their *kind*, that is, common to them all, is determined by a particular *difference*, which constitutes what is essential to each of these arts.

THE end of the painter, and the sculptor, is indeed imitation; but they attain it by different methods: The sculptor, by a solid matter, imitating the real quantities of objects; and the painter with colours, shewing the apparent quantity and quality of all things visible; so that he is not only obliged to please, but even deceive the eye, by what he represents.

To this 'tis usually objected, that design is the foundation and support of colouring; that tho' colouring depends upon it, yet it no-wise depends on colouring; and therefore the former is more necessary, more noble, and more considerable, than the latter. But 'tis easy to perceive, that this objection does not conclude any thing in favour of design, to the prejudice of colouring. On the contrary, we may infer from thence, that mere design alone is not, as it is supposed to be, the foundation of colouring, nor has a prior existence to it, in any other sense but this, that it must receive its perfection, with re-

O gard

gard to painting, from colouring; and there is no doubt but the thing which receives, muſt have a prior exiſtence to that which is to be received.

'T I s the ſame with all kinds of matters, which muſt be difpofed before they can receive the perfection of fubſtantial forms. The human body, for inſtance, muſt be intirely formed and organized, before it receive the foul : This was God's method with the firſt man : He took earth, and, after having given it the neceſſary difpofitions, he created the foul; which he infuſed into it, for perfecting it into a man. This body, as to its exiſtence, had no dependence on the foul, becauſe it was prior to the foul; and yet no one will affirm, that the body is the more noble and more conſiderable part of the man. Nature always makes her beginnings by means of things leſs perfect; and art, in imitation of her, takes the ſame method. The painter firſt rubs in his ſubject by means of deſign, and afterwards finiſhes it by the help of colouring; which, by giving truth to the objects deſigned, gives them, at the ſame time, all the perfection that painting is capable of.

As for being more or leſs neceſſary to make a whole; parts that are eſſential, are equally neceſſary. As he is not a man, who has not a foul joined to his body; ſo that is not

painting,

painting, where colouring is not joined to defign.

But if we confider defign by itfelf, and as 'tis inftrumental in moft parts of art, we might, for its utility, prize it more than colouring; as we prefer a large diamond before a *plant*, tho' the meaneft plant be in itfelf more noble and valuable than all the precious ftones in the world.

As every one purfues his own profit, and confiders things in this view, 'tis no wonder if defign, coming more often into play, and being confequently more profitable by its mathematical demonftrations, and alfo by the very draughts themfelves, which, however flight, let us into the thought of the work propofed, fhould be more efteemed: But if you fet colouring afide, there will be nothing in defign but what may be performed in fculpture; which, if compared with a piece of painting, muft needs be imperfect, for want of colouring. And this confideration fets the painter above the fculptor, fince objects fkilfully painted have a more perfect refemblance to the true ones.

Yet we cannot help allowing, that defign, perfect, as we fuppofe, and as we fee it in the antique, has feveral marks of elevation; which have divided the curious in their choice of pictures for enriching their cabinets. In effect, according to the fubjects and figures which the ancient fculptors had a mind to

reprefent,

reprefent, we difcover in their fculptures the terrible, or the gracious, the fimple, or the ideal of a great character, but always fublime and probable. On this account we are much in doubt, about the preference which ought to be given to pictures ; whether we ought to prefer fuch as are better defigned than coloured, or thofe which are better coloured than defigned. But from what we have faid of colouring with refpect to painting, it appears that we muft not prefer the former, if the defign in the latter be not too bad. And the reafon is, that there is defign in other things as well as in pictures ; 'tis to be found in good prints, ftatues and bas-reliefs; but fine colouring is only to be feen in a very few pictures.

WERE I to make a cabinet of pictures, I fhould fill it with all fuch as had any kind of beauty ; but I fhould prefer *Titian*'s to all others, for the reafons I have given ; and indeed the price which his works bear among the curious, fufficiently juftifies my opinion. It muft be granted, that fome perfons value defign, becaufe of the efteem the world has for it in general, and of the great numbers of people, who, for its utility, have got a manual habit of it, and love it much : To folve this difficulty, we muft inquire what is underftood by the word *defign*.

IN painting, this word has but two figni-cations : Firft, it means the thought of a

picture,

picture, which the painter puts either on paper or cloth, in order to judge of what he is contriving; and in this manner we may defign, not only a fketch, but a work well connected as to lights and fhades, or, even a fmall picture well coloured. This was *Rubens's* method in almoſt all his defigns; and the moſt part of *Titian's*, which are almoſt all done with the pen, have been performed in the fame manner. Secondly, we call defign, the *juſt meaſures, proportions, and outlines*, fuppofed to be in vifible objects, which, having no other exiſtence than in the extremities of thofe bodies, do actually refide in the mind: And if painters have made them apparent, by circumfcribing lines, and out of abfolute neceffity, it was for the information of their pupils, and for their own practice, in order to acquire with eafe an extreme correctnefs. And yet it may be faid, that the ufe of thefe lines is like that of a centre for an arch in architecture; where, after the ftone-work is fet, the centre is ftruck : In the fame manner, after the painter has formed his figure, his lines are of no further ufe, and muſt no longer appear. And it is in this fenfe, that defign fhould be underſtood to be one of the effential parts of painting ; but when we give lights and fhades to outlines, we cannot do it without white and black, two of

the

the capital colours in painting, and whofe management comes under colouring.

YET I have met with feveral painters, who would never allow, that defign contains only the proportions and outlines of vifible objects: They fay, that this part is one of the forts of defign I have defined, *viz.* The thought of a grand picture before it is executed; whether that thought be only a flight fketch, or be expreffed in *claro-obfcuro*, and by all the colours proper for the great work, of which this defign is the fpecimen.

I BELIEVE the beft anfwer to this will be to fay, that in fuch cafe defign would no longer be a part of painting, but the whole of it; fince it would contain not only lights and fhades, but alfo colouring, and even invention; and then we muft be always thinking of new terms, and afk thefe gentlemen, By what name they would call that part of defign, which furnifhes the objects that compofe an hiftory? And what name muft be given to that other part of defign, which difpofes the colours, lights, and fhades? Hence, without further trouble, 'tis eafy to conceive, that 'tis no matter how we call things, provided we underftand and agree upon their names. And as new terms would be troublefome to the memory, I think it better to retain the old.

BUT let us not here pafs over in filence the pre-eminencies of defign; the chief of

 which

which are thefe; *viz. Firſt,* It alone, without colouring, produces many ufeful things; for which reafon, a great many people are content to have fome fkill in defign, without troubling themfelves about colouring. *Secondly,* It gives a tafte for the knowledge of arts, and enables us to make fome judgment of them; and, for this reafon, defigning is look'd upon as a neceffary part of young gentlemens education, who have commonly their mafters for drawing, as well as for writing. *Laſtly,* As this part comprehends many other particular things, as the knowledge of the mufcles, perfpective, pofition of the attitudes, and the expreffion of the paffions of the foul, it might therefore be confidered rather as an intire whole, than as a feparate part.

IT cannot indeed be denied, that thefe pre-eminencies in defign are real and extremely ufeful: But then we here confider defign only as it relates to painting; and, in this light, all its parts require colouring, in order to make a perfect picture. For this reafon, we here confider defign, with all the parts it comprehends, not as a diftinct part itfelf, nor yet as an intire whole, but only as the foundation and beginning of painting.

WE have before faid, that the *claro-obfcuro,* which is nothing but the knowledge of lights and fhades, was comprifed in co-

O 4 louring:

louring : yet there are feveral painters who will not allow it. They alledge, that the only reafon, which is affigned for it, is, that, in nature, light and the *claro-obfcuro* are infeparable ; and add, that the fame may be faid of defign, becaufe, without light, the eye cannot perceive nor know in nature the outlines and proportions of figures.

To this we may anfwer, that, in this cafe, the hands might do the office of the eyes ; and, after feeling a folid body, might determine, whether it were round or fquare, or what its form was : Whence it follows, that, without light, the outlines and proportions of figures may be known.

Being upon this fubject, I cannot forbear relating a late ftory of a blind fculptor, who made portraits in wax, and very like. He lived in the laft century, and the ftory was told me by a man of probity, who was acquainted with him in *Italy*, and was witnefs to what I am going to relate.

The blind man, this perfon told me, was of *Cambaffi*, in *Tufcany*; he was well made, and fomething more than fifty years of age, had a great deal of wit and good fenfe, and delighted in talking and telling things agreeably. One day, meeting him in the palace of *Juftiniani*, where he had been copying a ftatue of *Minerva*, I took occafion to afk him, Whether he did not fee a little, becaufe he copied fo juftly ? *I can't fee at all,*

all, fays he ; *my eyes are at my fingers ends.*
But then, faid I —— *How is it poffible, that,
blind as you are, you can do fuch fine things ?*
He replied ——*I feel my original*; *I examine
the dimenfions, and the rifings and cavities ;
thefe I endeavour to keep in my memory ; then
I feel my wax, and comparing one with the
other, by moving my hand backwards and
forwards feveral times, I finifh my work in
the beft manner I can.*

I n fhort, he did not appear to have any
fight ; fince the Duke of *Bracciano*, to prove
him, obliged him to make his head in a
very dark cellar, and it was found to be
very like. But, though this piece was ad-
mired by all who faw it, they failed not to
object to the fculptor, that the Duke's beard
was a great help towards likenefs ; and that
he could not have hit it fo eafily, had the
Duke been beardlefs. *Well then*, fays the
blind man, *give me another.* Whereupon
they propofed to him to make the head of one
of the Duchefs's maids; he accordingly under-
took it, and made it very like. I have alfo
feen a bufto of *Charles* I. King of *England*,
and one of Pope *Urban* VIII. of this man's
doing, both after the marble, finely finifh'd,
and very like. The greateft trouble he found,
as he confefs'd, was in making hair ; becaufe
of its pliablenefs to the fingers.

But, without going farther, we have at
Paris a bufto, by this hand, of the late ex-
cellent

cellent Monſieur *Heſſelin*, maſter of the trea-
ſury-chambers, who was ſo well pleaſed
with it, and thought the work ſo wonderful,
that he deſired the author of it to ſit for his
picture, that he might take it into *France* as
a memorial of him. My curioſity induced me
to ſee this picture ; and, after having viewed
the face, I perceived that the painter had
ſet an eye on the tip of each of his fingers, to
ſhew, that thoſe he had elſewhere were uſe-
leſs to him. I have the more willingly re-
lated this ſtory, as I thought it worthy of
the reader's curioſity, and very proper to de-
monſtrate the propoſition before us, *to wit*,
That the knowledge of the *claro-obſcuro* is
comprehended in colouring.

IT is certain, that no one can fail, even
in great darkneſs, to perceive the contours
of a man or ſtatue, and to judge of the riſings
and cavities, by feeling about ; whereas it is
impoſſible to ſee any colour, or to make
any judgment of it, without the help of
light.

WE perceive, by the ſtory of this blind
man, that his art, which lay all in deſign,
afforded him an opportunity to gratify his
knowledge, and alſo ſome conſolation for
the loſs of ſo precious a ſenſe as light ; and
that if he had been a painter, he would have
been deprived of this conſolation ; for co-
lour and light are the objects only of ſight ;
but

but defign, as I have obferved, is alfo the object of feeling.

I MIGHT alfo mention a more recent example of blindnefs, in the late Sieur *Buret*, one of the ableft fculptors of the Academy, who, according to the teftimony of perfons of credit, loft his fight, by the fmall-pox, at twenty-five years of age ; which, however, left him the pleafure and confolation of diverting himfelf by working like the blind man of *Cambaffi*.

IT is in this place we ought to treat of the *claro-obfcuro*, as an effential part of colouring ; but as the treatife on this fubject is of fome length, we fhall fet it after the prefent difcourfe on colouring, and refer the reader to it ; the rather, that he may have a more diftinct idea of the knowledge of lights and fhades.

THE agreement and oppofition of colours are as neceffary as union and the cromatick in mufick. This agreement and oppofition proceeds from two caufes ; *to wit*, from their apparent and original qualities, and from their mixtures. Their apparent qualities proceed from their participation with the air and earth. The aereal colours preferve a lightnefs, which makes them look lovely ; as white, fine yellow, blue, lake, green, and fuch-like, of which may be made an infinity of colours that will always fympathize : The earthy, on the other hand, have

have a heavinefs, which, by mixture, de-
ftroys the fweetnefs and lightnefs of the
aereal.

'TIS difficult to affign the true phyfical
reafon, why a colour is aereal or terreftrial;
yet we may conclude, that luminous colours
are fweet, and airy, and perfectly agree,
when mixed together. It is certain, how-
ever, that fome beautiful, fweet, and lu-
minous colours, inftead of agreeing, deftroy
each other, in the mixture; as fine ultra-
marine mixed with white, or fine yellow, or
fine vermilion. And though thefe colours,
fet fingle one by another, have great bright-
nefs, yet, when mixed, they make an
earthy colour, as ugly as poffible.

WHENCE we may infer, that one of the
beft ways to prove the fympathy or anti-
pathy of any two colours fet together is, to
raife a third out of their mixture; for, if
this third colour fhews by its foulnefs, that
the two conftituent colours are deftroy'd, we
may conclude, that thefe two colours have
an antipathy to each other: If, on the con-
trary, that mixture makes a mellow, fweet,
and agreeable tint, which refembles their
original quality, 'tis an infallible proof of
their harmony.

THE bodies of colours are alfo another
principle, by which we may judge of
their agreement or repugnancy; for fome
have fo much body, that they cannot bear
<div align="right">any</div>

any other colour without taking away almoſt
intirely its natural qualities, as red oker, um-
ber, indigo, and others, proportionably.

BUT even if neither art nor reaſon re-
quired harmony of colours, yet nature herſelf
ſhews it to us, and obliges even thoſe to
imitate it, who copy her but ſervilely; for,
whether we conſider the light as direct in
open day, or reflected in the ſhades, it can-
not communicate itſelf without communi-
cating alſo its colour, which is ſometimes of
one kind, ſometimes of another. We have
an experiment of this in the light of the ſun,
which, at noon, is very different in quality
from what it is in the evening or morning;
and the moon has alſo a particular colour, as
well as the light of a fire, or of a flam-
beau.

BEFORE we quit this article of the har-
mony of colours, it muſt be obſerved, that
glazing is a mighty help to the ſweetneſs of
colours, ſo neceſſary for expreſſing truth.
Few people underſtand it, becauſe this know-
ledge is generally the effect of long expe-
rience, accompanied with good judgment.
Happy is the man, who, when he views
the works of great maſters, can penetrate
into the ſecrets of their art in this par-
ticular!

THE lovers of painting, who are not
artiſts, muſt alſo be informed, that glazing
is made by colours tranſparent and dia-
phanous,

phanous, as having but little body, which are thinly fcumbled, with a fitch-pencil, over colours that are more ftaring, in order to bring them down, and fweeten them into an harmony with thofe about them.

HAVING now fpoke of the union of colours, we muft, in the next place, add a word or two of their oppofition. Colours are oppofite, either through their natural qualities, when pure and fimple, or elfe in light and fhade, when they make a part of the *claro-obfcuro.*

THIS oppofition in quality is called antipathy; it appears among fuch colours as predominate, and deftroy by mixture, as ultramarine and vermilion; and the contrariety in the *claro-obfcuro* is nothing but a fimple oppofition of light with fhade, without any deftruction : For tho' nothing feems more oppofite than white and black, for example; the one reprefenting light, and the other the privation of light; yet, being mixed, they maintain a kind of friendfhip which cannot be deftroyed; they make a fweet grey, that partakes of both colours; and what fhall appear black by the oppofition of pure white, will feem white, when fet next to an intenfe black.

THE fame way of reafoning holds good as to all other colours, where more or lefs light alters nothing of their qualities.

IT

5

IT is certain, that this union and oppo-
fition are evident in fome colours; but the
difficulty of giving a reafon for it obliges me
to refer the painter to his own experience,
and to the folid reflections which he may
make in the fineft pieces of this kind, which
are very fcarce and few; for in near three
hundred years, that painting has been revived,
we can hardly reckon fix good colourifts;
whereas we may count at leaft thirty good
defigners. The reafon is, that defign has its
rules founded on the proportions, on ana-
tomy, and a continual experience of the
fame thing; whereas colouring has not any
rules that are yet well known; and the ex-
periments that are made, as they differ every
day, becaufe of the different fubjects that
are handled, have not been able to give any
fixed rules on this head: For which reafon
I am perfuaded, that *Titian* gained more
help from his long and ftudious experience,
joined to the great folidity of his judgment,
than from any demonftrative rule he had
fixed in his mind. But I cannot fay the
fame of *Rubens*, who muft always yield to
Titian as to the local colours; tho', as to
the principles of harmony, he had difcovered
fuch folid ones, that he was fure of pro-
ducing a good effect, and a good whole.

IF my remark on *Titian* and *Rubens* be
juft, thofe who defire to be good colourifts
cannot take a better method than to ftudy
the

the works of thofe two great mafters, as
publick books of inftruction. It will be
proper carefully to examine their works by
copying them for fome time, the better to
apprehend them, and to make all the re-
marks that appear neceffary for eftablifhing
principles. But it muft be granted, that all
forts of men are not capable of underftand-
ing books, fo as to profit by them ; for, in
order to this end, the mind muft be fo turned,
as to remark nothing but what is remark-
able, and to penetrate the very caufes of the
effects which are admired in fine pro-
ductions.

SOME painters have copied *Titian's* works
for a long time, examined them with care,
and, on the whole, made all the reflections
they could upon them, and yet have mifs'd
the mark for want of attending to the pro-
per objects. For this reafon their copies,
tho' very much laboured, and, as they
thought, extremely exact, have fallen very
far fhort of the management in the originals.
Others, of more fkill, and deeper reflection,
have procured copies of thefe pictures, to
pleafure themfelves with looking at them,
and alfo to profit by them. This is very
commendable ; but if they would themfelves
copy them, or at leaft the fineft parts of
them, they would underftand them more
thoroughly, and profit much better, than by
bare looking. The truth is, thefe originals,

 and

and all fuch others as are finely lighted and
coloured, are fcarce, and it is difficult to
borrow them for any time ; yet love is in-
genious, and finds no difficulty infuperable.
In fhort, would we gain the good graces of
painting, the fafeft way is to labour hard,
and make the neceffary reflections; and then
we fhall infallibly gain knowledge and faci-
lity : If, for this purpofe, we can't procure
good originals, fine copies muft ferve ;
where we may chufe their beft parts only,
if we think fit. We fhould alfo often vifit
the cabinets of particular perfons, and thofe
of the King, and of the Duke of *Orleans,*
as often as poffible.

THE *Luxemburg gallery* is one of *Rubens's*
fineft performances : And *Rubens* has, more
than all other painters, made the way to
colouring eafy and clear. The work I
mention is the helping hand, which may
fave the artift from the fhipwreck to which
he may have innocently expofed himfelf.

I HAVE always valued this work of
Rubens, as one of the fineft performances
in *Europe,* if, in feveral parts, we fet afide
the tafte of its defign, which is not the fub-
ject at prefent before us. I am fenfible, that
many differ from my opinion of this great
man's works, and that of a very confiderable
number of painters, and curious men, who
have with all their might oppofed my opi-
nion, when I brought to light, if I may fo

P fay,

fay, the merit of this great man, who be-
fore was confidered as a painter but little
above the common level : of thefe people,
I fay, fome yet remain, who without diftin-
guifhing the different parts of painting,
efpecially colouring, of which we are now
fpeaking, value nothing but the *Roman* man-
ner, the tafte of *Pouffin*, and the fchool of
the *Carracchis*.

THEY object, among other things, that
Rubens's works appear to have little truth,
on a near examination ; that the colours and
lights are loaded; and that, in the main, they
are but a daubing, and very different from
what we commonly obferve in nature.

IT is true, they are but a daubing ; but
it were to be wifhed, that the pictures that
are now painted, were all daubed in the fame
manner. Painting, in general, is but daub-
ing ; its effence lies in deceiving, and the
greateft deceiver is the beft painter. Nature
in herfelf is unfeemly, and he who copies
her fervilely, and without artifice, will al-
ways produce fomething poor, and of a
mean tafte. What is called *load*, in colours
and lights, can only proceed from a pro-
found knowledge in the values of colours;
and from an admirable induftry, which
makes the painted objects appear more true;
if I may fay fo, than the real ones. In this
fenfe it may be afferted, that, in *Rubens*'s
pieces, art is above nature, and nature only

a copy

a copy of that great mafter's works. And of what import is it, after all, if things, on examination, be not perfectly juft? If they appear fo, they anfwer the end of painting, which is not fo much to convince the underftanding, as to deceive the eye.

THIS artifice will always appear wonderful in great works; for when the picture is diftanced according to its bignefs, it is this artifice which fupports the character, both of the particular objects, and of the whole together; but without it the work, in proportion as we remove from it, will appear to remove from truth, and look as infipid as an ordinary painting. 'Tis in fuch great works, that *Rubens* is obferved to have fo happily fucceeded in this learned and apparent load, by thofe efpecially who are capable of giving attention, and of examining it; for, to others, nothing can be a greater myftery.

OF all the fcholars of this excellent man, *Vandyke* was he who profited moft by his mafter's inftructions; and in fpeaking of *Rubens*, one muft needs pay a particular regard to this illuftrious difciple, fince, if he had not fo much genius as his mafter for grand compofitions, he furpaffed him in certain fineffes of the art; and 'tis evident, that, in general, his portraits have a delicacy and freedom of penciling beyond any thing elfe in that way.

HAVING

HAVING now faithfully given my thoughts on colouring, and its dependencies, 'tis neceffary to anfwer thofe perfons who think, that it is impoffible to be mafter of defign and colouring at the fame time :: Their ftrongeft reafon is, that in addicting ourfelves to colouring, we neglect defign, the charms of the one making us forget the neceffity of the other.

To this it is eafy to anfwer, that if it be fo, we muft not impute it to colouring, but to the mind, as being too narrow to attend to two things at once. But it is not fuch narrow capacities that painting takes up with, Her only favourites are fuch minds as can embrace many objects, or are fo well turned, and conduct themfelves in fuch a manner, that they never apply but to fuch things as by degrees muft increafe their knowledge : Their new ftudies do not make them forget the old ; on the contrary, the former ftrengthen the latter; they ufe all their efforts to poffefs every ftudy, as the neceffary means to arrive at their end. This was *Raphael's* character : The order and perfpicuity with which he conceived things, never let him forget any thing ; he daily improved in knowledge, and ftrengthened his new difcoveries by fuch as he had formerly made.

AFTER the knowledge of colours, we are led to treat of their ufe, management, and

and operation; three points, in the use of which the painter's greatest satisfaction consists.

SENECA, speaking of the agreeableness of painting, says, *That it yields more pleasure in the execution, than when 'tis finished.* I am intirely of the same sentiment; because, in the course of the work, we handle the principles and secrets of the art to our own liking; we command them, as it were, and every one makes them obey according to his capacity and genius; whereas, when the work is finished, it commands the painter, and obliges him to be satisfied with it, be the performance what it will.

HERE follow some maxims concerning the use of colours.

PLINY says, *That the antients painted with four colours only, and out of them made all their tints.* But it is probable they were only for grounds, to prepare them for receiving such other colours as gave the work its freshness, vigour, and spirit.

WE must learn to view nature to advantage, in order to represent her well. There are two manners of colouring her, one depending on the habit which young beginners form to themselves, and the other comprehending the true knowledge of colours, and their values when they come together, and the proper temperament of their

mix-

mixtures, for imitating the various colours
in nature.

THE memory of man is often limited
to a few ideas, which he is therefore obliged
to repeat. The way for the artist to avoid
a tiresome repetition, is, to have recourse
to that inexhauftible fountain, nature itself:
Nay, it is proper to anticipate his occasions
in this respect, by painting, after extraordi-
nary natural objects, his various studies in all
the branches of the art, and painting them
on oiled paper, that they may be of use to
him when he wants them.

THE harmony of nature, in her colours,
arises from objects participating of one an-
other by reflexion; for there is no light
which does not strike some body, nor is
there any enlightened body which does not
reflect its light and colour at the same time,
in proportion to the force of the light, and
according to the variety of the colour. This
participation of reflexion in light and co-
lour conftitutes that union of nature, and
that harmony, which the painter ought to
imitate. Hence it follows, that white and
black are feldom good in reflexions.

VARIETY of tints, very near of the same
tone, employ'd in the same figure, and often
upon the same part, with moderation, contri-
bute much to harmony.

THE turn of the parts, and the outlines,
which infenfibly melt into their grounds,
and

and artfully difappear, bind the objects, and keep them in union ; efpecially as they feem to conduct the eye beyond what it fees, and perfuade it, that it fees what it really does not fee ; I mean, a continuity which their extremities conceal.

ANY loading or overcharge in colouring, whether to cover a ground, or give diftance to work, or make good the injuries of time, ought to be fo difcretely managed as not to deftroy the character of an object.

WE muft avoid, as much as poffible, the repetition of the fame colour in a picture ; but 'tis commendable to approach it by the principles of union and elegance. A fine inftance of this we fee in *the marriage of Cana*, by *Paul Veronefe*, where feveral whites and yellows meet harmonioufly.

THE eye grows tired with viewing the fame objects ; it loves a well imagined variety ; repetition is furfeiting in all things.

IN painting, as in any thing elfe, things become valuable only by comparifon ; practice and experience make us learned in this point.

COLOURS, which, either by mixture lofe ftrength, or become harmonious with others, are called broken colours. Their forts are infinite, and *Paul Veronefe*, for his happy fuccefs in this, may be a good copy. In order to fucceed in it, he affected to make choice of light colours, which he made more apparent by ftill lighter grounds. His

P 4 tafte

tafte was chiefly for wrought ftuffs, of a fweet colour; thefe he purchafed at great expence, to paint after.

'TIS wonderful that before, and even in *Raphael's* time, painters were fo jealous of their outlines, that they took no care to melt them into their grounds. It is really probable, that they were not acquainted with the paffages of antient authors, in praife of melting one object into another; for they only obferved regularity and precifenefs in their outlines.

So true it is, that there are times and countries where people blindly follow the prevailing practice, and where the fkilful draw in their pupils to their own habits, and are looked upon by them as infallible. Hence it appears, that it is a great happinefs for thofe who defign to be painters, to fall into the hands of able mafters. But what commonly happens is this:

AFTER the ftudent has made a fufficient progrefs in defign, and refolved to follow painting, he puts himfelf under a mafter, whofe fentiments he follows, and whofe works he copies. By this means his eyes and underftanding are fo accuftomed to thefe works, that for all the reft of his life he fees nature coloured in his mafter's manner; and yet, which is very extraordinary, fuppofe both mafter and pupil to fee nature very ill, I mean of a contrary colour to what fhe really

really has, and fhew them any pictures of *Titian*, or other good colourifts, they will neverthelefs admire thofe pictures, but ftill retain the tints and colouring they have been always ufed to; fo prevalent is habit, and fo hard to quit.

WHAT can we conclude from hence, but either that habit has debauched the painter's eye, or he has been negligent in correcting it? A thorough change is certainly very rare; for habit having made an alteration in the organs, 'tis hard to quit a manner we have been always ufed to, and find eafy in practice, for one which will coft much trouble. Let the pupil examine himfelf on this point, and without lofing courage; and, after having difcovered the right way, let him ufe all endeavours to follow it.

AFTER what I have faid on the practice of painting, I muft own, that I have paffed many things over in filence which relate to this fubject; but as what I have here communicated, I only learned by examining, with great attention, the works of the great painters, efpecially thofe of *Titian* and *Rubens*, and as the ftudent himfelf muft draw from the fame fource, I therefore refer him thither : To *Rubens*, in the firft place, becaufe his principles are more apparent, and eafy to the apprehenfion; and then to *Titian*, who feems to have polifhed his

<div align="right">pictures,</div>

pictures, I mean, to have made truth and exactnefs more apparent in his local colours, at a reafonable diftance ; but yielding to *Rubens* for grand compofitions, and the art of fhewing, at a greater diftance, the harmony of his whole together.

OF

OF THE

CLARO-OBSCURO.

THE knowledge of lights and fhades, which painting requires, is one of the moft important and moft effential branches of the art. We only fee by means of light, and light draws and attracts the eye with more or lefs ftrength, as it ftrikes the objects of nature ; for this reafon the painter, who is the imitator of thefe objects, ought to khow and chufe the advantageous effects of light, that he may not lofe the pains he may have taken in other things, to be an able artift.

THIS part of painting includes two things, the incidence of particular lights and fhades, and the knowledge of general lights and fhades, which we ufually call *the claro-obfcuro*. And tho', according to the force of the words, thefe two things feem to be the fame, yet they are very different, becaufe of the ideas we are ufed to entertain of them.

THE incidence of light confifts in knowing the fhadow which a body, placed on a

certain

certain plane, and expofed to a given light, ought to make upon that plane; a knowledge eafily attained from the books of perfpective. By the incidence of lights we therefore underftand the lights and fhades proper to particular objects. And by the word *claro-obfcuro* is meant the art of advantageoufly diftributing the lights and fhades which ought to appear in a picture, as well for the repofe and fatisfaction of the eye, as for the effect of the whole together.

THE incidence of light is demonftrated by the lines which are fuppofed to be drawn from the fource of that light to the body enlightened; and this the painter muft ftrictly obferve; whereas the *claro-obfcuro* depends abfolutely on the painter's imagination, who, as he invents the objects, may difpofe them to receive fuch lights and fhades as he propofes in his picture, and introduce fuch accidents and colours as are moft for his advantage. In fbort, as particular lights and fhades are comprifed in general ones, we much confider the *claro-obfcuro* as one whole, and the incidence of particular light as a part which the *claro-obfcuro* prefuppofes.

BUT in order to underftand thoroughly the meaning of this word, we muft know, that *claro* implies not only any thing expofed to a direct light, but alfo all fuch colours as are luminous in their natures; and

obfcuro,

obſcuro, not only all the ſhadows directly cauſed by the incidence and privation of light, but likewiſe all the colours which are naturally brown, ſuch as, even when they are expoſed to light, maintain an obſcurity, and are capable of grouping with the ſhades of other objects: Of this kind, for inſtance, are deep velvets, brown ſtuffs, a black horſe, poliſhed armour, and the like, which preſerve their natural or apparent obſcurity in any light whatever.

IT muſt be further obſerved, that the *claro-obſcuro*, which contains and ſuppoſes the incidence of lights and ſhades, as the whole includes a part, reſpects that part in a particular manner; for the incidence of light and ſhade tends only to point out precifely the parts enlightened and ſhaded; but the *claro-obſcuro* adds to this precifeneſs the art of giving objects more relief, truth, and apparency; as I have elſewhere demonſtrated.

BUT more plainly to diſcover the difference between the *claro-obſcuro*, and the incidence of light; the former is the art of diſtributing advantageouſly the lights and ſhades, both in particular objects, and generally throughout the picture; but it more particularly implies the great lights, and great ſhades, which are collected with an induſtry that conceals the artifice. And in this ſenſe, the painter uſes it for ſetting
objects

objects in a fine light, and repofing the fight, from diftance to diftance, by an artful diftribution of objects, colours, and accidents; and thefe are the three ways which lead to the *claro-obfcuro,* as we fhall further illuftrate.

1. *The Diftribution of Objects.*

THE diftribution of objects forms the maffes of the *claro-obfcuro,* when, by an induftrious management, we fo difpofe them, that all their lights be together on one fide, and their darknefs on the other, and that this collection of lights and fhades hinder the eye from wandering. *Titian* called it *the bunch of grapes,* becaufe the grape, being feparated, would have each its light and fhade equally, and thus dividing the fight into many rays, would caufe confufion; but when collected into one bunch, and becoming thus but one mafs of light, and one of fhade, the eye embraces them as a fingle object. This inftance muft not be underftood literally, either as to the order, or the form, of a bunch of grapes; but only, as an obvious comparifon, to fhew a conjunction of lights, and alfo of fhades.

2. *The Bodies of Colours.*

THE diftribution of colours contributes to the maffes of lights, and to thofe of fhades,

fhades, whilft direct light is of no other
affiftance in this refpect, than as it makes the
objects vifible. This depends on the painter's
management, who is at liberty to introduce a.
figure cloathed in brown, which fhall remain
dark, notwithftanding any light it may be
ftruck with ; and the effect will be the
greater, as the artifice will not appear. The
fame management and effect may be under-
ftood of all other colours; according to the
degree of their tones, and the painter's oc-
cafion for them.

3. *Accidents.*

THE diftribution of accidents may be of
fervice in the effect of the *claro-obfcuro,*
whether in light or in fhade, Some lights
and fhades are accidental : Accidental light
is what is but acceffory to a picture, or
proceeds from fome accident, as the light
of a window or flambeau, or other luminous
caufe; which is neverthelefs inferior to the
original light. Accidental fhades are, for
example, thofe of the clouds in a landfkip,
or of fome other body fuppofed to be out
of the picture, and giving advantageous
fhades. But in the cafe of thefe flying
fhadows, we muft take care, that the fup-
pofed caufe of them be probable.

THESE feem to me to be the three ways
of practifing the *claro-obfcuro*; but all I
have

have faid will be to little purpofe, unlefs I make the ftudent fenfible of the neceffity of the *claro-obfcuro,* both in the theory and practice of painting.

BUT of the many reafons for this neceffity, I fhall chufe to mention four, which feem to me to be the moft important.

THE firft is taken from the neceffity of making a choice in painting.

THE fecond proceeds from the nature of the *claro-obfcuro.*

THE third from the advantage which the *claro-obfcuro* yields to the other parts of painting. And

THE fourth is drawn from the general conftitution of all beings.

The firft Proof, taken from the Neceffity of making a Choice in Painting.

THE painter feldom finds fatisfaction in cafual nature, as being generally fhort of what he aims at. He muft, by the help of art, make as good a choice of her as poffible, in all her vifible effects, in order to bring her to fome perfection. Now light and fhade are the vifible effects of nature, as well as the outlines of an human body, the attitudes, the folds of draperies, or any thing elfe that comes into compofition ; all thefe require choice, and therefore light does the fame. Now the choice of light is

nothing

nothing but the artifice of the *claro-obfcuro* ; wherefore the artifice of the *claro-obfcuro* is abfolutely neceffary in painting.

The fecond Proof, taken from the Nature of the Claro-obfcuro.

THE fenfes in general have an averfion for every thing that difturbs their attention : The eye is not fatisfied with bare feeing ; it muft alfo embrace its object with fatisfaction, and the painter muft remove every thing that would make it uneafy. Now the eye will certainly be difpleafed, when directing itfelf to its object, 'tis obftructed by others near it, whofe lights and fhades are as apparent as that object itfelf ; and 'tis as certain, that the knowledge of the *claro obfcuro* alone can give to the fight a peaceable enjoyment of this object; for, as we have faid before, it is the *claro-obfcuro* which prevents multiplicity of angles, and hinders the eye from wandering, by means of the groups of lights and fhades, of which it gives the knowledge : Wherefore the *claro-obfcuro* is of the greateft confequence in painting.

The third Proof, drawn from the Advantage which the Claro obfcuro *yields to the other Parts of Painting.*

FIGURES ought to be well fet and diftanced, their draperies well caft, and the

Q

paſſions of the ſoul finely expreſſed : In a
word, each object ſhould be characterized
by a juſt and elegant deſign, and by a true and
natural local colour. But it is as neceſſary
to ſupport all theſe parts, and give them a
good light, in order to make them the more
capable of attracting the eye, and of agree-
ably deceiving it, by means of the force and
repoſe which the knowledge of general lights
gives to a picture. This ſhews, what ad-
vantage the parts of painting receive from
the *claro-obſcuro*, and conſequently eſtabliſhes
the neceſſity of it.

The fourth Proof, drawn from the general
Conſtitution of all Things.

IT is certain, that all beings tend to unity,
either by relation, or compoſition, or har-
mony ; and this as well in things human as
divine, in religion as politicks, in art as na-
ture, in the faculties of the ſoul as the or-
gans of the body. God is one, by the ex-
cellence of his nature : the world is one.
Morality brings every thing within the com-
paſs of religion, which is one ; as politicks
makes every thing ſubſervient to the govern-
ment of a ſtate. All nature preſerves, in
all her productions, an unity reſulting from
the many members in animals, and parts in
plants ; and art aſſigns various precepts for
making one only work. The ſeveral con-
ditions

ditions of men fit them for commerce and
fociety, as the feveral wheels of a machine
act for a principal motion. The faculties of
the foul are, at one time, taken up with
one thing only, in order to act well ; and the
organs of the body cannot fatisfactorily en-
joy more than one object at a time; for if
you fet many before them at once, they will
not fix upon any; and this multiplicity will
divide them, and intirely take away the
liberty of their functions. If, in a publick
affembly, two or three perfons fpeak at once,
in the fame tone, and with the fame force,
the ear, inftead of receiving what is faid,
will be ftunned with a confufed noife. In
the fame manner, if we prefent to the fight
many objects, diftinct and equally apparent,
'tis certain, that the eye not being able to
collect all thofe objects at once, will through
their divifion have fome pain in coming to a
determination. Thus, as in a picture there
ought to be an unity of fubject for the eyes
of the underftanding, fo there ought to be an
unity of object for thofe of the body. This
unity is only to be procured by the know-
ledge of the *claro-obfcuro*, and without it
we cannot view an object with any eafe or
fatisfaction.

WHEN I fpeak of the unity of object in a
picture, I muft be underftood to mean fuch
a diftance as the eye can reafonably take in,
without being diftracted by many diftinct ob-

jects,

jects, as ufually falls out in a fmall number of figures. Pictures may be large, and full enough of work to contain three groups of *claro-obfcuro*; and then the lights and fhades of each group, being fufficiently fpread, draw and fix the eye for fome time; giving it leave, however, to pafs from one group to another; and yet thefe groups of objects, and of the *claro-obfcuro*, in the fame picture, tend fo much to unity, that one of them ought to predominate. For this reafon the painter is obliged to bring into this group the principal figures of his fubject as much as poffible. This fubordination of groups creates a further unity, which we call *the whole together*; but care muft be taken, that thefe groups neither range too much, nor look ftarch, nor confufed, nor be alike in fhape; for 'tis indifferent to the eye, whether the maffes of the *claro-obfcuro* be of a convex, or concave, or any other figure.

WE muft only obferve, that tho' in great works the maffes of light and fhade neceffarily affift each other, yet the maffes of fhade muft not fo forcibly contribute to the repofe of the eye as to leave it in a ftate of inaction with regard to the light maffes. The painter fhould, in this point, imitate the orator, who, when he would fix the attention of his audience upon a certain particular paffage, which he would illuftrate and enforce, begins with fomething of lefs confequence,

and,

and, after having fixed the object in the mind. of his hearers, he refreshes them with speaking of something more temperate; but without ever suffering their attention to flag. In the same manner the painter makes his lights to shine, and supports them by masses of brown, which repose the eye, without hindering its being entertained by objects less apparent.

WE may even sometimes introduce single objects, but it must be done with prudence, and they must be brown in the light masses, and light in the brown, either for breaking through too great silence in a picture, or for loosening some figures, or for taking away affectation from the work. In a word, the whole should so appear as if every thing fell out by chance.

BUT I must own, that every painter has not the gift of thus concealing the artifice of the *claro-obscuro*, and executing it with industry.: It requires as much reflection and delicacy, as it starts new difficulties in every new subject. The geniuses proper for it are such as pierce through every thing, and know how to acquit themselves happily of what they undertake.

WE might here add, as a further proof of the force and necessity of the *claro-obscuro*, the praises which painters themselves always bestow on the works where that artifice appears, and also on the authors of them.

IN effect, whoever will reflect on the advantages which all the parts of painting receive from the *claro-obscuro*, muft own, that any picture, be it ever fo correct, and ever fo faithful in defign, and local colouring, is, without that artifice, dull and tafte-lefs; whereas another painting, where the defign, and the local colours are but tolerable, if fupported by the faid artifice, will not fuffer the fpectator to pafs unconcernedly by ; it will even call to him, and detain him for fome time, whether he have a tafte for painting, or not. What then would be the effect, if the *claro-obfcuro* was fupported by fine performance in other parts, and the work was viewed by a good judge, or fkilful lover of painting ?

I THOUGHT it would not be improper to give here the principal explications of the effect of the *claro-obfcuro*, to let the reader at once into what has been faid upon this fubject.

Fig. I. *Plate* II. proves the unity of an object, as it has been treated in the difcourfe of *Difpofition*. We fee there alfo a demonftration of objects entering the picture in perfpective : Both diminifh equally in force as they recede from the centre of vifion. Their only difference is, that the latter decreafe in magnitude, according to the rules of perfpective, as they go off from the faid centre ; and the former, which only extend

to

A Demonstration of the Unity of the Object.

Page 230.

Plate II

Fig. 1.

The Clair Obscure on a Single Object.

Fig. 2.

The Clair Obscure on a Group of Objects.

Fig. 3.

Clair Obscure on Objects disperfed and consequently without effect.

Fig. 4.

to the right and left of that centre, grow fainter by diftance, without lofing their forms or bignefs.

Fig. II. of *Plate* II. fhews how to handle a particular object, in order to give it relief; which is, to ufe, in the fore-part, the moft lively light, and ftrongeft fhades, always pre-ferving the reflected lights, near the turning on the fide of the fhade.

Fig. III. of *Plate* II. proves the neceffity of grouping, for the fatisfaction of the eye. This was *Titian's* great rule, and ought ftill to be the rule of thofe who would obferve in their paintings that unity of object, which with fkilful colouring conftitutes all the har-mony of the art.

Fig. IV. of *Plate* II. fhews the neceffity of preferving unity of object in making groups, according to the bignefs of the picture, and the number of its figures; for, as we have faid, we muft, to pleafe the eye, fix it by a predominant group, which, by means of the repofes caufed by a fpread of lights and fhades, does not hinder the effect of other groups, or fubordinate objects; for, if the objects are difperfed, the eye is at a lofs which to fix upon, and is in the fame cafe with the ear, when many perfons are fpeaking at the fame time.

MUCH more might be faid on the fubject of lights and fhades, which indeed is of great extent; but I content myfelf with

Q 4 giving,

giving, according to my notion, an idea of the *claro-obfcuro*, and fhewing the feveral methods of practifing it, together with its abfolute neceffity in painting. Thofe who would know more of it, may confult my commentary on *du Frefnoy's* poem, beginning at the 267*th* verfe, and continued for feven or eight leaves following.

SCULPTORS, as well as painters, when they have occafion, may practife the *claro-obfcuro* by the difpofition of their figures, or by the place where their work is to ftand. The cavalier *Bernini* has left pofterity fome illuftrious inftances of this in fome churches of *Rome*, where he has difpofed the fculpture to the lights of the windows, or elfe has pierced the windows for an advantageous opening, when he had leave, in order to let in fuch a light as might produce an extraordinary effect, and awaken the fpectator's attention ; but the fkilful fculptor may go yet further, by adding to the *claro-obfcuro* the local colours, if he underftands them ; Of this we have two wonderful examples at Monf. *le Hay's* in the *Grenelle-ftreet*, in the fuburbs of *St. Germains*. They are in two cafes ; one is, *the defcent from the crofs*; and the other, *the adoration of the fhepherds*. Thefe two fubjects are fo profoundly and beautifully handled, that I believe the publick will be pleafed with their defcription ; and tho' I have drawn it with all poffible exactnefs,

exactnefs, yet I queftion not but the curious
will find it far fhort of the fublime, which
the abbot *Zumbe*, the author of thofe works,
has attained in all the parts of his art. It
would here be proper to fay fomething of
the life of that illuftrious man ; but I have
thought it would be more fo to referve it
for a fecond edition, which is going to be
publifhed, of my *Lives of the Painters* ;
wherefore I fhall here only give the defcri-
ption of thefe fculptures : Which I have
fubjoined to the end of this work, that the
order of my prefent difcourfes might not
be interrupted.

O F

OF THE
O R D E R

Which ought to be Obferved in the

STUDY of PAINTING.

MOST of the fkilful painters have taken great pains, and fpent many years in the fearch of knowledges, which they might have attained in a little time, had they hit at firft upon the right path. This truth, of which all ages have been convinced by experience, principally concerns youth; and it is youth efpecially, who, while they are greedily purfuing knowledge, have need of light to conduct them orderly to the point they aim at.

PAINTING may be confidered as a fine parterre, genius as the ground or foil, principles as the feeds, and good underftanding as the gardener who prepares the earth for receiving the feeds in their feafons, and raifes all forts of flowers both for profit and delight.

'T I S

'T I S certain that the genius, which gives birth to the fine arts, cannot lead them to perfection without culture; that culture is impracticable without the direction of the judgment; and that judgment is of no use, unlefs grounded on true principles. We muft therefore fuppofe a genius in all our under-takings, which would otherwife be lame and imperfect. It muft be owned, that all ages are not equally rich in producing real geniufes, and that art grows weak for want of fkilful men : But this ought not to dif-courage fuch as endeavour to be as good as they can. The earth yields according to its ftrength, and the feed fown: Genius, in the fame manner, by cultivating, will always produce fomething, more or lefs, in pro-portion to its elevation and extent. Thus genius has its degrees, and nature has fixed one for fome things, and others for others, as may be obfervable, not only in the feveral profeffions, but even in the feveral parts of the fame art or fcience. In painting, for inftance, one may have a genius for por-traiture or landfkip, for beafts or flowers; but as all thefe parts meet in a genius proper for hiftory, it is certain, that fuch a genius ought to prefide over all the kinds of paint-ing; and the rather, becaufe, if it fhould fucceed better than others, this is the com-mon effect of its being more employ'd in this part of painting; and becaufe, feeling a
.talent

talent for history, it has embraced this part
with pleasure, and had more frequent oc-
casions to examine and practise it. But let
this be said, without derogating from those
geniuses, which, after being inlarged enough
to succeed in history, have applied them-
selves, either occasionally, or through taste,
to one part of painting, rather than another:
For painting ought to be considered as a long
pilgrimage, where, in the course of the
journey, we discover several things capable
of diverting the mind agreeably for a while :
We consider the several parts of the art, and
stop in the way to it, as a traveller bates at
an inn ; but if we make our abode at that
inn, because we find beauties there agreeable
to our taste, or suiting our interest, and
therefore are satisfied to view, at a distance,
or rather to hear talk of our journey's end,
we must never expect to finish our pilgrimage,
and come up to the perfection of painting.

THIS is certainly the case of those, who
intend to be painters, and yet, passing thro' the
parts of the art, are stopped by the charms of
some of them, without considering that perfect
painting arises only from the perfection and
union of them all. What is therefore of the
greatest importance, is the cultivation of that
genius which ought to preside over all the parts
of painting. History demands its whole appli-
cation and attachment, and forbids it to en-
gage in any disputes that may delay its pro-
grefs,

grefs, or in any affair that may divert or encumber it.

But a pupil's difpofition for inftruction may poffibly caufe an averfion in a mafter, through fear of lofing, in a fmall time, the fruits of his long experience; for, by imparting his lights, he may be either equalled or furpaffed by his pupil. To this I anfwer, That to bury one's knowledge in this manner, is neither natural, chriftian-like, nor politick. 'Tis not natural, becaufe nature's property is to beget her like; nor chriftian-like, fince 'tis the part of charity to inftruct the ignorant; I mean, fuch as have talents to learn; and 'tis impolitick, becaufe the mafter's reputation fpreads, and is preferved, by that of his difciples, who tranfmit to pofterity the glory of their inftructors.

If, among the fkilful painters, fome of the youngeft plead intereft againft communicating their lights and fecrets, and it be thought a fufficient reafon, yet we cannot excufe the more advanced in age, nor thofe whofe reputation is fixed; becaufe, far from running any rifque, their good intentions will be a fatisfaction to themfelves, and procure them the praife of others; for, What do fuch mafters? They only find methods for removing difficulties, fhortening time, and putting their difciples in a way to perfect their tafte and genius.

I AM

I AM aware, that able painters (I mean in general) may have taken different methods of ftudy, and therefore muft lead their difciples by different roads, though all tending to the fame point. I know alfo, that there are fome, who, after having ftudied, without order, and fpent many years in the fearch of a good method, have not found it till very late, and who after being better inftructed, and having difabufed themfelves, would be very capable of pointing out to youth the beft methods of ftudy; but my furprize at the many years ufually affigned for this ftudy, obliged me here to give my thoughts upon the fubject, and upon the order I could wifh were obferved in it.

I SHALL not determine at what age one ought to begin ftudy, becaufe, in all profeffions, genius and application are half the work : Yet fuch as propofe to be painters, cannot fet about defigning too foon ; for, as their genius comes to fhew itfelf by practice, they may be fuffered to go on, if they have any; or, if they have none, may be employ'd about things for which they may feem to be better turned. But if their inclination for painting continues, care muft be taken, during their firft exercifes in defign, to put them in a method of reading and writing to advantage, in order to prevent the general indifference people have for reading, for want of its being familiar to them in their youth.

youth. And as painters ftand in great need of the helps arifing from thence, the firft books put into the ftudent's hands fhould be fuch as are agreeable, and fitting his age, to give him a tafte for reading; and afterwards, in proportion as the mind forms itfelf, nothing will better teach him to think well, than good books.

But, at what age foever one begins painting, every ftudent advances, more or lefs, in proportion to his genius. Some are drawn by their genius, and follow it; others are dragged by force : There are but few of thefe laft. Thefe make great progrefs in a little time, and no age is fet for them. But, as we are laying down a plan for ftudy, I think the ftudent fhould begin very young, according to the ufual cuftom of pupils.

Pliny tells us, that when *Alexander the Great* affigned to painting the firft rank among the liberal arts, he at the fame time ordered, that young people of condition fhould before all things learn to defign. *Alexander*, in fo doing, could have no other view than forming the tafte of his principal fubjects, by that difpofition to painting which defign gives the mind.

In effect, the firft fruit of defign is the exactnefs it creates in the eye of the defigner; and its firft ufe is to make a general diftinction in the characters of objects, and then

then to imprint on the, mind the principles·
of what 'is good in the fine arts; and, at
laft, the tafte being formed by a progrefs in
thefe principles, the defigner thus becomes
·more·capable of judging of the works both·
of art and nature.

.ALEXANDER,· who did not propofe to
make all thofe perfons of condition painters,
commanded them, however, to begin de-
figning betimes, that they might thus be
qualified, all their life-time, to judge, of
any object that offered.

·PAINTERS and fculptors have the greater·
reafon to obferve this law in their 'early
youth, as it not only enables them to give
their opinions on the works of others, but
alfo to compofe works of their own; of
which others are to judge.

THE firft thing which ought to be con-
fidered, in the purfuit· of an art which 'we
propofe to follow. all our life, is to make a
proper diftribution of our time, and to allow,
each ftudy as much of it as it requires. In
our younger years, for inftance, when rea-
fon is weak, and reflections unfeafonable,
we ought to make advantage of the foftnefs
of the brain; and purity of the organs, which
are then capable of any impreffion or habit
we would have them take.

IF this be fo, there are but two exercifes,
proper for the ftudent in his early years: The
one is, to accuftom his eye to exactnefs, in

faith-

faithfully fetting down on paper the dimenfions of the objects he copies, and the other, to ufe his hand to the crayon and pen, till he has got a neceffary facility in defigning; for exactnefs of eye, and facility of hand, are the two inlets to defign.

'Tis therefore of the laft confequence to young people, in order to begin painting well, and to make a fpeedy progrefs in it, not to difcontinue thefe two exercifes till they are perfect in them.

Now, if this point be of great importance to the ftudent, 'tis more fo to an academy; for if they will but attend to their own fupport and advancement, they muft look upon it as neceffary to admit no fcholar, who has not before fufficiently practifed drawing after defigns and plafters, that is, who has not acquired an exactnefs of eye, and facility of hand, in ufing the crayon; and that in the judgment of the officers in exercife. My reafon is, that when fcholars are received too young and ignorant into the academy-fchool, they wafte a great deal of time there, without tafte or difcernment; and, in fhort, without making any remarkable progrefs in their pretended ftudies: and yet, after fome years, relying more upon the time they have fpent, than the progrefs they have made, they rafhly fet up as competitors for the prize, of which they are wholly unworthy. Afterwards it happens, in confequence of

R this,

this, that thofe who pretend to the prizes of painting, being chips of the fame block, of ignorance, yield the fame fruit, either bad, or infipid.

THE young ftudent ought, in the next place, to learn geometry; becaufe, as he is, now advanced fo far as to reflect and reafon upon all the parts of painting, with which it is neceffary to be thoroughly acquainted; and as geometry teaches to reafon, and to infer one thing from another; it will ftand him in ftead of logick, and clear him out of all his doubts and perplexities.

THEN, as perfpective prefuppofes geometry, as the foundation of it, it is natural to place it next, and to apply to it, with the greater attention, as nothing can be done in painting without it.

BY this time the ftudent may be fuppofed to have got an habit of copying with eafe all forts of defigns, and of defigning all forts of pictures; and yet this habit muft not be confidered otherwife, than as a difpofition neceffary for attaining defign.

IN this view the young ftudent muft confider the imitation of fine nature as his chief aim, and be acquainted with the exterior characters of all the forms fhe produces. And beginning with her mafter-piece, man, he muft underftand anatomy, and human proportion, becaufe thefe two parts are the bafis of defign. Anatomy eftablifhes the
folidity

folidity of the body, and the proportions form its beauty. The proportions derive from anatomy the truth of their outlines, and anatomy owes to the proportions the exact regularity of nature in her firft intentions. In fine, both thefe parts mutually affift to make a defign folid, and perfectly correct.

THO' thofe two parts feem to be linked together, yet it is beft to begin with anatomy, as being the offspring of nature, whereas proportion is the product of art; and if proportion arife from good choice, good choice owes its origin to nature.

IN the ftudy of the proportions, the general ones muft, in the firft place, be well underftood; I mean, fuch as generally fuit each part, fo as to make a *finifhed whole*. Thus, we muft know, how an head, foot, or hand, ought to be made, and, in fhort, the whole body, in order to form a perfect man.

BUT nature being various in her productions, we muft obferve what fhe produces that is fineft in the different characters of men, arifing from the diverfity of their ages, countries, and profeffions.

NATURE indeed affords fuch a variety as is infinite; but as her riches have their allay, 'tis beft, at firft, to have recourfe to the antique for an exquifite choice in all the ages and conditions of life. The antique figures not only contain every thing that is

moft

moſt beautiful, in the proportions, but are in themſelves the very fources of grace, elegance, and expreſſion : and the ſtudy of them is the more neceſſary, as 'tis the path that leads to beautiful truth. And this we muſt purſue, without regard to the time it may take ; for, ſince the antique is the rule of beauty, we muſt perſiſt in deſigning after it, till we have formed a juſt and ſtrong idea of it, that may help us to view nature in the beſt manner, and to bring her back to her firſt intentions; from which ſhe often departs.

As the fineſt pattern we have for this conduct, are the works of *Raphael*, 'tis proper to copy them at the ſame time, that they may ſerve to guide us in the happy mixture he has made of the antique with nature.

HERE, by-the-bye, we muſt obſerve, that in the antique there is a general taſte diffuſed over all the works of thoſe times, and a particular one, characterizing each figure, according to its age and quality; and this muſt be the ſubject of the ſtudent's careful reflections, according to the compaſs of his improvement and penetration.

HAVING ſpent the neceſſary time in the aforeſaid ſtudies, we muſt now conſider them as ſteps, by which the underſtanding riſes to the knowledge of the natural object, both ſuch as it is, and ſuch as it ought to be. By theſe firſt ſtudies we diſcern the defects

of

of our copy, and how far 'tis fhort of per-
fection; and our ideas inform us, what muft
be added to, or taken from the life, to make
it as perfect as we think it ought to be.

'Tis here therefore we ought to place
the ftudy of the model; which, with con-
traft and ponderation, completes the ftudy
of the attitudes.

As in fetting a model 'tis neceffary to find
an attitude that has a natural contraft, and
fhews its fineft parts, it is alfo neceffary to
give it relief and roundnefs : but as the relief
and roundnefs of one particular object is not
fufficient in a company of figures ; and as, to
pleafe the eye, and for the effect of *the
whole together*, there muft be a knowledge
of lights and fhades, which is called *the
claro-obfcuro* ; it follows, that this ftudy
cannot be difpenfed with. It demands a
particular attention, and ought to be the
more thoroughly maftered, as the *claro-
obfcuro* is one of the principal grounds of
painting, as its effect calls to the fpectator,
as it fupports the compofition of a picture,
and as without it any pains beftowed on
particular objects would be loft labour.

After this part of painting is well un-
derftood, it is proper, in order to root it
deep in the mind, to view attentively the
prints of thofe mafters who beft underftood
lights and fhades, and to go to the bottom
of this knowledge, in order to confirm the

R 3 ftudent

ftudent in that of the *claro-obfcuro.* He
muft alfo have a general acquaintance with
the prints and defigns of the great mafters,
to fhew him how they managed both in
compofition and fimple figures.

Good prints, as well as good drawings,
are alfo proper to warm the genius, and ex-
cite it to produce the like. We are made
fenfible of the character of each object by its
different drawing and handling; and, having
copied after good mafters, we perceive that
thofe fine touches and handlings are the
foul of defign. Thefe we muft imprint in
our mind, in order to gain more difpofition
and facility to obferve in nature the man-
ner of expreffing the character of objects.
The ftudent muft ufe all his endeavours to
feed his eye with the fight of thefe fine
things.

But, to rivet them in his memory and
underftanding, it will be convenient to copy
and make extracts of their fineft parts, fuch
as he moft wants, or his genius chiefly leads
him to : 'Tis in fuch cafes that intelligent
and fincere friends, who often know our
weakneffes, and the bent of our genius, bet-
ter than ourfelves, may affift us with their
counfels and knowledge, if confulted.

Thus far painting and fculpture have
gone hand in hand ; for I fuppofe the
fculptor to be ufed to defigning on paper,
as I defire the painter, for his own profit, to
learn

learn to model. Each of them muſt now take a path of his own, in order to, arrive happily at his end, which is, the imitation of nature : The ſculptor muſt give relief to his matter, and the painter uſe his colours on a flat ſuperficies. But my preſent deſign is chiefly to direct the painter, in order to bring him to the end of his career.

THE method I have thus far pointed out, only relates to the ſtudy of deſign ; what I have yet to ſay relates chiefly to colouring.

SEVERAL painters think, that the ſtudy of deſign implies that of colouring ; becauſe, ſay they, ſeveral good deſigners, having too long enjoyed the pleaſures and charms of deſign, have ſo filled their mind with it, that they left no room for colouring ; or, having made too great progreſs in deſign, they ſoon grew tired of colouring, which was uneaſy to them. For which reaſon they returned to the pleaſure they found in their habit of deſigning ; for 'tis a pleaſure to do what we can eaſily do.

THESE reflections are certainly not groundleſs. But to comply, in ſome meaſure, with the weakneſs of men who do almoſt every thing by habit ; I think that the ſtudent ſhould, in the courſe of deſigning, ſometimes handle the pencil and colours, to make this part, through early cuſtom, a pleaſure to him. But if we go to the bottom of theſe inconveniences, they will not

R 4 appear

appear to proceed from not colouring early, but from beginning ill; I mean, either copying at firſt after bad things, or being tutored by a maſter who had not the principles of colouring.

WE naturally quit a bad manner of deſigning, as may be obſerved in thoſe who deſign; for they become more correct by practice, and by change of object and model; but it is very rare to exchange a bad manner in colouring for a better: I ſay, that it is not impoſſible, but very rare. *Raphael*, *Michael Angelo*, *Leonardo da Vinci*, *Julio Romano*, and other great maſters of thoſe times, followed the ſchools and the practice of the places where they were educated; and ſpent their whole lives without truly underſtanding good colouring. Even in our own times, *Voet*'s diſciples, tho' numerous, and men of good ſenſe, have not been able, whatever they could do, to ſhake off their maſter's bad manner. We have further inſtances of young painters, who, by beginning to copy pictures of trivial colouring, have retained that manner in every thing they coloured; making it as a glaſs, through which they ſaw nature coloured like their paintings. From hence we may infer, that a young man, who begins with copying an ill-coloured picture, ſwallows a poiſon, with which he himſelf will taint all his future performances.

BUT

BUT a folid judgment, and good education, can furmount difficulties, and correct bad tafte, where the underftanding is docile. There is no reafon therefore why we may not place here the ftudy of colouring, yet leaving every ftudent at liberty to refrefh himfelf fometimes, by interrupting the order of ftudy I am going to lay down.

THE ftudent's firft care muft be to begin with copying what he finds beft coloured, moft finifhed, and moft freely penciled in the works of the great mafters; among whom *Titian, Rubens,* and *Vandyke,* are of the firft rank: *Vandyke* chiefly, with regard to beginners, becaufe his good colouring is joined with freedom of penciling.

As colouring is not farther valuable than it perfectly imitates nature, the ftudent, after having obtained fome habit from the beft pictures, muft alfo copy after nature herfelf, examine and compare it with the works of the great mafters. This practice will accuftom his tafte to an idea of truth, and his eye to fee truth without any cloud or obftruction.

AFTER having thus acquired a good habit, and put his tafte in a condition to fear nothing, he may copy pictures of all manners, if he finds any thing in them to entertain the activity of his genius; but, like the bees, which gather their honey from feveral good flowers, he fhould chiefly copy excellent

excellent pieces, such as are best for forming
a good manner. He should do the same in
the fine productions of nature, whether
figures, beasts, or landskip, of which he may
make a collection, as well for common use
in the way of his busines; as to keep up
his taste, or to feed his curiosity.

BEING come to this pitch, and so fur-
nished, the young painter may fly with his
own wings, and, by reading or reflecting,
raise his thoughts, and exercise his imagin-
ation, in compofing variety of subjects,
adorning them with such choice of beauties
as nature affords in abundance.

BUT let him remember above all things
never to set about a picture till he has first
made a slight sketch of it in colours, where
he may give a loose to his genius, and re-
gulate the motions of it afterwards, in the
objects, and in the effect of the whole toge-
ther. This sketch must be made as quickly
as possible, after he has fixed his thought,
that the fire of his imagination may not have
time to evaporate; and, being only a loose
sketch, as we suppose it, he may afterwards
alter, add, or diminish, either in composition
or colouring, as he thinks fit.

AND now, having brought things to his
mind, he must, before he begins to dead-
colour the great picture, consult every thing
he has by him that is most beautiful either
in nature or the antique, and proper for his
subject,

subject, and draw exactly after each of them in their proper places, to save himself the trouble and vexation of alterations, and doing one thing twice. In this point *Raphael* went further: His method was, to paste as many papers together as made the size of his picture; and after having correctly designed, and put all things in their places, he transferred this cartoon to the ground he intended to paint on.

YET, if after all those precautions it should still be necessary, for the effect of the picture, to make some alterations, it will be prudent not to neglect them; the trouble will not be great, and there will, besides, be no room to reproach ourselves with any neglect.

THE artist being now supposed to have brought his work to good forwardness, he must consider what place it is to be hung in, and at what distance from the eye, and to regulate the force of his colouring and touches accordingly.

OF all geniuses, I believe there is not any which takes greater liberties than that for painting, nor any which suffers the bridle more impatiently; nay, I question not but several painters, besides some extraordinary geniuses, have, without any order of study, attained to a considerable reputation; though indeed not without losing much time for want of some method. But as, in a machine,

chine, the bad difpofition of the wheels retards the motion, fo the parts of painting, diforderly ftudied, confufe the underftanding and memory, and make things difficult either to be underftood or remembred : Wherefore the beft way is, to put our ftudies into fome order not inconfiftent with a reafonable liberty.

A
DISSERTATION,

WHETHER

POESY *be preferable to* PAINTING.

IT is not my defign to maintain, that painting excels poefy : I never doubted but thefe two arts go hand in hand, and equally deferve the fame honours. I have fpoken of them accordingly, when occafion offered; and in this I have only followed the fentiments of the moft celebrated authors. But as people do not always agree, even in points that are moft received; I find there are fome perfons of great diftinction, who have expreffed their difpleafure at my claffing poetry with painting. However much dif-pofed I may be to agree with them, I will examine this with all the application I can ; for if I muft at length come into their fenti-ments, they will not difapprove of my de-ferring to do it, till I have difabufed my-felf.

I

I PROPOSE, in profecuting this difcourfe, not to affert any thing but what is fupported by the beft authorities, both antient and modern ; and I muft premife, that where I mention poetry or painting, each of thefe arts is fuppofed to be in its higheft degree of perfection.

It is not poetry therefore I am going to attack, but it is painting I am to defend. When at length, through exercife and reflection, both thefe arts appeared in their greateft luftre, men of extraordinary genius gave the publick their rules, as well as productions, in each of them, to ferve as guides to pofterity, and to give an idea of their perfection. Yet both have been unhappily neglected, ever fince the fall of the *Roman* empire, till thefe latter ages, when *Raphael* and *Titian* for painting, and *Corneille* and *Racine* for dramatick poetry, have ufed their utmoft efforts to revive them, and bring them to their original perfection.

There is, however, this difference between them, that poetry has only difappeared, and is preferved pure and entire in the works of *Homer, Efchylus, Sophocles, Euripides,* and *Ariftophanes,* and in the rules of *Ariftotle* and *Horace.* Thus the way for latter poets was plainly pointed out, and the true idea of poefy preferved, or, at leaft, eafily recovered : whereas painting has been intirely annihilated, both by the lofs

lofs of the many volumes, which, according to *Pliny*, the *Greeks* wrote on the fubject, and by our being deprived of thofe per- formances, which the writers of thofe times have fo highly celebrated ; for I make but little account of the remains of antient paintings, that are extant at *Rome*.

IF therefore there be nothing left to give us a juft idea of painting, as practifed by the antients, that is, when arts were in their greateft perfection ; and if poetry appears at this time in its full luftre ; thofe who are given to poetry may thus be prejudiced in its favour, and induced to prefer it to painting : for it is certain, that many peo- ple of fenfe, far from confidering painting as in its antient efteem and perfection among the *Greeks*, have not given the leaft attention to it as revived in thefe latter ages, and now practifed ; and yet poffibly, when they meet a picture, they judge of the art by it, inftead of judging of it by an idea of the art.

NOW, tho' we have not yet recovered the idea of painting in its full extent, and its re-eftablifhment is not guided by fuch certain principles, and fuch perfect works, as poefy ; yet nothing hinders our conceiving a juft idea of it by the works of the beft painters, who have revived it, and by what we gather from thofe who have laid down the rules of poefy, as *Ariftotle* and *Horace*.

THE

The former affirms in his *Poetica* *, *That tragedy is more perfect than the epick poem; because it produces its effect better, and yields more pleasure.* And in another place † he says, *That painting yields an extreme satisfaction; because it comes so perfectly to its end, which is imitation, that such objects as we cannot behold in nature without horror, give us in painting an exquisite pleasure.* He adds, *That painting instructs, and affords matter of reasoning, not only to philosophers, but to every one.* And further, measuring the beauty of the two arts by the pleasure they afford, by their manner of instruction, and by the way they take in coming to their end, he says, *That painting yields an extreme pleasure, instructs more generally, and comes most perfectly to its end.* This philosopher therefore is very far from preferring poesy to painting. As for *Horace* ‡, he plainly declares, *That poesy and painting have always gone hand in hand, and had it in their power to represent whatever they would.*

But had we not these authorities, sense and reason plainly tell us, that poesy cannot relate any event which painting cannot shew. They have been a long time reckoned two sisters, in all things so perfectly like, that

* *Chap.* 27.
† *Chap.* 4.
‡ *De Arte Poet.*

they

4

they lend each other their office and name: painting is commonly call'd dumb poefy, and poefy, fpeaking painting.

BOTH arts require an extraordinary genius, which rather tranfports than guides: and we fee, that nature, by a fweet violence, has drawn great painters, and great poets, into their refpective profeffions, without allowing them time to deliberate or chufe. Were we to dive into their excellent works, we fhould feel in them a fecret impulfe, fomething more than human. *There is a God within us*, fays *Ovid* *, fpeaking of poets, *who warms and moves us.* And *Suidas* fays, *That* Phidias *the famous fculptor, and* Zeuxis *the incomparable painter, were tranfported to enthufiafm, and gave life to their works.*

PAINTING and poefy tend to the fame end, which is imitation. And it appears, as a learned author fays, *That, not content with imitating terreftrial things, they have mounted the fkies, to obferve the majefty of the Gods, and communicate it to men, as they paint men to make them Demigods.* In this fenfe, *Charles* V. † gloried not only in having fubjected provinces, but in having been thrice immortalized by the hand of Titian.

BOTH arts are intended to deceive; and, if we do but give attention to them, they

* *Fafti, lib.* 6.
† *Ridolfi.*

S will

will tranfport us, as it were, magically, out
of one country into another *.

T he ir bufinefs is, to inftruct while they
divert; to form the manners, and excite to
virtue, by reprefenting heroes, and great acti-
ons. This made *Ariftotle* fay, † *That fculp-*
tors and painters teach us to form our man-
ners by a fhorter and more effectual method
than the philofophers; and that there are
pictures and fculptures as capable of cor-
recting vice, as all the precepts of morality.

Both arts exactly preferve unity of place,
time, and object.

Both are built on the force of imagina-
tion, for the invention of their productions;
and on the folidity of the judgment, for their
good conduct. They are capable of chufing
fubjects worthy of them, and ufing fuch cir-
cumftances and accidents as may make them
valuable, rejecting any thing that is impro-
per or unworthy to be reprefented.

In fhort, painting and poetry both fet out
from the fame place, take the fame road,
and come to the fame end; and received
their greateft honours in the earlieft times,
when magnificence and delicacy fhone with
greateft fplendour.

The poets of thofe times received infinite
honours and rewards, and were excited by

* *Et modò me Thebis, modò ponat Athenis. Horat.*
Epift. 1. lib. 2.
† *Politicks, § 5.*

the

the prize given to thofe whofe works fuc-
ceeded beft: and all kinds of poefy had their
praifes and protectors. *Virgil* and *Horace*
* were loaded with favours by *Auguftus*.
Terence was admitted to an intimacy and
friendfhip with *Lelius*, and with *Scipio* the
conqueror of *Carthage*. *Ennius* was alfo che-
rifh'd by *Scipio Africanus*, and buried in the
† tomb of the *Scipio's*, on which a ftatue
was erected to him. *Euripides*, fo often ap-
plauded by all *Greece*, ‡ was raifed to the
higheft honours by *Archelaus* king of *Ma-
cedon*; and the *Athenians* regretted his
death by a publick mourning. *Homer* was
revered by all antiquity; and often honoured
with altars and facrifices. ‖ *Alexander*, on
vifiting the tomb of *Achilles*, could not help
faying, *Happy prince, who hadft a* Homer *to
fing their praifes!* Nor did *Alexander* march
without *Homer's* works in his cuftody: he
read them inceffantly, and ufed to place
them under his pillow. § Being prefented
one day with a cafket of great value, the
moft precious of all the fpoils of *Darius*,
his courtiers afk'd him, What ufe he would
put it to. He anfwered: To hold the works
of *Homer*.

* *Donat.*
† *Cic. pro Archiâ, Val. Max.*
‡ *Solin. Thomaftin.*
‖ *Vita Homeri.*
§ *Plutarch.*

BUT

BUT what has not *Alexander* done for painters? What mark of affection and efteem did he not fhew them?* He ordained, *That painting fhould have the firft rank among the liberal arts; and that none but the noble fhould practife it; and that in their tendereft youth they fhould begin their education with learning to defign;* thinking it the moft capable to difpofe the mind to a good tafte, and to the knowledge of other arts, and to make a judgment of the beauty of all objects whatfoever.

THIS Prince often vifited painters, and took pleafure in converfing with *Apelles* on the fubject of his art. *Pliny* fays, *That* Alexander, *touch'd with the beauty of one of his flaves, whofe name was* Campafpe, *whom he tenderly loved, made her fit to* Apelles *for her picture; and perceiving the painter to be alfo enamoured with her, he gave her to him; not being able to beftow a greater reward for the painting, than depriving himfelf of what he loved with paffion.*

† CICERO relates, *That if* Alexander *forbad any but* Apelles *to draw his picture, and all but* Lyfippus *to carve his ftatue, it was not only thro' a defire to be well reprefented, but alfo that nothing might remain of him but what was worthy of immortality, and*

* *Pliny,* 38. 10.
† *Ep. fam.* 12. *lib.* 5.

that

that he might shew his singular esteem for these two arts. I need here make no distinction between those two arts; for there is not any thing in *sculpture*, which the painter ought not to understand well, in order to attain perfection; and whatever is most beautiful in this art, is common to it and painting. Both have at all times come to an equal degree of perfection : painters and sculptors have always lived, as they live at this day, in a laudable jealousy with regard to the beauty and merit of their performances. And if the antique sculptures have been the admiration of the antients, as they are the wonder of the moderns, what must we think of the painting of those times ? since by its taste and regularity of design, it must have obtained all those praises which are due to the surprising effects of colouring.

IF we go farther back, than the times of *Alexander*, we shall find, that God himself made this art honourable by communicating his knowledge and wisdom to *Bezaleel* and * *Aholiab*, who were to embellish the temple of *Solomon*, and make it venerable by their works.

IF we consider, in what manner painting was rewarded, it will appear, that the pictures of excellent artists were purchased by *full measures* of pieces of gold, † *without*

* *Exod.* xxxi. *Josephus.*
† *In nummo aureo mensuram accepit, non numero.*

tale

tale or number: whence *Quintilian* infers, *That nothing is more noble than painting; since most other things are traffick'd for, and bear a price, whereas painting has none.*

*A SINGLE statue, by the hand of *Aristides*, was sold for 375 talents: another of *Polycletus* for 120,000 sesterces. † And the King of *Nicomedia* having proposed to ease the town of *Cnidos* of divers tributes, on condition they would give him the ‡ *Venus* of *Praxiteles*, which yearly drew thither a great concourse of people, ‖ they chose rather to remain tributary, than part with a statue which was the greatest ornament of their town.

THERE have been excellent painters, and excellent sculptors, who, highly sensible of the merit of their arts, consecrated their works to the Gods, believing mankind unworthy of them. § And *Greece*, in gratitude to the famous *Polygnotus*, who had given it pictures which were the admiration of the whole world, gave him a magnificent entrance into the towns where he had work'd; and ordained, by a decree of the senate of *Athens*, *That his charges should be borne by the publick in all the places thro' which he passed.*

* *Pliny; 10. 35.*
† *Cic. lib. 1. Ep. 7. Attico.*
‡ *Ælian. Hist.*
‖ *Cic. contra Verrem.*
§ *Plut. Op.*

IN

IN thofe times, painting alfo was fo much honoured, that fkilful artifts work'd not on any thing that was not moveable from place to place, and could not be preferved from fire. *They were very far, fays Pliny, from painting on a wall, that could belong but to one owner; that always continued in the fame place, and where the work could not be preferved from fire. Painting was not confined, as in a prifon, to walls; it remained indifferently in all towns, and a painter was a common good to all the world.*

THE honour paid to painting has been carried to *veneration.* King *Demetrius* gave memorable tokens of it at the fiege of *Rhodes;* where he could not forbear fpending fome part of the time he owed to the cares of his army, in vifiting *Protogenes,* who had juft then finifh'd the picture of *Ialyfus. This piece, fays Pliny, prevented the king's taking the town, for fear he fhould burn the paintings of this great artift : and not being able to fire it on any other fide than where this illuftrious man's cabinet was, he chofe rather to fpare painting, than to accept of the victory, that was offered him.* Protogenes, continues *Pliny, worked at that time in a garden out the town, near the enemies camp, and there finifhed the work he had begun, without being in the leaft difturbed at the noife of arms. The King having fent for him, and asked*

how

how he could dare to work amidst his enemies;
he answered, That he was very sensible, the
war Demetrius *had begun was against the*
Rhodians, *and not against the arts.* This
induced the King to appoint him a guard for
his safety, being glad it was in his power to
preserve the hand he had saved from the in-
solence of the soldiers.

GREAT perfons have loved painting with
paffion, and exercifed it with pleafure:
among others, *Fabius* a moſt famous *Roman,*
who, according to * *Cicero,* having had a taſte
for painting, and practifing it, would be cal-
led *Fabius Pictor.* By this he meant to give
freſh luſtre to his birth, according to the
idea, which was then entertained of painting.
For what in this art is admirable, ſays
Pliny †, *is, that it makes the noble more*
noble, and the illuſtrious more illuſtrious. Tur-
pilius a *Roman* knight, *Labeo* pretor and
conful, the poets *Ennius* and *Pacuvius, So-*
crates, Plato, Metrodorus, Pyrrho, Commo-
dus, Veſpaſian, Nero, Alexander Severus,
Antoninus, and feveral other Emperors and
Kings, did not think it beneath them to
ſpend fome part of their time in painting.

WE know what pains great Princes
have taken, at all times, to collect the pic-
tures of the great maſters; which they have

* *In Bruto.*
† *Mirum in hac arte eſt, quod nobiles viros nobiliores*
 facit. 34. 8.

eſteemed

efteemed among the moft precious orna-
ments of their palaces. And we daily ob-
ferve what pleafure the art yields to men of
high rank, and people of good fenfe, who
have a tafte for fine things. We know
with what diftinction the fkilful painters of
latter times have been treated by crowned
heads; and how highly *Titian* and *Leonardo
da Vinci* were efteemed by the Princes they
ferved. The latter died * in the arms of
Francis I. and the former gave fo much
jealoufy to the courtiers of *Charles* V. †. be-
caufe he delighted in that painter's conver-
fation, that the Emperor was obliged to tell
them, *he could always have courtiers, but
could not always have a* Titian. We know
alfo, that this artift having once dropt a pen-
cil, as he was drawing *Charles* V.'s picture,
the Emperor took it up; and, on *Titian's*
making apologies, and returning thanks,
he faid, Titian *deferves to be ferved by*
Cæfar ‡.

But, fuppofe the *idea* of painting, con-
fidered in its perfection, be not yet well
eftablifh'd, and that our prefent conceptions
of it, in all its parts, and powers of working
on the mind, have not a fufficient fund of
merit; whence comes the paffion which men
of diftinguifhed rank, and perfons of know-

* *Vafari.*
† *Ridolfi.*
‡ *Idem.*

ledge,

ledge, have for this art ? Whence còmès it, that others, who entertain an indifference for painting, care not to own it without a blufh ?

'Tis *an unhappinefs,* * *fays* a grave au-thor, *for a man to diflike painting, and re-fufe it the efteem it deferves : for he who does it out of ignorance, is very unfortunate not to difcern thofe beauties which the world af-fords; and he who does it out of contempt, is guilty of a wickednefs, in declaring himfelf an enemy to an art employ'd to do honour to the Gods, and to give inftruction and immorta-lity to men.*

As to the effects which poefy and paint-ing have on the mind, 'tis certain that both are capable of ftrongly moving the paffions. And if the fine pieces for the theatre have drawn, and ftill draw, the fpectators tears; painting can do the fame in a proper and well exprefs'd fubject. † *Gregory* of *Nice,* after a long defcription of *Abraham*'s facri-fice, fays, *I have often caft my eyes on a picture, which reprefented this moving fight, and never could take them off without tears; fo much has painting reprefented the thing as if it was real.*

THE end of painting, as well as poètry, is, in fuch a manner to furprife, that their

* *Dion. Chryfoftom. Or.* 12.
† *Or. of the Divinity of the Son and Holy Ghoft.*

imita-

imitations may seem to be truths. *Zeuxis's*
picture of * *a boy carrying grapes*, which
the birds peck'd at, is an inſtance, that the
painting of thoſe times uſed to deceive the
eye in the objects it repreſented : and
Zeuxis himſelf found no other fault with
the boy's figure, than that it had not alſo
deceived.

LET us now a little conſider the natural
agreements between poeſy and painting; *by*
which at all times, as *Horace* ſays, *painters*
and poets are allowed to be equally bold :
with this caution; *that ſuch liberty ought*
not to make them produce any thing that is
improbable ; as joining ſweet things with bit-
ter, tygers with lambs, or the like.

THIS general idea, in the next place,
obliges both artiſts to purſue the common
methods of good ſenſe and reaſon in all their
conduct : for we perceive, by one of *Ho-*
race's ſatires †, that he loved painting
extremely, and was allowed to be a good
judge of it. But the precepts he has left us,
reſpect only the theory of the two arts;
and they differ only in practice and perform-
ance. The practice of poeſy lies in diction
and verſification, ſuppoſing the latter to be
itſeſſential but to this we might add decla-
mation, as it is the ſinew of words, and be-

* *Pliny,* 35. 10.
† *Horat.* 3. 2.

cauſe

caufe without it we cannot well reprefent the manners and actions of mankind; which is the end of poefy. And painting is performed by means of defign and colouring.

THESE different manners of performance have indeed their values and difficulties; but, of the two, painting requires the moft ftudy and time: for diction may be obtained by the help of grammar, and by good ufe, which prevails among all people of diftinction, as they are under a neceffity to fpeak good language; tho' to do it purely and elegantly is the effect of ferious ftudy. Declamation, of which *Quintilian* treats very exactly, and without which, as he fays, *imitation, the very foul of eloquence, is imperfect*, depends on few principles, and almoft intirely on a natural talent. Verfification confifts of an harmonious meafure in its cadence, turn, and rhyme; which things indeed require reflection, yet by reading and practice may become familiar.

BUT, in defigning and colouring, the cafe is otherwife; for they require an infinity of knowledge, and obftinate ftudy. In the former, there muft be fuch an exactnefs of fight, for determining the various dimenfions of vifible objects, and fuch a great habit for fettling their outlines, that, as *Michael Angelo* faid, *the compaffes muft be in the eye, rather than in the hand.*

DE-

DESIGN implies the knowledge of the human body, not only as it commonly appears, but as perfect as it ought to be, and agreeable to the original intention of nature; 'tis founded on skill in anatomy, and in the proportions, which are sometimes strong and robust, at other times delicate and elegant, according to age, sex, and condition. And this point alone requires many years study and reflection.

DESIGN also obliges the artist to understand geometry perfectly, for the sake of exact perspective, which he has an indispensable occasion for in every thing he does.

DESIGN likewise requires an habit in shortnings and outlines; in which the variety is as infinite, as the number of *attitudes*.

IN design also is included the knowledge of physiognomy, and the expression of the passions of the soul; which are very necessary and valuable parts of painting.

COLOURING respects the incidence of lights, the artifice of the *claro-obscuro*, local colours, the sympathy and antipathy of particular colours, their agreement and union with one another, their aereal perspective, and the effect of the whole together. All these knowledges depend on the finest and most abstracted physics.

I SHOULD never have done, if I was to mention all the various ways, which painting has to express its thoughts; and, by what I

have

have faid, it appears to be as fruitful in invention as poefy, for pleafing and deceiving the eye, and affecting the foul.

B U T tho' thefe two arts be fifters, and very like in whatever is moft refined, yet we may afcribe to panting, feveral advantages over poetry; fome of which I fhall here fet down.

IN effect, if poets were allow'd to chufe their language, as foon as they had given the preference to one, and fixed upon it, they would fcarce be underftood by more than one nation : whereas painters have only one language, which imitates (if I may be fuffered to fay fo) that which God gave to the apoftles, and which all nations were to underftand.

PAINTING befides difplays itfelf, and enlightens us, all at once; whereas poefy goes not to its end, and does not produce its effect, but by making one thing fucceed another. Now, what is concife, fays *Ariftotle*, is more agreeable, and affects in a more lively manner, than what is diffufe. And if poefy increafe pleafure by the *variety* of its *epifodes*, and a detail of circumftances, painting can alfo reprefent as much of them as it pleafes, and by feveral pictures enter into all the parts of an action : and in whatever manner it expofes its works to view, the fpectator is not fuffered to grow tired. Paint-
ing

ing therefore yields a more lively pleasure
than poesy.

BUT painting has this farther advantage,
that it is conveyed by a sense which is the
most subtile, and the most capable of move-
ing us, and raising the passions; I mean,
the sight : *For the things,* says *Horace,*
which enter the mind by the ears, take a
much longer way than those which enter by
the eyes, which are more faithful and surer
evidences than the ears.

IF, after this first emotion, we weigh the
effects produced in the mind, it must be al-
lowed, that it is the property of both arts to
instruct; but that painting does it more gene-
rally : it instructs the ignorant, as well as the
learned. Without the assistance of painting
we find it difficult to fathom the other arts;
because to apprehend them it is necessary to
have demonstrative figures : and it is only for
want of these that the works of *Vitruvius,* and
of the antient *Hiero,* who treats of machines,
appear to us so obscure. But further : Of
what profit is not painting in books of travels?
Nay, is there any science, to the perfect
understanding of which painting is not ne-
cessary ? Can *Topography, Medals, Devices,*
Emblems, treatises of *Plants,* or of *Animals,*
be without the assistance which painting is
always ready to afford them ? To begin with
sacred story, what gladness, mixed with ve-
neration,

neration, fhould we not entertain, had
painting handed down to us the magnificent
Temple of Solomon? What pleafure fhould
we not take in reading the hiftory of *Pau-
fanias,* which defcribes all *Greece,* and leads
us, as by the hand, through the divifions of
that country, if this work were accompa-
nied with demonftrative figures?

IF the chief end of poefy be, to imitate
the manners and actions of men, painting
has the fame object; but proceeds in a more
extenfive manner: for it cannot be denied
but that painting imitates God in his omni-
potency, in the creation of vifible things;
that is, the poet indeed may defcribe them
by the force of words, but words will never
be taken for the things themfelves, nor can
they imitate that omnipotency, which at
once becomes manifeft by vifible creatures.
Now painting, with a few colours, and, as
it were, out of nothing, fo well forms and
reprefents all things, whether on earth, in
the waters, or in the air, that we believe
them to be real ; for the effence of painting
is to deceive the eye, and furprife us.

BUT one thing I will not pafs by, which
is in favour of poefy : it is, that *epifodes*
give the greater pleafure in the courfe of a
poem, the more imperceptibly they are
brought in, and interwoven with the reft.
Now painting may indeed reprefent all the
facts of ftory fucceffively, in feveral pictures;
<div align="right">but</div>

4

but cannot fhew either the caufe or the con-
nexion of them.

HAVING now drawn a parallel between
thefe two arts, our next bufinefs is, to
anfwer fome objections.

'TIS faid, that painting borrows of poefy;
that *Ariftotle* afferts, *That the arts, which
require manual performance, are lefs noble
on that account :* In a word, *That poefy is
wholly fpiritual, but painting is partly fpi-
ritual, and partly material.*

I ANSWER, That the mutual affiftance
which arts afford each other, fhews that
neither of them can difpenfe with the reft.
And it is fo certain, that painting borrows
no more of poefy, than poefy does of paint-
ing; that the falfe divinity, which gave rife
to fables, had not been made ufe of by the
poets in their fictions, if painters and fculptors
had not originally fet them before the eyes
of the *Egyptians* for their adoration.

OVID fays *, *That* Venus, *the goddefs
whom the pens of authors have made fo fa-
mous, had been ftill under water, did not
Apelles's pencil make her known.* As if poefy
had publifhed her beauties, but painting had
traced her figure and character.

* De Arte Amandi.

*Si Venerem Cous nunquam pinxiffet Apelles,
Merfa fub æquoreis illa lateret aquis.*

T HORACE,

H o r a c e, who had indeed a great taste for painting, tho' he devoted his fortune and reputation to poefy, fays, *That painters and poets have always had the liberty to under-take any thing.* Thus he owns, that, in matters of fiction, their power is neither limited nor reftrained.

I f we pafs from fable to hiftory, which is another fpring for both painters and poets equally to draw at, we fhall find, that, excepting the facred writers, moft others have written according to their paffions, or according to the memoirs which they were furnifhed with ; and therefore have left us room to doubt of many facts, which are often varioufly related. But the hiftorical facts of greateft certainty, according to the beft judges, are fuch as we fee eftablifhed and confirmed by antique medals and bas-reliefs, or elfe by the paintings with which the primitive Chriftians adorned the fubterraneous places, where they performed their worfhip : and thefe places were in *Rome,* and other parts of *Italy. Baronius* relates, that the people of *Rome,* having difcovered another city under ground, were tranfported to fee in painting what they had read in hiftory. In effect, *Bofius* and *Severan,* who have written large volumes upon *Subterranean Rome,* difcover to us, in the paintings which are preferved to this day, the antiquity of our facraments, the way in which the primitive Chriftians

offered

offered their prayers, and buried their martyrs, and feveral other particulars re-lating to the myfteries of our religion.

WHAT is it we do not learn from antique medals and fculptures ; variety of temples, altars, victims, vafes, pontifical ornaments, and implements for facrifice ; all forts of arms, chariots, fhips, inftruments of war, either for attacking or defending towns ; the feveral crowns, according to the feveral kinds of dignities and victories ; fo many various head-dreffes for the women, and fuch a diverfity of habits, according to times and places, in peace and war ? What books can give fuch certain accounts of the cuftoms and ufages among the *Romans*, as what we learn from the fculptures of thofe times ? The bas-reliefs of the *Trajan* and *Antonine* pillars are filent books, where indeed we find not the names of things, but the things themfelves which were in ufe, at leaft in the times of thofe Emperors.

THOSE who have treated of the religion of the antient *Romans*, their encampments, allegorical fymbols, iconology, and images of their gods, could bring no better proof of their affertions, than from the antique monuments of bas-reliefs and medals. In fhort, thefe, and the antient paintings afore-faid, are the moft infallible fources of eru-dition ; and 'tis for this reafon we fee among the learned fo great a curiofity and keennefs

T 2 after

after medals, graved ſtones, and other things in the fine arts, which bear the ſtamp of antiquity. From all that I have ſaid, both of fable and hiſtory, we may conclude, that poeſy borrows at leaſt as much from painting, as painting does from poeſy.

As to *Ariſtotle*'s aſſertion, *That the arts which require manual performance, are leſs noble on that account*; and as to what is added, *That poeſy is wholly ſpiritual, but painting is partly ſpiritual, and partly material* ; I anſwer, that the hand is no other to painting, than words are to poeſy ; both are the ſervants of the mind, and the chanels for conveying our thoughts : and as to the underſtanding, it is the ſame in both arts. *Horace*, who has laid down ſuch excellent rules for poeſy, ſays, * *That a picture keeps in equal ſuſpenſe both the eyes of the body, and thoſe of the underſtanding.* What they call *the material part* in painting, is nothing elſe but the execution of that ſpiritual part which is allowed it, and is properly the reſult of the painter's thought, as declamation is the reſult of the poet's. But the art of executing a thought in painting differs very much from that of rehearſing a declamation in a tragedy ; for this laſt requires but few precepts beſides the outward talents of na-

* *Suſpendit pictâ vultum mentemque tabellâ.*
Epiſt. I. *lib.* ii.

ture ;

ture; whereas the execution of painting requires much reflection and knowledge. The declaimer need little more than give himself up to his talent, and enter thoroughly into his subject. I know indeed, that *Roscius* the comedian acquitted himself with so much force, that for this reason alone, says *Cicero*, * *his death ought to be lamented by all worthy men ; or rather, he ought to live for ever.* But the painter must not only enter into his subject; but, as we have observed, he must be very skilful in design and colouring, and express, in a delicate manner, the various looks of persons, and the emotions of the soul. In any of these, the hand has no part, but as it is guided by the head. Painting therefore, properly speaking, has nothing in it, but what is the effect of a profound speculation. Even the bare motion of the pencil contributes to give objects their soul and character.

I T is further alledged, that the reasoning faculty, the most precious inheritance of man, which is found with all its ornaments in poetry, is not found in painting.

WHAT I have been just saying, might be more than sufficient to remove this objection; but I will clear it up a little further. It must be observed, that arts being only imitations, the reasoning, which is in a work,

* *Pro Archiâ.*

T 3 passes

paſſes only into the mind of him who judges of it. Let us therefore ſee, whether the ſpectator does not find a reaſoning in painting, as well as the ſtudent does in poetry.

BY the word *reaſoning*, is underſtood either the cauſe and the reaſon, why a work has a good effect ; or elſe the act of the underſtanding, by which it knows one thing by another, and from thence draws concluſions. If, by the word *reaſoning*, be underſtood the cauſe and the reaſon, why a work has a good effect, there is as much reaſoning in painting, as in poeſy ; becauſe both arts act by virtue of their principles. And if, by the word *reaſoning*, be meant the act of the underſtanding, which infers one thing by the knowledge of another, it will be found, when occaſion offers, as much in painting as in poetry. The heſt way to demonſtrate this truth is, by viewing ſome picture, to which we may have eaſy recourſe. The paintings in the *Luxemburg* gallery, repreſenting the life of *Mary de Medicis*, would be ſo many proofs of it. Among theſe I ſhall ſingle out *Lewis* XIII. as being moſt known,

UPON viewing this picture, we may, for example, infer, that the delivery happened in the morning ; becauſe the ſun appears in his chariot to be riſen, and taking his courſe upwards. We may alſo infer, that this delivery was happy, by the conſtellation *Caſtor*, which

which the painter has fet above in the picture,
as the fymbol of favourable events. On a
fide of the picture is *Fruitfulnefs*, turning
towards the Queen, and fhewing her, in an
horn of plenty, five little infants ; alluding
to the number which this Princefs fhould
bear. In the Queen's figure, we may eafily
judge, by the rednefs of her eyes, that fhe
had been fuffering the pains of child-bed ;
and yet, by thofe eyes, amoroufly inclined,
towards the new-born prince, and by the
lineaments of her face, which the painter
has divinely managed, it is eafy to obferve a
double paffion proceeding from the remains
of pain, and the beginning of joy : from
whence may be drawn this confequence,
that her maternal love and joy, at bringing a
Dauphin into the world, had made her forget
the pains of child-birth. The other pictures
in the fame gallery, which are all alle-
gorical, afford matter for reafoning from
the fymbols, which fuit the fubjects and
circumftances the painter was difpofed to
handle.

THERE is no fkilful painter who has not
fhewed the like reafoning, when his work
requires it : for tho' reafoning may enter
both into poefy and painting, yet productions
of thefe two arts are not always intermixed
with it, nor fufceptible of it. *Ovid's Me-
tamorphofes*, tho' poetick works, are moftly
but defcriptions. It is true, the reafoning
which

which is found in painting, is not for all
forts of underftandings. Yet thofe which
are a little above the common level, take
pleafure in diving into the painter's thought,
in difcovering the true meaning of his
picture, by the fymbols he makes ufe of in
it, and, in a word, in underftanding the
language of the mind; which language was
defigned not ultimately, but only immedi-
ately for the eyes.

Too great facility in difcovering, ufually
leffens the defire of it; for which reafon, the
firft philofophers thought it proper to couch
truth under fables, and ingenious allegories,
that their fcience might be fought with
greater curiofity, or elfe more firmly rooted
by keeping the underftanding attentive.
This management makes a much greater im-
preffion on the underftanding and memory, as
it more agreeably exercifes the attention. Our
Saviour himfelf took the fame method of
inftruction, that his comparifons and parab-
les might keep his hearers more attentive
to the truths they fignified.

In painting, conclufions may be alfo
drawn from the attitudes, expreffions, and
paffions of the foul: and we perceive, in
converfations and dialogues, the very fenti-
ments of the figures. In the Annunciation,
for inftance, when the Angel approaches the
Virgin *Mary*, the fpectator may eafily de-
termine, by her expreffion and attitude, the
very

very time the painter has chosen, and whe-
ther..this happened when she was troubled
at so unexpected a fight, or astonish'd at the
Angel's proposal, or when confenting with
such humility as made her fay, *Behold the
fervant of the Lord,* and so forth.

IT is plain, that *Ariftotle* himfelf makes no
difficulty to allow reafoning to this art, when
he fays, *That painting inftructs, and finds
matter for reafoning, not only to philofophers,
but to all men.* And *Quintilian* owns *, *that
painting penetrates the underftanding fo deeply,
and moves the paffions fo lively, that it appears
to have more force than any fpeech whatever.*

FOR the reft, reafon is not only found in
painting, but there difplays ornaments, ele-
gancies, agreeable turns, and fublimities, as
well as poefy. Harmony, which introduces
both arts, and procures them a gracious re-
ception, is indifpenfable in both : for we draw
from colours an harmony for the eye, as we
do from founds an harmony for the ear.

BUT, fay fome, whatever reafoning we
affign to painting, it can never be fo brightly
nor ftrongly exprefs'd as by means of words.

I AM very fenfible, that expreffions may
be attributed to words, which painting can
but imperfectly imitate; but I know too,
that poefy is very far from expreffing, with

* *'Pictura, tacens opus, & habitus femper ejufdem, fic
in intimos penetrat affectus, ut ipfam vim dicendi non-
nunquam fuperare videatur.* L. 11. c. 3.

fo much truth and exactnefs as painting, the things which fall under fight. Whatever defcription poefy gives of a country, whatever pains it takes to reprefent the look, lineaments, and colours of a face, it always leaves the·underftanding in the dark and uncertain, and never comes up to painting. We have feen feveral painters, who, not able, in words, to give an idea of perfons whom they were obliged to know, have made fingle-line fketches of them fo exact, that they could not be miftaken. The very men, whofe profeffion it was to perfuade, have often called in the affiftance of painting, in order to touch the heart ; becaufe the mind, as we have made appear, is fooner and more lively moved by what *ftrikes the eye, than by what enters at the ears. Words,* they fay, *are but wind, but examples are moving.* On *this account,* according to *Quintilian* *, who has laid down the rules of eloquence, *the advocates in criminal caufes ufed fometimes to fhew a picture, reprefenting the fact they were employed about, in order to move the hearts of the judges by the enormity of the fact.* The poor in antient times took the fame method for·defending themfelves againft the oppreffion of the rich, as *Quintilian* alfo attefts †; *becaufe,* fays he, *the money of the rich could eafily gain voices.* But *as foon as the picture, repre-*

* *Lib.* 6.
† *Del.* 252.

fenting

senting the injustice, appeared to the bench, it wrested truth from the hearts of the judges, in favour of the poor person. The reason is plain : Words are only the signs of things, whereas painting shews truth in a more lively manner, and moves and penetrates the heart more strongly, than can be done by discourse. In a word ; 'tis the essence of painting to speak by things, as that of poesy is to paint by words.

But some say, that painting speaks not, nor is understood, by things themselves, but by the imitations of things.

I answer, That is the very thing which raises the value of painting; since by this imitation, as we have observed, painting pleases more than the things themselves.

I could here alledge a great many of the best authorities in support of the merit of painting, if I was not afraid of making this discourse too prolix and too shewy. I have therefore contented myself with observing, how imperfect an idea some have had of the art, and the preference which for this reason has been given to poesy. I have endeavoured to shew the natural conformity between the two arts ; and touch'd on some *pre-eminencies*, that may be ascribed to each of them. I have answered some objections, which have been made to me ; and, in short, have done what I could to preserve to painting the rank which some would take from it.

A

A
DESCRIPTION
O F

Two Pieces of SCULPTURE, *in the* *Poffeffion of Monf.* LE HAY, *done* *by Seign.* ZUMBO, *a Gentleman of* SICILY.

THE author of thefe two pieces, one of which reprefents *the nativity of Chrift*, and the other his *burial*, has been often heard to fay, *That he chofe thefe two fubjects in order to exprefs two different paffions, joy and grief.* For this purpofe, he has chofen, in the ftory of the *nativity*, the arrival of the fhepherds, when they come to acknowledge and adore our *Saviour*, who, according to the Angel's words, *was to be, to all the world, the fubject of great joy.* In the ftory of the *burial*, he has fixed upon the time when *Jofeph* of *Arimathea* having begg'd the body of *Jefus*, the Virgin and other holy women attending her, exprefs their *grief.* And as this happy genius was very fenfible,
that

that colouring would be of infinite advantage to fet off his work, and give a value to his expreffions, he has accordingly coloured it, and by this means made both, the carnations and draperies appear with greater truth.

The Nativity.

TO follow the text of the Scripture, the author has laid the fcene in a place deftitute of all things; which, as appears by the ruins, had been antiently a temple for idols, but was now only fit to be a covert for beafts; and at beft a ftable open to the firft comer. The author has introduced into his compofition fome magnificence; to fhew, by this oppofition, *the poverty of Chrift*, and the *eftablifhment of Chriftianity on the ruins of Idolatry*. He further confidered, that in order to contribute to the joy which he intended to exprefs, he might, without abating the idea of the poverty of the place, introduce fomething of antient fculpture, in order to awaken the tafte of the fpectator, and renew the pleafure which judges take in fuch valuable remains of antiquity. Befides, as nothing can be more humble, nor more grand, than the birth of the Son of God, the author endeavours to allude to both, by mixing the ruins of a magnificent building with the beauty of its remains.

THE

· The fculptor has alfo introduced twenty-four figures, and fix beafts of feveral kinds. The *Virgin* and her *Son* are in the middle of the piece; fhe appears in a modeft cha-racter, but infinitely pleafing; and the child, preferving the figure of a new-born infant, difcovers, by his action, fomething more than human.

We may obferve a great variety in the figures, by their different faces, characters, fexes, ages, attitudes, and expreffions. Four fhepherds are taken up, in confidering, near at hand, the child and his mother, whom the Angel had pointed out to them. To the right are four others round *Jofeph*, who ex-plains the myftery to them, of which they are witneffes. The fhepherds difcover in different ways the effects of grace, by the joy they exprefs for this inftruction.

Others, on the fore-ground, and full of fear, adore the *Saviour* who is born to them.

On the left fide, are fome fhepherds dif-courfing of what they fee: one of them is calling to others farther off to haften and partake of the novelty of the fight.

In the clouds over *Chrift* and the *Virgin*, are four Angels, fuppofed to be fent from Heaven to make the fhepherds acknowledge their Divine Mafter, and with them to worfhip him.

The

THE dreffes, draperies, head-attire, and every thing elfe belonging to the figures are fo perfectly proper for them; that whoever examines particulars, muft needs admire the diverfity and probability. The expreffions efpecially are fo lively, and make fuch an impreffion on the mind, that they force our attention. In one we fee admiration, in another fimplicity, in another furprize, in another devotion; and each object denotes a fine choice of character. The figures are moft juftly defigned, in a great tafte, and in a manner proper to their conditions. We may alfo admire the tendernefs of the carnations, the fine folding of the draperies, the truth and contraft of the attitudes, the difpofition of the groups, and the diftancing of the grounds.

THE whole work is highly finifh'd; and the exact truth, that is obferved in all things, even to the plants and other minute circumftances, yields great pleafure. The very colours, which ufually little agree with fculpture, are managed with a certain moderation, which gives the whole a greater probability. Among other things, one of the ftatues appears to be of old marble, ftained and weather-beaten, and is very deceiving. In fhort, the whole compofition difcovers a wonderful harmony, and expreffes the fubject with all the agreeablenefs imaginable.

The

The Burial.

THE author of this excellent piece has chosen, as we have observed, the moment when *Joseph* of *Arimathea,* having taken down from the cross the body of *Jesus,* leaves it, for some time, to the care of the chief persons who loved him in his life-time. The situation of the place, which is rocky, suggests to us, that the scene is not far from the place intended for his burial.

CHRIST, his *Mother,* St. *John,* the three *Maries,* three *Angels, Joseph* of *Arimathea, Nicodemus,* and the *Centurion,* who acknowledged *Christ's* divinity presently after his death, are the persons who compose the story.

IN the middle of the piece, is *Christ's* body, carelesly, but naturally, laid out on a stone which is covered with a sheet; the disposition is suitable to a motionless body, yet so swayed, (as if by chance) as to move the spectator's compassion, even to weeping. The figure is so noble and delicate in proportion, that even in such circumstances we are ready to believe it to have something divine. The *Virgin* is next to the body, and rests his head upon her knees, in order to view it the better: her body is bent forwards, her arms raised, in a posture expressing tenderness, and all she feels upon seeing the present condition of her *Son, and her God.*

I THE

THE holy women of her company, with hearts overflowing with grief, difcover each in her way the force of compaffion, at the fight of fo moving a fpectacle. The notion thefe women had of Chrift's divinity might indeed well have quieted their fpirits; and effaced all figns of affliction ; but their love for their mafter, the outrages he had fuffered in his life-time, and his fhameful death, would not let them intirely forget the late difgraces which they had feen him fuffer. Our Saviour indeed had told them of the neceffity for his fufferings, and of his approaching refurrection ; but that only could allay the unbounded tranfports of an extreme forrow : Accordingly, we do not here difcern any outward expreffion of an abandoned grief, but only all the tokens of an heart, which, in the excefs of its love, is indeed perfectly fenfible of Chrift's fpeedy triumph, but yet more imployed in the remembrance of his fufferings.

St. JOHN is placed to the left, leaning againft a rock, in a dejected pofture, holds in his hand the nails with which his mafter was faftened to the crofs, and feems to make reflections on the pains they occafioned.

ON the fame fide, is *Mary Magdalen*, placed at *Chrift*'s feet, which fhe kiffes with love, and feems to have bathed with her tears, and to wipe with her fcattered hair,

U as

as fhe had before done in the houfe of *Simon the Pharifee.*

THE other two women, next the Virgin, are one kneeling, and the other ftanding; this laft bows her body, her head inclines to one of her fhoulders, and fhe wipes her eyes with her linen veil. Thefe women exprefs ftrongly, tho' without any violent emotion, a mixture of grief and tendernefs, with which their hearts are deeply affected.

THE two old men, behind thefe women, in the corner of the piece, are *Nicodemus* and the *Centurion*, and feem to be dif-courfing very earneftly of the injuftice with which the *Jews* condemned innocence it-felf.

JOSEPH of *Arimathea*, a little more forward on the fore-ground, in a ftanding pofture, with one hand on his fide, and the other on his breaft, in a noble attitude, with his eyes fixed on *Chrift*, is pondering on what he fees. The whole of his action, however, fhews, that he is more taken up with the faith he had received, and with the greatnefs of the myftery of re-demption.

THE tafte of defign in this ftory is won-derfully fuitable to the figures which com-pofe it: 'Tis moving, elegant, and noble, in *Chrift* and the women; and more robuft and bold in the three old men, each accord-ing to the diverfity of his nature; for St.

John's

John's character of defign is between the delicatenefs of *Chrift*, and the more heavy proportion of the other figures; and yet all the proportions, in their kinds, are perfectly exact.

THREE Angels above, over *Chrift*, make a group agreeably varied by their contrafted attitudes, and by the variety of their expreffions and colouring : In their character they are infants, defigned like women; I mean, with the fame delicacy.

CONSIDERING the difficulty to practife colouring in fculpture, 'tis aftonifhing to fee how well the author has acquitted himfelf here. The carnations are fo fkilfully managed, and finely oppofed, that they cannot be enough admired ; and the local colouring fo ordered, as to raife the value of one colour by comparifon with another. The fheet, for inftance, under *Chrift*'s body, gives to the flefh a great character of truth, by the comparifon of thefe two colours.

IN order to draw the eye to *Chrift*, as the principal figure, the author has cloathed the Virgin, and *Mary Magdalen*, in a fweet brown colour, which makes the light, that falls upon the body of *Chrift*, appear more lively and confpicuous.

THE woman on her knees, between the *Virgin* and the other *Mary*, contributes much to the effect of the *claro-obfcuro*, in

U 2 diftinguifh-

diftinguiſhing, by the obſcurity, the figures
ſhe ſeparates.

THE colour of the cloathing of *Nicode-*
mus, and of the *Centurion*, throws off and
brings forward the figure next to them.

JOSEPH of *Arimathea* is in purple ;
which not only denotes a man of diftinction,
but, being of a ſtrong and briſk tone, agrees,
according to the rules of art, with the fore-
ground figures, and, on the meeting of the
colours, contributes to the harmony of *the*
whole together. But this figure is more con-
ſpicuous than others, not only by the colour
of its cloathing, but alſo by the work of the
head; which is a maſter-piece of art. He
is old, and his face full of wrinkles ; but
thoſe are ſo learnedly managed, as to expreſs
the look of a man of a ſound underſtanding,
after a ſtrong, tender, and finiſhed manner ;
but tho' this head is wrought with the utmoſt
exactneſs, yet it does not ſmell at all of the
labour : The pains it coſt was pains to the
underſtanding, and from thence it imme-
diately flows. The patience it required was
owing rather to the pleaſure which the author
took in the work, than to any neceſſity of
bringing it to a concluſion. Every thing
therefore is finiſhed in this particular figure ;
but every thing there is full of fire ; and the
manual performance, ſupported by a fine
genius, and profound knowledge, hath cer-
tainly

tainly made this piece of art worthy of the greateſt admiration,

THUS our learned ſculptor has woven with this mournful ſubject all the graces of which it was capable, has given all the proofs of a profound and ingenious ſcience, and thus has confecrated this work to poſterity. Yet, after all the care that could be taken in a faithful deſcription of both theſe pieces, 'tis impoſſible, by bare reading, without a ſight of the works themſelves, to conceive a juſt idea of all their beauties.

THE

THE
BALANCE
OF
PAINTERS.

SOME perfons, curious to know the degree of merit of every painter of eftablifhed reputation, have defired me to make a kind of balance, where I might fet down, on one fide, the painter's name, and the moft effential parts of his art, in the degree he poffeffed them ; and, on the other fide, their proper weight of merit ; fo as, by collecting all the parts, as they appear in each painter's works, one might be able to judge how much the whole weighs.

THIS I have attempted, rather to pleafe myfelf, than to bring others into my fentiments ; Opinions are too various in this point, to let us think, that we alone are in the right. All I afk is, the liberty of declaring my thoughts in this matter, as I allow others to preferve any idea they may have different from mine.

THE

THE method I have taken is this : I divide my weight into twenty parts, or degrees. The twentieth degree is the higheſt, and implies *ſovereign perfection* ; which no man has fully arrived at. The nineteenth is the higheſt degree that we know, but which no perſon has yet gained. And the eighteenth is, for thoſe who, in my opinion, have come neareſt to perfection ; as the lower figures are for thoſe who appear to be furⸯther from it.

I HAVE paſt my judgment only on the moſt noted painters, and in the enſuing ca-talogue have divided the chief parts of the art into four columns; to wit, *Compoſition, Deſign, Colouring,* and *Expreſſion.* By *Expreſſion,* I mean not the character of any particular object, but the general thought of the underſtanding. And thus, againſt each painter's name, we ſee his de-gree of merit in all the aforeſaid four di-viſions.

WE might introduce, among the moſt noted painters, ſeveral *Flemings,* who have very faithfully ſhewn truth of nature, and been excellent colouriſts ; but we thought it better to ſet them by themſelves, becauſe their taſte was bad in other parts of the art.

IT now only remains to be obſerved, that as the eſſential parts of painting conſiſt of many other parts, which the ſame maſters

U 4 have

have not equally poffeffed ; 'tis reafonable to fet one againft another, in order to make a fair judgment. Thus, for inftance, *Com-pofition* arifes from two parts ; viz. *Invention* and *Difpofition.* Now a painter may poffibly be capable of inventing all the objects proper to a good compofition, and yet not know how to difpofe them, fo as to produce a great effect. Again, in *Defign,* there is tafte and correctnefs ; and a picture may have one of them only, or elfe both may appear jointly, but in different degrees of goodnefs; and by comparing one with another we may make a general judgment on the whole.

For the reft : I am not fo fond of my own fentiments as to think they will not be feverely criticized : But I muft give notice, that in order to criticize judicioufly, one muft have a perfect knowledge of all the parts of a piece of painting, and of the reafons which make the whole good; for many judge of a picture only by the part they like, and make no account of thofe other parts which either they do not underftand, or do not relifh.

A

A

CATALOGUE

OF THE

Names of the moſt noted PAINTERS, and their Degrees of Perfection, in the Four principal Parts of *Painting*; ſuppoſing abſolute Perfection to be divided into twenty Degrees or Parts.

NAMES.	Compoſition.	Deſign.	Colouring.	Expreſſion.
	Deg.	Deg.	Deg.	Deg.
A.				
Albano	14	14	10	6
B.				
Barocchio	14	15	6	10
Baſſano, Jacomo	6	8	17	
Belino, John	4	6	14	
Bourdon	10	8	8	4
Le Brun	10	16	8	16

C.

NAMES.	Composition. Deg.	Design. Deg.	Colouring. Deg.	Expression. Deg.
C.				
The *Caracches*	15	17	13	13
Da Caravaggio, Polydore	10	17	0	15
Correggio	13	13	15	12
Da Cortona, Pietro	16	14	12	6
D.				
Diepembeck	11	10	14	6
Dominichino	15	17	9	17
Durer, Albert	8	10	10	8
G.				
Giorgione	8	9	18	4
Gioseppino	10	10	6	2
Guerchino	18	10	10	4
H.				
Holbein, Hans	9	10	16	13
I.				
Jordano, Luca	13	12	9	6
Jourdaens, James	10	8	16	6
L.				
Lanfranco	14	13	10	5
Van Leyden, Lucas	8	6	6	4
M.				
Michael Angelo Buonarotti	8	17	4	8
Michael Angelo da Caravaggio	6	6	16	0
Mutiano	6	8	15	4
P.				
Palma the elder	5	6	16	0
Palma the younger	12	9	14	6

NAMES.	Composition.	Design.	Colouring.	Expression.
	Deg.	Deg.	Deg.	Deg.
Parmesan	10	15	6	6
Penni, Francisco il Fattore	0	15	8	0
Del Piombo, Baptista	8	13	16	7
Perugino, Pietro	4	12	10	4
Pordenon	8	14	17	5
Pourbus	4	15	6	6
Poussin	15	17	6	15
Primaticcio	15	14	7	10
R.				
Rembrant	15	6	17	12
Reni, Guido	0	13	9	12
Romano, Julio	15	16	4	14
Rubens	18	13	17	17
S.				
Salviati, Francisco	13	15	8	8
Santio, Raphaele	17	18	12	18
Del Sarto, Andrea	12	16	9	8
Le Seur	15	15	4	15
T.				
Teniers	15	12	13	6
Testa, Pietro	11	15	0	6
Tintoret	15	14	16	4
Titian	12	15	18	6
U.				
Del Vago, Pierino	15	16	7	6
Vandyke	15	10	17	13
Vanius	13	15	12	13
De Udine, John	10	8	16	3

Vero-

N·A·M·E·S.	Composition.	Design.	Colouring.	Expression.
	Deg.	Deg.	Deg.	Deg.
Veronese, Paolo Cagliari	15	10	16	3
Venius Otho	13	14	10	10
Da Vinci, Leonardo	15	16	4	4
Da Volterra, Daniele	12	15	5	8
Z.				
Zuccharo, Taddeo	13	14	10	9
Zuccharo, Friderico	10	13	8	8

F I N I S.

THE

TABLE.

The TABLE.

5

The TABLE.

4

The T A B L E.

Rhodes

The TABLE.

The T A B L E.